Seventh Edition

A GUIDE BOOK
of
MODERN UNITED STATES
CURRENCY

By
NEIL SHAFER

A Comprehensive Illustrated Valuation
Catalog of All Modern-Size United States
Paper Money From 1929 to the Present,
With Historical Data and Official Totals.
Also Includes Complete Catalog Listing of
U.S. Military Payment Certificates.

Whitman Coin Products

Copyright © 1975 by
WESTERN PUBLISHING COMPANY, INC.
RACINE, WISCONSIN 53404

9373 ISBN: 0-307-09373-5 Printed in U.S.A.

TABLE OF CONTENTS

Preface

The collecting of modern U.S. paper money has now come into its own, largely because of the belated recognition that its numismatic significance is as great as that of other areas of collecting. The many types and major varieties of "small-size" notes issued since January 10, 1929 are becoming better known by an ever increasing number of collectors. Sophistication has also made its appearance in the discovery that a multitude of hitherto overlooked minor varieties allow for even further expansion of interest.

The great stimulus came in November of 1963 with the appearance of Federal Reserve $1 notes bearing easy identification from each of the twelve Districts. It became suddenly apparent that the "ever-present" Silver Certificates were about to become extinct. Half-forgotten facts concerning the addition of the motto to various notes quickly assumed compelling importance, and the hunt was on.

The first edition of this book appeared early in 1965. Since then, a constant flow of new data has necessitated periodic revisions leading to the present 7th edition. The main thrust of this book is to concentrate on all major types, and to include a few varieties which are easily understood by newer collectors. There has developed a rather large array of variations, chiefly through the efforts of researcher Chuck O'Donnell. Excellent coverage of these varieties is found in his Standard Handbook.

Expansion of interest in a particular field sometimes means an increase in the importance of closely related material. Such is the case with the various issues of U.S. Military Payment Certificates which are now viewed by many as part and parcel of the modern United States paper money field. MPC's are included in their entirety in this volume.

All available source material was thoroughly researched in order to prepare the detailed explanatory text and diagrams contained herein. With this information it is sincerely hoped that the collector entering this field can successfully meet the great challenge offered in the study and acquisition of modern U.S. currency.

N.S.

ACKNOWLEDGMENTS

Appreciation and sincere thanks are extended to the following who have contributed suggestions, valuations and information to add to the completeness of this work:

A. E. Bebee
Kenneth E. Bressett
Amon G. Carter, Jr.
Robert A. Condo
James A. Conlon
William P. Donlon
B. M. Douglas
Ben Dreiske
Don Fisher
Dennis Forgue
Jack Friedberg
Ira Goldberg
Lawrence S. Goldberg

David Hakes
Mrs. Adolph B. Hill, Jr.
Edward B. Hoffman
Floyd O. Janney
Harry E. Jones
A. M. Kagin
Donald H. Kagin
Paul Kagin
Theodore Kemm
Bill Kiszely
Herbert T. Krisak
Mrs. Sue Leebrick
Robert H. Lloyd

Bob Medlar
Sheldon L. Moses
Dean Oakes
Chuck O'Donnell
V. H. Oswald
Donald G. Peterson
Roger J. Radtke
Carlton F. Schwan
James W. Seville
Gary F. Snover
Holland Wallace
Robert K. Wilcox

GLOSSARY OF CURRENCY TERMS

The following diagram illustrates the respective positions of various characters and symbols found on modern U. S. currency issues. The nomenclature will be fully explained in succeeding sections of the book.

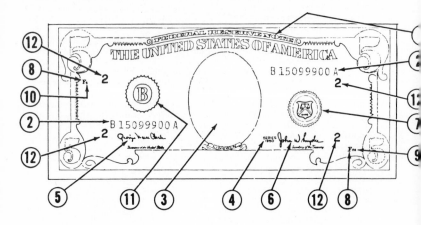

*1. TYPE OF NOTE — Federal Reserve Note, Silver Certificate, United States Note, National Currency.

2. SERIAL NUMBER — Every note has two identical serial numbers.

3. PORTRAIT — Each denomination carries a distinctive portrait.

4. SERIES DATE — The indicated position is for notes of later issue. Earlier printings carry the series date two times on the face, and in varying positions.

5. SIGNATURE — Treasurer of the United States.

6. SIGNATURE — Secretary of the Treasury.

7. TREASURY SEAL — Blue, green, red, brown, gold or yellow.

8. CHECK LETTERS — Each note has two identical check letters which indicate its position on the full printed sheet.

9. FACE PLATE SERIAL NUMBER — Consisting of the lower right Check Letter and adjacent number, this signifies the specific plate from which the note was printed.

10. QUADRANT NUMBER — Going from 1 to 4, this is found only on issues printed in sheets of 32 notes.

11. FEDERAL RESERVE BANK SEAL — Found only on Federal Reserve Notes.

12. FEDERAL RESERVE DISTRICT NUMBERS — Found only on Federal Reserve Notes.

*Gold Certificates do not have the Type Heading in the usual position at the top.

[4]

BRIEF HISTORY OF THE
BUREAU OF ENGRAVING AND PRINTING

(Based on a Bureau publication of the same title)

Organization and Growth

The Bureau of Engraving and Printing was created out of necessity rather than law, since there was no organic act which authorized its establishment nor any legislation providing for the appointment of its officers. It was really not needed prior to 1861, as no federal paper money had been issued up to that time. However, the outbreak of the Civil War in 1861 forced the government to introduce paper money as a substitute for coins which had practically disappeared from circulation. The first issue was authorized by Acts of Congress of July 17 and August 5, 1861, and February 12, 1862, which required the Secretary of the Treasury to issue Demand Notes signed by the Treasurer of the United States, the Register of the Treasury, and other officials whom he might designate. These Demand Notes were printed by private bank note companies for the Treasury Department.

The Bureau came into functional existence because of an Act of Congress of July 11, 1862. A new issue of currency was authorized by that Act, and the Secretary of the Treasury was empowered to have some or all the notes engraved and printed by private firms or at the Treasury Department, and to prepare them for circulation by providing the necessary machinery, materials and personnel to accomplish this task. Operations commenced on August 29, 1862, when a force of two men and four women working in a single room in the attic of the main Treasury building began to separate, seal, and sign $1 and $2 notes which had been printed by private contractors. In November 1862, the First Division of the National Currency Bureau, later called the Bureau of Engraving and Printing, also commenced the printing of currency notes from plates engraved by Treasury employees. By 1864, it had become apparent that the United States government was to be indefinitely engaged in the manufacture of paper money. It was therefore recommended to the Secretary of the Treasury that "The Engraving and Printing Bureau of the Treasury Department" be established; however, the proposal was not accepted at that time. Congressional legislation finally recognized its existence in the Appropriation Act of August 15, 1876, and it has since functioned as a distinct entity within the Treasury Department.

As the years progressed, the Bureau of Engraving and Printing gradually absorbed the functions performed by the private bank note companies, and by October 1, 1877, the printing of all United States securities was centralized in the Bureau. The printing of internal revenue stamps was taken over in 1876 and the production of postage stamps in 1894.

From 1862 until 1880, all Bureau functions were housed in the main Treasury building. In 1880, Congress appropriated $300,000 for the purchase of a site and erection of a separate building for the Bureau. This is the red brick edifice which stands today just north of the present main building. By 1914, the Bureau operations had increased to such an extent that a larger building was needed. In the spring of that year, the Bureau occupied the present main building which had just been completed at a cost of approximately $3,000,000. The Bureau Annex, directly across from the main building, was completed in 1938. Thus, in a little over a century the Bureau has grown from a small unit of six persons to a large modern factory housed in two buildings with a combined floor space of close to 25 acres, and employing about 3,000 people.

Products of the Bureau

The Bureau in many ways resembles a private contracting firm. It receives orders for work from almost every branch of the government. But the greatest number of orders are received from four agencies — the Treasury Department, Federal Reserve System, Internal Revenue Service, and Post Office Department. The Bureau performs the work contracted for and is reimbursed for all work delivered.

The Bureau designs, engraves, and prints currency, bonds, Treasury notes and bills, Food Coupons, postage and revenue stamps, checks and miscellaneous engraved work for the various governmental departments and independent establishments, and the insular possessions. Printings cover a wide range of subject matter from the 1¢ postage stamps to the lofty $500,000,000 Treasury note, officers' commissions printed on artificial parchment, invitations and admission cards to White House receptions, diplomas for the Coast Guard Academy, and certificates of meritorious awards made to service personnel by the Army and Navy. In addition to work printed from engraved plates, numerous items are produced on surface printing presses from offset plates. Such work includes liquor stamps and United States savings bonds ($500, $1,000, $5,000, and $10,000 in Series H; $25, $100, $500, $1,000, $5,000, $10,000, and $100,000 in Series J; $25, $50, $100, $200, $500, and $1,000 in Series E, 1943 design, and the Kennedy $75 Series E issued in 1964).

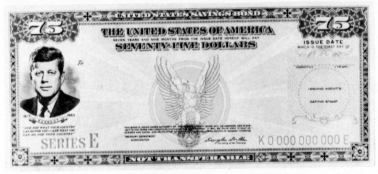

The $75 Kennedy Savings Bond

The principal product of the Bureau is paper currency. A face value of over 12 billion is printed annually, averaging over 10 million notes a day. Regardless of the type of bill issued, all those of like denomination bear the same portrait, and the backs are of uniform design. There are twelve denominations of currency ranging from $1 to $100,000. However, the $100,000 note is a Gold Certificate issued only to the Federal Reserve Banks; it never entered into public circulation. The $100 note is the highest denomination printed since about 1945, and is the highest in circulation at this time. All higher denominations were retired from circulation on July 14, 1969.

Designing and Preparations for Printing

When a new item is to be produced, a model is prepared by a designer after discussions with officials of agencies interested in the product. By tradition, portraits used for securities and regular issue stamps are those of Americans of historical importance. Portraits used on currency are of persons whose places in the annals of our country are particularly well known to the public. By law, no portrait of a living person may be used.

[6]

TABLE OF PORTRAITS AND DESIGNS

Denomination	Portrait on Face	Design on Back
$1	George Washington	Great Seal
$2	Thomas Jefferson	Monticello
$5	Abraham Lincoln	Lincoln Memorial
$10	Alexander Hamilton	U. S. Treasury
$20	Andrew Jackson	White House
$50	Ulysses S. Grant	U. S. Capitol
$100	Benjamin Franklin	Independence Hall
$500	William McKinley	Value
$1000	Grover Cleveland	Value
$5000	James Madison	Value
$10,000	Salmon P. Chase	Value
$100,000	Woodrow Wilson	Value

Papers and Inks

To guard against counterfeiting, United States paper money is printed by engraved intaglio steel plates on distinctive paper. The currency paper for dry printing is made of 75% cotton and 25% linen, and contains small segments of red and blue fibers which are imbedded during manufacture. Strict government control is exercised during the preparation of this paper.

For 85 years (1879-1964) the firm of Crane and Company, Dalton, Massachusetts, was the sole producer of currency paper for the Bureau. From 1964 to 1969 the Bureau has had contracts with the Gilbert Paper Company of Menasha, Wisconsin (a subsidiary of the Meade Paper Corporation of Dayton, Ohio) to furnish some of its paper needs. Since then Crane has been the exclusive supplier.

All inks used in plate and surface printing are manufactured in the Bureau by blending dry colors, oils and extenders of the highest quality obtainable in huge mixers similar to the large kneading machines used by commercial bakeries. The blended ink mixtures are ground under extreme pressure in large mills between water-cooled heavy steel rollers to ensure the proper texture. A test is made of each new batch to see that it conforms with laboratory standards before it is used for printing.

Plate Manufacture

To afford the best protection against counterfeiting, all United States paper money, as well as nearly all postage stamps and other evidences of a financial character issued by the United States Government, are printed from plates made from steel engravings. This type of printing is known as intaglio. Of all the printing processes, intaglio is the most difficult to produce and to counterfeit. Other processes lack the fidelity of fine line engraving and the distinctive third dimensional effect of raised line on paper inherent in intaglio printing. Another outstanding element of protection is the portrait. The use of portraits in security design takes full advantage of the characteristics of intaglio printing since even a slight alteration in breadth, spacing, or depth of line on the part of a counterfeiter will cause a perceptible facial change.

In the intaglio-plate manufacturing process the individual features of a chosen design are hand-tooled by highly skilled engravers who carve dots and lines of varying depths into soft pieces of steel with delicate steel-cutting instruments called gravers. With infinite care each feature, such as the portrait, the vignette, the numerals, the lettering, the script, and the scroll work, is hand-engraved by a different master craftsman expertly trained in his own particular skill. The fine crosshatched lines in the background of the portrait are precisely etched from lines ruled in wax on a ruling machine. An unlimited number of intricate lacy patterns for use as borders and ornamentation are deftly cut by means of a geometric lathe. It takes years to

acquire the skill of an engraver and it is impossible for him to exactly reproduce his own work, much less that of another engraver. It takes several engravers to prepare the hand-engraved pieces of steel, or dies, as they are called, that are used to make up a master roll or plate.

Currency Manufacture

The Bureau printed all currency by the wet intaglio process on sheet-fed flatbed presses until 1957. As part of an extensive modernization program which has been in progress since 1950, nine high-speed sheet-fed rotary intaglio printing presses, using one plate per press, were procured during the calendar year 1957 and one more in 1964 for printing currency by the dry intaglio process from plates bearing 32 notes (or subjects) to a sheet. These high-speed presses were first used to print one dollar Silver Certificates, Series 1957. Since new dies were adopted and new plates had to be made, these certificates were the first to include in the back design the motto "In God We Trust" in accordance with Public Law 140 of the 84th Congress. Early in 1965, four additional sheet-fed presses having four plates each and capable of printing high-quality 32-subject currency by the dry intaglio process at greatly increased production rates were purchased and placed in operation. By April of 1968, the transition to the dry process was completed.

The major components of these high-speed presses include an intaglio plate cylinder, an impression cylinder, an ink fountain, and an automatic sheet-feeding device capable of holding 10,000 sheets in one loading. Each sheet of paper passes between the plate and impression cylinder, under extremely heavy pressure, forcing it down into the fine engraved lines of each plate to pick up the ink. The printed sheets are automatically delivered and deposited one on another in a well-aligned pile.

The backs of the notes are printed with green ink on one day and the faces are printed with black ink on the following day. After the intaglio printing operation, the stacks of 32-subject sheets are trimmed to a uniform dimension. The Treasury seal and serial numbers are then simultaneously overprinted on the face of each of the 32 notes on the sheet by the typographic process on two-color rotary presses.

For many years this overprinting also included the series date and the two signatures of Treasury officials, but with the complete conversion to the dry printing process in April of 1968, it was found more efficient to engrave these features once again on the plate itself. This was first accomplished on the $100 United States Note Series 1966 (issued in 1968). Next were the $1 Federal Reserve Notes Series 1963 B with Joseph W. Barr's signature as Secretary of the Treasury. All notes series dated 1969 and later have been made in a similar fashion.

A Federal Reserve district seal is also overprinted on the face of each Federal Reserve Note. The district seal and number are always overprinted in black ink. A detailed examination is then made in 16-subject form (½ of a full-size sheet) and the defective notes marked or identified for subsequent removal. When examined, the sheets are separated into stacks of individual notes on paper cutting machines. After a final note examination — in units of 100 each — for the removal of imperfect notes and the replacement with "star" notes, the currency is securely banded and wrapped for delivery to the vaults of the customer agencies. Each currency package or "brick" contains 40 units of 100 notes each, or 4,000 notes, and weighs about 8½ pounds.

The COPE Process

During the past several years the Bureau has taken yet another giant step forward in its continuing program of modernization. A revolutionary new currency processing machine designed to automate the largely manual final steps in preparing paper money for issue has been activated for part of the

Bureau's production. The Currency Overprinting and Processing Equipment (COPE), built to Bureau specifications by a German firm, is destined to save more than two million dollars a year in production costs. The machine starts with two stacks of 10,000 engraved 16-subject sheets which have been inspected for errors. This is the final human inspection, as COPE is designed to catch its own mistakes.

The sheets are fed simultaneously, one at a time, from each stack, into a letterpress overprinting unit which adds the seals and serial numbers. Sheets are accumulated into stacks of 100, cut into stacks of 100 single notes, banded and delivered into large rotating units which hold 1,280 packages of 100 notes each. These are emptied in turn for boxing and shipping.

In addition to reducing manual handling, COPE is expected to allow fewer error notes from reaching the public, since any accidental fold or crease causes the machine to stop.

"Notes" From Test Plates

Several years ago some curious-looking items appeared which at first glance seem to be some sort of United States paper money. This is because they are test prints from special 32-subject plates showing portions of design elements from various regular notes. The plates were made by the Bureau of Engrav-

This is the test print under discussion. The black lines through the portraits are a part of the plate. Both color variants are identical in design.

ing and were sent to Germany for test runs on new Giori presses which were subsequently purchased and are now being used by the Bureau.

Two color varieties are presently known: the first is printed in black on the face side and reddish brown on the back, and the second has a slate green face side and black printing on the back. All such special printings should have been destroyed, according to Bureau officials, even though they cannot be construed as obligations of the United States government. Thus, they may legally be held by collectors since they are test prints and not special notes.

When available, which is very seldom, the green/black piece will bring about $250. The rarer black/reddish brown piece has not been seen for sale publicly by the author.

Miscellaneous Information

The cost of producing United States currency is 1¢ a note regardless of denomination. Two-thirds of the currency notes produced are of the $1 denomination. The life of the dry-printed $1 Federal Reserve Note averages about 18 months. Other denominations remain in circulation longer. The size of a currency note is 2.61 inches x 6.14 inches and the thickness is .0043 inch. There are 233 new notes to an inch (not compressed) and 490 to a pound. A million notes of any denomination weigh approximately 2,000 pounds and occupy approximately 42 cubic feet of space (with moderate pressure). Approximately 3,500 tons of paper and 1,000 tons of inks are used each year in producing the Government securities.

THE SERIAL NUMBER SYSTEM FOR U.S. CURRENCY

The system of numbering paper money must be adequate to accommodate a large volume of notes. For security and accountability purposes, no two notes of any one type, denomination and series may have the same serial number. The serial numbers on each note have a full complement of eight digits and an alphabetical prefix and suffix letter. When necessary, ciphers are used at the left of the number to make a total of eight digits. Every note has two identical serial numbers.

Whenever a new numbering sequence is used for United States Notes, Silver or Gold Certificates, the first note is numbered A00 000 001A; the second A00 000 002A; the hundredth A00 000 100A; the thousandth A00 001 000A; and so on through A99 999 999A.* The suffix letter "A" will remain the same until a total of 25 groups of 99,999,999 notes are numbered, each group having a different *prefix* letter from A to Z. The letter "O" is omitted, either as a prefix or as a suffix, because of its similarity to zero. The 100,000,000th note in each group will be a star note, since eight digits are the maximum practicable for the numbering machines.† Further testimony to modern numbering machines' inability to produce the nine-digit number is seen in the late discovery of a note with a serial number of eight zeros.

At this point, the *suffix* letter changes to "B" for the next 25 groups of 99,999,999 notes, and numbering proceeds the same as with suffix letter "A."

*Serial numbers start from the beginning when a completely new issue and series date is printed. For minor changes within a series date, the numbers usually continue undisturbed. This is not always the case; as an instance, the $1 Silver Certificate Series 1957 has numbers starting from the beginning, but the *same* is true for the Series 1957 A notes as well. The 1957 B notes, however, do *not* start over but simply continue where the 1957 A notes leave off.

†Apparently in earlier issues of modern-size notes, the 100,000,000th piece *was* prepared with nine digits. Such a note ($1 1928 A) was rediscovered and reported late in 1966 by Thomas B. Ross. The famed Grinnell sale of 1946 also contained one of these, as well as a specimen of the 1928 B series and two dated 1934.

A total of 62,500,000,000 notes could be numbered before a duplication of serial numbers would occur. However, the Bureau has never been required to number that many notes of any one type, denomination and series.

The Federal Reserve Notes printed for the twelve Districts are numbered the same way as United States Notes and Silver Certificates, except that the letter identifying each District is used as a *prefix* letter at the beginning of the two serial numbers, and it does not change. Only the suffix letter changes in the serial numbers on Federal Reserve currency.

The numbering system used for National Currency and Federal Reserve Bank Notes is illustrated with sheets and described in detail on pages 93-94.

BLOCK LETTERS

Many collectors are now seeking certain kinds of notes by their prefix-suffix letter combinations in serial numbers, such as A--A, A--B, A--C, and so on. This is called collecting by "block letters." Some combinations are obviously more difficult to find than others because of the varying amounts that might have been made. Scarcer combinations when sold may bring much more than the catalog valuations.

For further details on this aspect of collecting modern U.S. currency, the reader is referred to the book by O'Donnell as listed in the Bibliography.

★ STAR OR REPLACEMENT NOTES ★

As mentioned previously on page 8, if during the course of examination a note is found to be imperfect, it is removed and replaced by a "star" note.

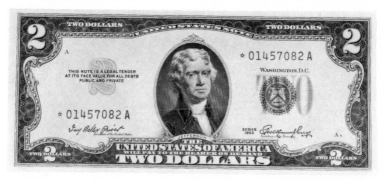

Typical star note

Star notes are exactly the same as regular notes except that an independent series of serial numbers is assigned. Instead of the usual prefix letter, a star appears with the serial numbers on Gold Certificates, United States Notes and Silver Certificates; on Federal Reserve Notes and Federal Reserve Bank Notes the star appears in place of the suffix letter since the prefix letter is the Bank letter as well. No star notes were used in connection with the National Bank Note issues.

As explained on page 10, the 100,000,000th note of any group will also be a star note because the numbering machines are not geared to print over eight digits.*

*See Footnote on previous page.

Star Note Totals

A given total for any issue of star notes during the last few years refers only to the quantity of that series that was *printed*, not to the quantity issued. The practice has been to make star notes in anticipation of spoilage, with their actual issuance only as necessary. Thus they may or may not be released with their regular issue counterparts.

As cases in point, Fowler star notes were still available at the time the regular Barr series was issued, and were interspersed with them as required. Similarly, Barr star notes were mixed into early releases of the Kennedy series. Another good example is the $100 U.S. Note Series 1966. There were 120,000 star notes printed but very few have been released as not many have been needed thus far. The remaining Series 1966 star notes will eventually be used with future printings of regular $100 U.S. Notes *regardless* of series designation. In any case, regular issue totals include all star notes (of whatever series) used to make up those totals, as no figures are available for the number of defective regular notes replaced by star notes in a given series.

Occasionally whole decks (100) of star notes are "dumped" out when new notes have been printed.

Scarcity and Valuation

Recently a great deal of attention has been focused on star printings with demand centering chiefly on the better issues. Earlier issues of star notes are generally scarce, and certain ones are rare. The most popular of these are each listed in the catalog along with the corresponding regular issues.

Selected later issues are also in demand; these are shown where possible.

THE SERIES YEAR ON U.S. CURRENCY

The series year which appears on the face of each note signifies the year in which the design was adopted. The series year does not change each calendar year; it changes only when the basic design has a major revision. The capital letter often found following the series year indicates that a minor change was authorized in a particular currency. Minor revisions usually occur when a new Secretary or Treasurer is appointed.

The series year appears twice on older printings of modern U. S. currency. More recent issues carry this designation only once.

Series Year Appearing on All Issues of Modern-Size Notes

Since 1929, the year modern-size currency was first issued into circulation, the Bureau of Engraving has printed and delivered the following series of notes:

UNITED STATES NOTES

Denomination	Series
$1	1928.
$2	1928, 1928 A, 1928 B, 1928 C, 1928 D, 1928 E, 1928 F, 1928 G, 1953, 1953 A, 1953 B, 1953 C, 1963 and 1963 A.
$5	1928, 1928 A, 1928 B, 1928 C, 1928 D, 1928 E, 1928 F, 1953, 1953 A, 1953 B, 1953 C and 1963.
$100	1966 and 1966 A.

Denomination	Series

SILVER CERTIFICATES

$1 . 1928, 1928 A, 1928 B, 1928 C, 1928 D, 1928 E, 1934, 1935, 1935 A, 1935 B, 1935 C, 1935 D, 1935 E, 1935 F, 1935 G, 1935 H, 1957, 1957 A and 1957 B.

$5 . 1934, 1934 A, 1934 B, 1934 C, 1934 D, 1953, 1953 A, 1953 B and 1953 C.

$10 . 1933, 1933 A, 1934, 1934 A, 1934 B, 1934 C, 1934 D, 1953, 1953 A and 1953 B.

NATIONAL BANK NOTES

$5, $10, $20, $50 and $100 1929.

FEDERAL RESERVE BANK NOTES

$5, $10, $20, $50 and $100 1929.

FEDERAL RESERVE NOTES

$1 . 1963, 1963 A, 1963 B, 1969, 1969 A, 1969 B, 1969 C, 1969 D and 1974.

$5 . 1928, 1928 A, 1928 B, 1928 C, 1928 D, 1934, 1934 A, 1934 B, 1934 C, 1934 D, 1950, 1950 A, 1950 B, 1950 C, 1950 D, 1950 E, 1963, 1963 A, 1969, 1969 A, 1969 B, 1969 C and 1974.

$10 and $20 . 1928, 1928 A, 1928 B, 1928 C, 1934, 1934 A, 1934 B, 1934 C, 1934 D, 1950, 1950 A, 1950 B, 1950 C, 1950 D, 1950 E, 1963, 1963 A, 1969, 1969 A, 1969 B, 1969 C and 1974.

$50 and $100 . 1928, 1928 A, 1934, 1934 A, 1934 B, 1934 C, 1950, 1950 A, 1950 B, 1950 C, 1950 D, 1950 E, 1963, 1963 A, 1969, 1969 A, 1969 B, 1969 C and 1974.

$500, $1,000, $5,000 and $10,000 1928, 1934 and 1934 A.

GOLD CERTIFICATES

$10, $20 and $100 1928 and 1928 A.
$50, $500 and $5,000 1928.
$1,000 and $10,000 1928 and 1934.
$100,000 . 1934.

THE TREASURY SEAL

The design of the Treasury Seal now imprinted on the face of all U.S. currency is older than the Constitution. On September 25, 1778, the Continental Congress appointed a committee composed of John Witherspoon, Gouverneur Morris and Richard Henry Lee to design a seal. In the Journals of Congress of that date is a resolution providing "that the Comptroller shall keep the Treasury books and seal . . . shall draw bills under said seal." The resulting

design was submitted and approved, and the Seal is found on official documents dating back to 1782. It was retained after the ratification of the Constitution in 1788.

Through the years, the design of the Seal has remained basically the same though minor changes were effected in 1849 when a new die was prepared. The third die made by the Bureau of Engraving in 1915 and in use until mid-1968 is described as follows: The design includes a shield on which appear a balance scale representing Justice and a key which symbolizes official authority. They are separated by a chevron bearing 13 stars for the 13 original colonies or states. The shield is surrounded by a spray of laurel in blossom. The following Latin legend surrounds the shield: THESAUR. • AMER. • SEPTENT. ★ SIGIL. Written out, this is "Thesauri Americae Septentrionalis Sigillum," meaning "The Seal of the Treasury of North America." There is no reverse to the Treasury Seal.

As found on currency, the Treasury Seal was originated by Spencer M. Clark, Chief Engineer of the Currency Bureau. It is imprinted on official Treasury documents and on the face side of U.S. currency beginning with the first issue of Legal Tender Notes authorized in 1862. The Demand Note Series 1861 and the first three issues of Fractional Currency constitute the only U.S. paper money which does not bear the Treasury Seal.

New Seal Adopted

A new rendition of the Seal was adopted during 1968 after its approval by Treasury Secretary Fowler in January of that year. While generally similar in appearance to previous designs, several major changes took place. English inscription "The Department of the Treasury 1789" replaced the Latin legend, and the surrounding laurel spray was removed.

The new Seal was first used on the $100 United States Note Series 1966 (issued in 1968); it is also being used for all currency series 1969 and later.

 THE GREAT SEAL OF THE UNITED STATES

On August 15, 1935, the Treasury Department announced that production of a new $1.00 Silver Certificate had begun. The design chosen for the new back was the Great Seal of the United States. This was the first time both sides of the Great Seal were to appear on any U. S. money.

The obverse of the Great Seal is the familiar American eagle with a shield, holding an olive branch in one talon and arrows in the other. Above are thirteen stars and the Latin motto "E Pluribus Unum."

The reverse of the Great Seal shows an unfinished pyramid, surmounted by an eye in a triangular glory. The pyramid bears in Roman numerals the year of the Declaration of Independence, 1776. Above the eye is the Latin motto "Annuit Coeptis," rendered as "He (God) favored our undertakings." The motto at the bottom is "Novus Ordo Seclorum" and is translated as "A new order of the ages." The eye and triangular glory represent an all-seeing Deity. The pyramid is the symbol of strength; its unfinished condition denotes the belief of the Seal's designers that there was yet work to be done. Both mottoes on the reverse are condensations of excerpts from Virgil's Aeneid.

The first committee on the Great Seal was formed on the afternoon of July 4, 1776, and consisted of Benjamin Franklin, Thomas Jefferson and John Adams. The Great Seal as finally adopted was largely the work of Charles Thomson, Secretary of Congress, and William Barton, a private citizen of Philadelphia. The design was officially adopted on June 20, 1782, by Fundamental Law. The Great Seal was again ratified after the Constitution was adopted in 1789.

According to Treasury records, the only previous use of the reverse of the Great Seal was in 1882, when a centennial medal was issued by the United States mint to celebrate the 100th anniversary of the Great Seal's adoption.*

*Further details concerning the adoption of the Seal on $1 notes, including illustrations of models before and after approval, are contained in the *History of the Bureau of Engraving and Printing,* pages 121-123.

THE NATIONAL MOTTO ON U.S. CURRENCY

An Act of Congress approved by the President on July 11, 1955, authorized the appearance of the National Motto on all U. S. currency. The first notes to bear the motto were $1 Silver Certificates Series 1957, which were released to circulation on October 1 of that year.

The changeover was implemented gradually, as the Bureau installed new high-speed rotary presses using the dry-print method to produce sheets of 32 subjects. By April of 1968 the process of change was completed, and all currency now produced bears the motto.

TREASURY OFFICIALS
AND THEIR TERMS OF OFFICE

Modern U.S. currency is very often collected by signature combination. These facsimile signatures appear on currency made either during the respective tenures of office of the Treasury officials or until one or both new officials are appointed. National Currency and Federal Reserve Bank Notes Series of 1929 used the Register-Treasurer signatures; all the rest from the first issues series dated 1928 to the present show the Treasurer-Secretary combination.

When the Treasurer or Secretary, or both, leave office and a new official is appointed, a letter is added after the series date and of course the signatures are changed. Originally these signatures were engraved on the face plates, which then had to be replaced upon the appearance of a new official. In recent years the signatures (along with other numbers and symbols) have been overprinted on the following issues:

SILVER CERTIFICATES

$1 Series 1935 A through 1957 B
$5 Series 1953 through 1953 C
$10 Series 1953 through 1953 B

UNITED STATES NOTES

$2 Series 1953 through 1963 A
$5 Series 1953 through 1963

FEDERAL RESERVE NOTES

All — Series 1950 through 1963 A

As explained on page 8, the Bureau has again resumed the practice of engraving the signatures and series dates on the face plates. All notes printed since 1969 have been made from plates bearing engraved signatures and series dates.

Chart of Concurrent Terms of Office

Following is a chart showing the length of time the various signatories of modern U. S. currency have held concurrent office:

Treasurer–Secretary	First Day	Last Day	Years	Months	Days
H. T. Tate–A. W. Mellon	Apr. 30, 1928	Jan. 17, 1929	00	08	17
W. O. Woods–A. W. Mellon	Jan. 18, 1929	Feb. 12, 1932	03	00	25
W. O. Woods–Ogden L. Mills	Feb. 13, 1932	Mar. 3, 1933	01	00	18
W. O. Woods–W. H. Woodin	Mar. 4, 1933	May 31, 1933	00	02	27
W. A. Julian–W. H. Woodin	June 1, 1933	Dec. 31, 1933	00	07	00
W. A. Julian–Henry Morgenthau, Jr	Jan. 1, 1934	July 22, 1945	11	06	22
W. A. Julian–Fred M. Vinson	July 23, 1945	July 23, 1946	01	00	00
W. A. Julian–John W. Snyder	July 25, 1946	May 29, 1949	02	10	04
Georgia Neese Clark–John W. Snyder	June 21, 1949	Jan. 20, 1953	03	07	00
Ivy Baker Priest–G. M. Humphrey	Jan. 28, 1953	July 28, 1957	04	06	00
Ivy Baker Priest–Robert B. Anderson	July 29, 1957	Jan. 20, 1961	03	05	23
Elizabeth Rudel Smith–C. Douglas Dillon	Jan. 30, 1961	Apr. 13, 1962	01	03	14
Kathryn O'Hay Granahan–C. Douglas Dillon	Jan. 3, 1963	Mar. 31, 1965	02	02	28
*Kathryn O'Hay Granahan–Henry H. Fowler	Apr. 1, 1965	Oct. 13, 1966	01	06	13
Kathryn O'Hay Granahan–Joseph W. Barr	Dec. 21, 1968	Jan. 20, 1969	00	01	00
Dorothy Andrews Elston–David M. Kennedy	May 8, 1969	Sept. 16, 1970	01	04	07
†Dorothy Andrews Kabis–David M. Kennedy	Sept. 17, 1970	Feb. 1, 1971	00	04	15
Dorothy Andrews Kabis–John B. Connally	Feb. 8, 1971	July 3, 1971	00	04	26
Romana Acosta Bañuelos–John B. Connally	Dec. 17, 1971	June 12, 1972	00	05	26
Romana Acosta Bañuelos–George P. Shultz	June 12, 1972	May 8, 1974	01	10	26
Francine I. Neff–William E. Simon	June 21, 1974	Presently in office			

Register–Treasurer					
E. E. Jones–W. O. Woods	Jan. 22, 1929	May 31, 1933	04	04	09

Important: It should be clearly understood that the printing time of a particular issue does not generally coincide with the actual term of office of the officials whose names appear on the notes. Thus, while the length of joint tenancy of any two officials might serve as a rough indication of possible scarcity of notes containing their signatures, in actual practice it means little. A perfect example is seen in the much publicized issuance of notes with signatures of Granahan-Barr (see page 44).

Introduction to the Catalog

During 1964, the Bureau of Engraving finished the compilation of all available records showing the amounts delivered of each note by denomination, type and series. Figures showing these totals as corrected by O'Donnell, Breen and others (see next page) are incorporated in the body of the catalog itself. Portions of the rest (dates of issue, serial numbers and other pertinent data) are included as Appendix B.

Detailed files relative to the adoption of modern-size United States currency have also been maintained by the Bureau. The most important excerpts, which include Secretary MacVeagh's official order of 1913 to reduce the size of U. S. currency, will be found as Appendix A.

*Mrs. Granahan resigned as Treasurer on October 13, 1966, but no replacement was appointed for over 2½ years. During this time her signature continued in use, explaining why her name is listed with Joseph W. Barr for his brief tenure of office.

†On September 17, 1970, the former Mrs. Elston became Mrs. Kabis. This is the first time the Treasurer's name was changed during tenure of office.

Since the Bureau's compilation of note totals in 1964, and especially during the past several years, it became apparent that there were many discrepancies between the information contained in Bureau files and the notes themselves. A large degree of success in straightening out these differences and obtaining verified information has been achieved by Chuck O'Donnell through his intensive research efforts in privately held records. His Standard Handbook (see Bibliography) contains all the results of his findings, for which he holds the copyright. Figures showing amounts printed which appear in this book for the first time, as well as any figures which are changed from any previous edition, are included with the express written permission of O'Donnell. These figures cannot be used without such permission from him.

For the last edition much new information on note totals was shown through the efforts of Walter Breen, who found estimates for some earlier issues where the Bureau itself could not furnish such data. All such estimates of earlier issues as well as amounts printed (but not necessarily all released) are *italicized*.

For the sake of continuity all notes of every type and denomination issued for general circulation are included in this section, though notes higher than the $100 denomination carry no catalog valuation. Also, some of the most recent issues of higher denomination notes show no premium value.

GRADING OF CURRENCY
Grades of Condition Used in this Book

NEW — A note that is as clean and crisp as the day it was printed. Such a note may have been obtained directly from a bank teller, or it may have passed through several careful hands. New bills have no folds or creases. Minor flaws or signs of careless handling are at times found on new notes right out of a bank pack. Such notes may be described as new but the flaws must be mentioned.

EXTRA FINE — A note that is almost new, with very minor creases which have not impaired the design and appearance of the note. It must not have cuts, tears or discoloration, and should still be quite crisp. A note that has been washed cannot be considered Extra Fine.

VERY FINE — A note showing slight evidence of circulation. It may have light folds or creases, but will still retain some of its original feel and appearance. The note might have been carefully cleaned or pressed, but this process must not have impaired the appearance of the vignette.

FINE — A note which shows considerable use but is completely legible and not torn or stained. The note will have lost its crispness and may show a little edge wear. It may also have been more heavily creased or folded.

Catalog Values

In compiling the average retail valuations as shown in this book, we have found that there is often a great deal of variation in pricing among the contributors. This is especially true with respect to the more popular issues, which often exhibit spurts of localized activity. We therefore wish to stress the idea that the values included here are meant only as a guide to general retail prices; the notes may be quoted at higher or lower prices depending on local supply and demand.

Star Note Listings

In this catalog star or replacement notes where included are listed immediately after their regular issue counterparts.

Example: ★28 on page 19 refers to the $1 star note for the Series of 1928.

UNITED STATES NOTES — Red Seal

United States Notes, also known as Legal Tender Notes or Greenbacks, were first authorized by the Act of Congress of February 25, 1862. Denominations for the large-size notes ranged from $1 to $10,000. Modern-size notes are presently being issued only in the $100 denomination, as delivery of $2 notes was terminated in July of 1965 and $5 in November of 1967.* The $1 Series of 1928 was released mainly in Puerto Rico years after the notes were printed, but it is no longer in circulation.

When finished, United States Notes are delivered to a vault under custody of the Treasurer of the United States. As required by the Act of May 31, 1878, and the recently enacted Old Series Currency Adjustment Act, the amount outstanding is kept at $322,681,016. The Treasury holds a reserve in gold of $156,039,431 to back these notes. The seal and serial numbers are in red.

Explanatory Notations for Various Series

Series of 1928 — The legal tender clause on earlier issues of this type reads, "This Note Is A Legal Tender at its Face Value For All Debts Public and Private Except Duties on Imports and Interest on the Public Debt."

Series of 1928 B — The Act of May 12, 1933 removed legal tender restrictions from all U. S. money, and the clause on $5.00 notes of this type was changed as follows: "This Note Is A Legal Tender at its Face Value For All Debts Public and Private." For $2.00 notes, this change began with Series of 1928 C issues. All subsequent printings up to Series 1963 carry this same clause.

Series of 1928 C — For $5 notes, the Face Plate Number appears in larger-size numerals on this and succeeding issues. For $2 notes this begins with Series of 1928 D. Lathework also added to frame of $2 notes, 1928 C.

Series 1953 — Along with a general rearrangement of the face side, the following changes occurred on this and succeeding issues:
Series designation appears only once, and the word "OF" is deleted.
The Treasury seal and serial numbers are reduced in size.
Signatures and series date are overprinted instead of engraved.

One Dollar, Portrait of Washington

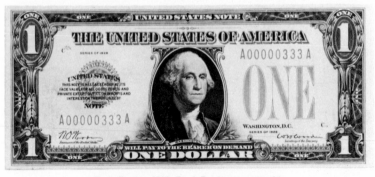

Face Design 1928. Back Design on page 26.

*$10 and $20 plates were made, as a specimen of each note (Series of 1928, Woods-Mills) was in the Treasury's currency exhibit at the Chicago World's Fair 1933-1934.

$1.00 UNITED STATES NOTES

Series 1963 — The addition of the motto to the backs of United States Notes took place in 1963, along with the changeover in printing method from wet to dry and increase in number of subjects per sheet from 18 to 32. The new legal tender clause reads, "This Note is Legal Tender For All Debts, Public and Private." The "Will Pay . . ." clause, near the bottom of the face side on previous issues, no longer appears on the notes.

Series 1966 — The $100 denomination was introduced late in 1968, but bearing the series date 1966. Signatures and series date were engraved in the plates for this issue. The new Treasury Seal was also used for the first time.

✓	Series	Treasurer-Secretary	Delivered	V. Fine	Ex. Fine	New
............	1928	Woods-Woodin...........1,872,012	$14.00	$21.50	$35.00 *	
............	★28	(highest Serial No. seen 7643)......	300.00	600.00	1000.00	

24,000 star notes reportedly assigned to be printed. BEP is unable to tell how many were actually made, or even to confirm the 24,000 assigned numbers.

*Value is for a well centered note. These usually have serial numbers below 8000 (original April-May 1933 issue); those between 8001 and 1872000 were released in Puerto Rico in 1949 and most are imperfectly centered. Such notes are worth less than listed values.

$2.00 UNITED STATES NOTES
Two Dollars, Portrait of Jefferson

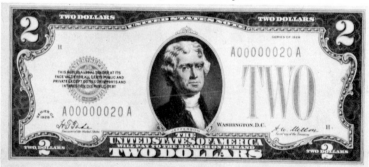

Face Design 1928 through 1928 G

✓	Series	Treasurer-Secretary	Delivered	V. Fine	Ex. Fine	New
............	1928	Tate-Mellon............55,889,424	$10.00	$20.00	$45.00	
............	★28	40.00	70.00	140.00	
............	1928 A	Woods-Mellon..........46,859,136	20.00	55.00	130.00	
............	★28 A	70.00	175.00	300.00	
............	1928 B	Woods-Mills.............9,001,632	100.00	225.00	400.00	
............	★28 B	200.00	425.00	850.00	
............	1928 C	Julian-Morgenthau..... 86,584,000	7.50	13.00	30.00	
............	★28 C	50.00	80.00	175.00	
............	1928 D	Julian-Morgenthau.....146,381,364	6.00	10.00	21.50	
............	★28 D	12.50	20.00	40.00	

$2.00 UNITED STATES NOTES

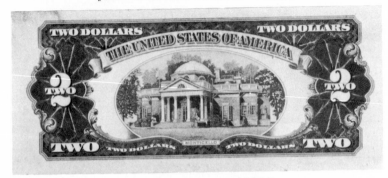

Back Design 1928 through 1953 C

✓	Series	Treasurer-Secretary	Delivered	V. Fine	Ex. Fine	New
............	1928 E	Julian-Vinson............6,480,000		$9.00	$18.00	$42.50
............	★28 E		250.00	400.00	750.00
............	1928 F	Julian-Snyder...........42,360,000		5.00	9.50	20.00
............	★28 F		11.50	19.00	35.00
............	1928 G	Clark-Snyder...........52,208,000		4.25	7.50	12.00
............	★28 G		6.00	12.00	24.00

Total star note printing for 1928 through 1928 G is 4,152,000. No further separation of this total is possible.

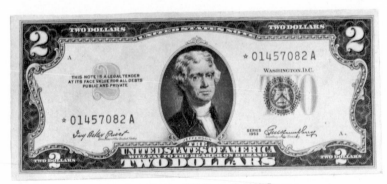

Face Design 1953 through 1953 C

	Series	Treasurer-Secretary	Delivered	V. Fine	Ex. Fine	New
............	1953	Priest-Humphrey........45,360,000		3.50	4.50	7.50
............	★532,160,000 printed		4.00	6.50	14.00
............	1953 A	Priest-Anderson........18,000,000		3.50	4.50	7.00

$2.00 UNITED STATES NOTES

√	Series	Treasurer-Secretary	Delivered	V. Fine	Ex. Fine	New
..............	*53 A720,000 printed	$3.75	$6.00	$13.00	
..............	1953 B	Smith-Dillon............10,800,000	3.50	4.50	6.00	
..............	*53 B720,000 printed	3.75	5.00	8.00	
..............	1953 C	Granahan-Dillon.........5,760,000	3.50	4.50	6.00	
..............	*53 C360,000 printed	3.75	5.50	8.50	

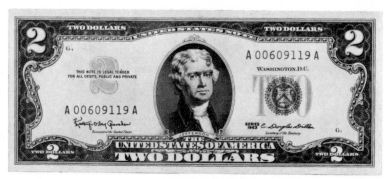

Face Design 1963 and 1963 A

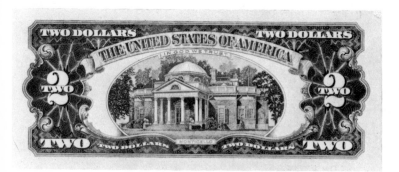

Back Design 1963 and 1963 A

√	Series	Treasurer-Secretary	Delivered	V. Fine	Ex. Fine	New
..............	1963	Granahan-Dillon........15,360,000	3.00	4.25	6.00	
..............	*63640,000 printed	3.25	4.50	7.00	
..............	1963 A	Granahan-Fowler.........3,200,000	3.00	4.25	6.00	
..............	*63 A640,000 printed	3.25	4.50	7.50	

$5.00 UNITED STATES NOTES
Five Dollars, Portrait of Lincoln

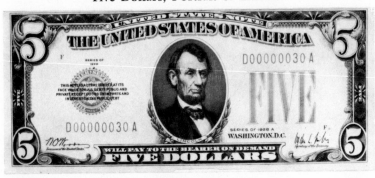

Face Design 1928 through 1928 F

Back Design U.S. Notes 1928-1953 C; Silver Certificates; National Currency; Federal Reserve Bank Notes; Federal Reserve Notes 1928-1950 E

✓	Series	Treasurer-Secretary	Delivered	V. Fine	Ex. Fine	New
..............	1928	Woods-Mellon........	267,209,616	$9.00	$15.00	$30.00
..............	★28		25.00	45.00	75.00
..............	1928 A	Woods-Mills...........	58,194,600	15.00	27.50	55.00
..............	★28 A		175.00	250.00	325.00
..............	1928 B	Julian-Morgenthau.....	147,827,340	8.00	13.00	26.00
..............	★28 B		25.00	45.00	75.00
..............	1928 C	Julian-Morgenthau.....	214,735,765	8.00	13.00	26.00
..............	★28 C		20.00	35.00	70.00
..............	1928 D	Julian-Vinson...........	9,297,120	18.00	42.50	90.00
..............	★28 D		60.00	135.00	275.00
..............	1928 E	Julian-Snyder..........	109,952,760	8.00	13.00	26.00
..............	★28 E		17.50	30.00	55.00
..............	1928 F	Clark-Snyder..........	104,194,704	8.00	13.00	25.00
..............	★28 F		12.50	25.00	47.50

Total star note printing for 1928 through 1928 F is 9,744,000. No further separation of this total is presently available.

$5.00 UNITED STATES NOTES

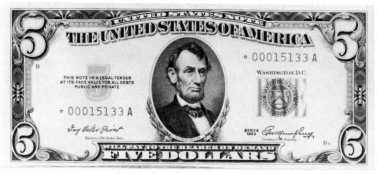

Face Design 1953 through 1953 C

✓	Series	Treasurer-Secretary	Delivered	V. Fine	Ex. Fine	New
...............	1953	Priest-Humphrey.......120,880,000		$8.00	$10.00	$20.00
...............	★535,760,000 printed		12.50	30.00	70.00
...............	1953 A	Priest-Anderson........90,280,000		7.00	9.00	16.50
...............	★53 A5,400,000 printed		8.00	10.00	22.50
...............	1953 B	Smith-Dillon...........44,640,000		7.00	9.00	15.00
...............	★53 B2,160,000 printed		7.50	9.50	20.00
...............	1953 C	Granahan-Dillon.........8,640,000		6.50	8.50	14.50
...............	★53 C320,000 printed		7.00	9.00	15.00
...............	1963	Granahan-Dillon........63,360,000		6.50	7.50	10.00
...............	★633,840,000 printed		7.00	8.50	14.00

Back Design U.S. Notes 1963, Federal Reserve Notes 1963-1969 C; 1974

[23]

$100 UNITED STATES NOTES
One Hundred Dollars, Portrait of Franklin

Courtesy Amon G. Carter, Jr.
Face Design 1966 and 1966 A. Back Design on page 78.

✓	Series	Treasurer-Secretary	Delivered	V. Fine	Ex. Fine	New
...............	1966	Granahan-Fowler...........768,000	$115.00	$140.00	
...............	*66128,000 printed*	155.00	
...............	1966 A	Elston-Kennedy...........512,000	130.00	

*Relatively few released to date; see Star Note Totals on page 12.

------◆◆------

SILVER CERTIFICATES — Blue Seal

Certificates backed by silver dollars were first authorized by the Bland-Allison Act of February 28, 1878. Large-size notes were made in denominations from $1 to $1000 at various intervals.

Modern-size Silver Certificates were made only in the $1, $5 and $10 denominations. Upon completion they were delivered to a vault under the custody of the Treasurer of the United States. However, Silver Certificates are no longer being printed, as they were abolished by the Act of June 4, 1963 (at which time Federal Reserve $1 and $2 notes were authorized).

The seal and serial numbers are in blue.

Redemption and Catalog Value

Early issues of modern-size Silver Certificates were also backed by silver dollars; their wording referred to their redemption in "One Silver Dollar" as had all previous issues of Silver Certificates. All this was changed by the Silver Purchase Act of 1934, which allowed for such certificates to be issued against any standard silver dollars, silver, or silver bullion held by the Treasury. Accordingly, the wording in the redemption clause was changed to read "One Dollar in Silver," allowing for the option of redemption in silver dollars or bullion.

On March 25, 1964, Secretary of the Treasury Dillon halted the outflow of silver dollars, stating that thenceforth silver bullion would be used for the redemption of Silver Certificates presented for that purpose.

SILVER CERTIFICATES

On June 24, 1968, redemption in bullion was discontinued, but not before literally millions had been turned in. The initial effect on the collector market was a downward adjustment of catalog values, but this may be only temporary. As the market stabilizes, values even on the more common notes will show more of an increase.

$1.00 Note Varieties

Late issues of the $1 Silver Certificates present an unusual combination of significant technical and numismatic developments. The result of this is an array of different varieties created by the gradual changeover from wet to dry printing method and the addition of the motto "In God We Trust."

Notes Dated 1935

All notes with the date 1935, with or without suffix letter, were produced by the old "wet-intaglio" method. These notes were made from 1935 through 1963. The motto was added to these notes in 1962 *during* the printing of the 1935 G issue; therefore, notes dated 1935 G come both without and with the motto. All 1935 H notes have the motto.

Notes Dated 1957

All notes dated 1957, with or without suffix letter, were produced by the present "dry-intaglio" process. Three varieties are involved — 1957, 1957 A, and 1957 B, made from 1957 through 1963. All such notes bear the motto on the back.

Order of Appearance

From the above, it may be seen that notes of both the wet-printed 1935 series and the dry-printed 1957 series were being produced and released concurrently from 1957 to 1963. According to delivery records, notes of both kinds were introduced in the following order: Series 1957, 1935 F, 1957 A, 1935 G (no motto), 1935 G (with motto), 1957 B, and 1935 H.

———•—•———

Explanatory Notations for Various Series

Series of 1928 — The legal tender clause first read, "This Certificate is Receivable For All Public Dues and When So Received May Be Reissued."

Series of 1928 A and B — For data on experimental notes see p. 154.

Series of 1928 E — See below under *Series of 1934*.

Series of 1933 — Pursuant to the Act of May 12, 1933, a new series of Silver Certificates was initiated. Issued only in the $10 denomination, this is one of the most desirable and unique notes in the modern U.S. currency series. It is in fact a "Silver Coin Note," so stated on the face side. Its legal tender clause is as follows: "This Certificate is Issued Pursuant to Section 16 of the Act of May 12, 1933, and is Legal Tender at its Face Value For All Debts Public and Private."

Series of 1934 — The Act of June 19, 1934 necessitated further change in the legal tender clause; it was altered on the Series of 1928 E $1 notes, on all Series of 1934 notes and for the remainder of Silver Certificate issues, reading as follows: "This Certificate is Legal Tender For All Debts, Public and Private." On $1 notes of the 1934 series, the Treasury seal was moved to the right side and a large blue numeral 1 was added on the left.

Series of 1934 A — Numerals in the Face Plate Serial Number are larger on this and succeeding issues of $5 and $10 notes.

Series 1935 — The word OF was deleted from the series designation on these $1 notes and succeeding series dates. "Series 1935" appears twice on the face. Also, the large word ONE at the right is removed, and the numeral 1 at the left is gray instead of blue.

There was an issue of experimental notes of this series in 1937 (see p. 154).

SILVER CERTIFICATES

Series 1935 A — The size of the numerals in the Face Plate Serial Number was made larger, and the series designation appears only once on this and succeeding issues of $1 notes. Series dates are overprinted from this series onward.

Aside from issues for regular circulation, notes from this series were used as part of the special **HAWAII** overprint and Yellow Seal emissions of World War II.

Series 1953 — The following changes took place on the face side of this and succeeding issues of $5 and $10 notes:

Series designation appears only once, and the word **OF** is deleted.

Signatures are overprinted instead of engraved.

The Treasury seal and serial numbers are reduced in size.

The numeral at the left is gray instead of blue.

Series 1957 — For the first time the motto appears on U.S. currency. Also, printings of 32-subject sheets begin with this series.

One Dollar, Portrait of Washington

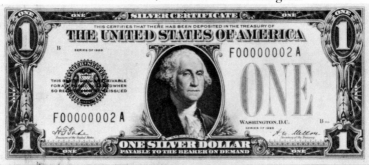

Face Design 1928 through 1928 E

Back Design U.S. Note 1928; Silver Certificates 1928-1934

✔	Series	Treasurer-Secretary	Printed	V. Fine	Ex. Fine	New
...............	1928	Tate-Mellon..........638,296,908		$4.00	$8.00	$13.50
...............	★28		15.00	25.00	50.00
...............	1928 A	Woods-Mellon.......2,267,809,500		3.00	6.00	11.00
...............	★28 A		10.00	17.00	30.00
...............	1928 B	Woods-Mills..........674,597,808		4.00	8.00	13.50
...............	★28 B		18.00	30.00	70.00

$1.00 SILVER CERTIFICATES

✓	Series	Treasurer-Secretary	Printed	V. Fine	Ex. Fine	New
.............	1928 C	Woods-Woodin..........*5,364,348*		$100.00	$175.00	$340.00
.............	★28 C		200.00	410.00	750.00
.............	1928 D	Julian-Woodin..........*14,451,372*		75.00	125.00	250.00
.............	★28 D		150.00	275.00	600.00
.............	1928 E	Julian-Morgenthau.......*3,519,324*		275.00	450.00	875.00
.............	★28 E			Very Rare	

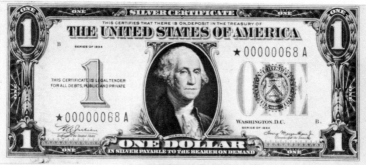

Face Design 1934

Totals from 1934 through 1957 are for amounts delivered.

	Series	Treasurer-Secretary	Printed	V. Fine	Ex. Fine	New
.............	1934	Julian-Morgenthau.....682,176,000		3.00	5.50	11.00
.............	★34*7,680,000* printed		35.00	65.00	110.00
.............	1935	Julian-Morgenthau....1,681,552,000		3.00	5.50	11.00
.............	★35		30.00	45.00	95.00
.............	★1935 A	Julian-Morgenthau....6,111,832,000		2.50	3.00	5.00
.............	★35 A		6.00	9.00	15.00
.............	1935 B	Julian-Vinson..........806,612,000		3.00	5.50	11.00
.............	★35 B		15.00	25.00	55.00
.............	1935 C	Julian-Snyder........3,088,108,000		2.00	3.00	6.00
.............	★35 C		5.00	8.50	16.00
.........W	†1935 D	Clark-Snyder.........4,656,968,000		1.75	2.50	4.50
.........W	† ★35 D		2.50	4.00	8.00
.........N	†1935 D	Clark-Snyder...........incl. above		1.75	2.50	4.50
.........N	† ★35 D		2.50	4.00	8.00
.............	1935 E	Priest-Humphrey.....5,134,056,000		1.50	2.00	4.00
.............	★35 E		2.00	3.00	5.50
.............	1935 F	Priest-Anderson......1,173,360,000		1.75	3.00
.............	★35 F53,200,000		1.50	2.25	5.00
.............	1935 G	Smith-Dillon..........194,600,000		1.75	3.00
.............	★35 G	no motto........*8,640,000* printed		1.50	2.25	5.00

The 1935 D series was printed in sheets of 12 and 18 subjects:
 4,510,024,000 in sheets of 12 notes
 146,944,000 in sheets of 18 notes
 4,656,968,000 Total 1935 D notes

*For HAWAII, yellow seal, and R & S notes, see World War II Issues.
†Wide and Narrow Designs — See explanation on following page.

$1.00 SILVER CERTIFICATES

Face Design 1935. General Face Design 1935 A-1957 B.

√	Series	Treasurer-Secretary	Delivered	V. Fine	Ex. Fine	New
..........	†1935 G	Smith-Dillon........... 31,320,000		$1.50	$2.50	$5.00
..........	★35 G	with motto....... *1,080,000* printed		3.50	6.50	15.00
..........	†1935 H	Granahan-Dillon....... 30,520,000		2.00	4.00
..........	★35 H 1,436,000		2.00	4.50	10.00
..........	1957	Priest-Anderson...... 2,609,600,000		1.75	3.00
..........	★57 307,040,000		2.00	3.50
..........	1957 A	Smith-Dillon......... 1,594,080,000		1.75	3.00
..........	★57 A 94,720,000		2.00	3.50
..........	1957 B	Granahan-Dillon....... 718,400,000		1.75	3.00
..........	★57 B 49,280,000		2.00	3.50

The "Great Seal" Back Design

Wide Back Design 1935 through 1935 D

There are two varieties of backs for Series 1935 D notes designated as the Wide and Narrow designs. The Wide design is about ¹⁄₁₆ inch wider, easily recognized when compared with the Narrow design. The most obvious area for comparison is the lathework border under ONE DOLLAR.

The Narrow design was used for subsequent issues of the 1935 series.

†With Motto "In God We Trust." 1935 G comes with and without the Motto.

$1.00 SILVER CERTIFICATES

Narrow Back Design 1935 D through 1935 G

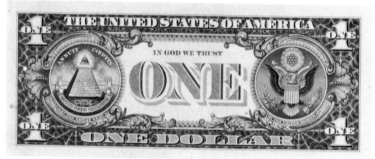

Back Design Silver Certificates 1935 G and H; also 1957 through 1957 B. Federal Reserve Notes 1963 through 1969 D; 1974.

Five Dollars, Portrait of Lincoln

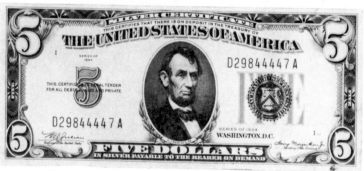

Face Design 1934 through 1934 D. Back Design on page 22.

$5.00 SILVER CERTIFICATES

✓	Series	Treasurer-Secretary	Delivered	V. Fine	Ex. Fine	New
..........	1934	Julian-Morgenthau.....350,352,000		$7.00	$10.00	$22.50
..........	★343,960,000 printed		12.00	27.50	55.00
..........	1934 A	Julian-Morgenthau.....740,128,000		6.00	8.50	17.00
..........	★34 A		10.00	18.00	36.00
..........	1934 B	Julian-Vinson..........60,328,000		10.00	20.00	40.00
..........	★34 B		35.00	60.00	120.00
..........	1934 C	Julian-Snyder..........372,328,000		6.50	9.00	20.00
..........	★34 C		10.00	17.50	35.00
..........	1934 D	Clark-Snyder..........491,660,000		6.00	8.00	15.00
..........	★34 D		10.00	17.50	35.00

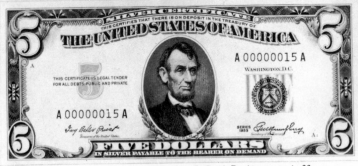

Face Design 1953 through 1953 C. Back Design on page 22.

	Series	Treasurer-Secretary	Delivered	V. Fine	Ex. Fine	New
..........	1953	Priest-Humphrey.......339,600,000		6.00	8.00	15.00
..........	★5315,120,000		7.50	12.50	25.00
..........	1953 A	Priest-Anderson........232,400,000		6.00	7.50	13.00
..........	★53 A12,960,000		6.00	8.50	17.50
..........	1953 B	Smith-Dillon...........73,000,000†		6.00	8.00	15.00
..........	★53 B3,240,000†		175.00	225.00	300.00
..........	1953 C	Granahan-Dillon........90,640,000			Not Released	

†Of the 1953 B issue only 14,196,000 notes were released because of the discontinuance of Silver Certificates. Apparently less than 400,000 star notes were released, according to O'Donnell's listings.

Ten Dollars, Portrait of Hamilton

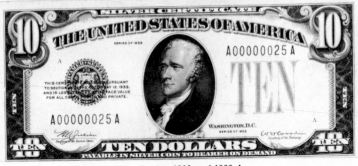

Face Design 1933 and 1933 A

$10.00 SILVER CERTIFICATES

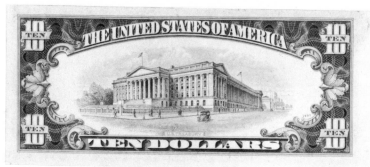

Back Design Silver Certificates; National Currency; Federal Reserve Bank Notes; Federal Reserve Notes 1928-1950 E; Gold Certificates.

√	Series	Treasurer-Secretary	Delivered	V. Fine	Ex. Fine	New
...............	1933	Julian-Woodin.................*		$500.00	$800.00	$2250.00
...............	1933 A	Julian-Morgenthau.............*			——	——

The 1933 and 1933 A $10 Issues

*The matter of just how many of the 1933 and 1933 A $10 notes were issued has never been cleared up satisfactorily. Bureau records show that 216,000 of the 1933 series and 336,000 of the 1933 A series were delivered; however, records of the Treasury Department Cash Division are at variance. Those records indicate 156,000 of the 1933 notes and 396,000 of the 1933 A notes as having been delivered. Further, their issue figures show that all 156,000 of the 1933 series and 28,000 of the 1933 A were released. The balance — 368,000 of the 1933 A notes — were destroyed.

Though records show that one uncut sheet was released, no regular issue 1933 A notes are known today in collectors' hands; perhaps the only ones yet in existence are those of the single sheet of Specimen notes retained by the Bureau of Engraving. (O'Donnell reports the existence of a 1933 A star note.)

As a matter of interest, the following letter written by former Bureau Director A. W. Hall on April 3, 1941 is included:

"...in regard to the $10 silver certificates, series of 1933 and 1933-A, you are advised that a total of 552,000 of the two were delivered to the Treasurer of the United States in 1934. Of this number at least 300,000 were series 1933-A.

"Of the number delivered to the Treasurer, 184,000 were issued between January and August, 1934, and the remainder, 368,000, were destroyed in November, 1935. Whether any 1933-A's were among those issued apparently cannot be determined. However, as the 1933 plate was first at press, it is possible that all the certificates issued were from this plate."

This letter appeared in *The Numismatist*, June, 1941, and was addressed to Mr. Robert H. Lloyd.

$10.00 SILVER CERTIFICATES

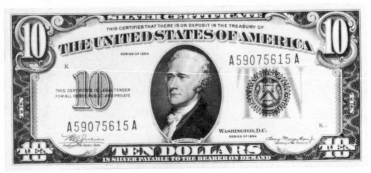

Face Design 1934 through 1934 D

✔	Series	Treasurer-Secretary	Printed	V. Fine	Ex. Fine	New
..............	1934	Julian-Morgenthau......88,692,864		$16.00	$24.00	$40.00
..............	★34		25.00	40.00	100.00
..............	1934 A	Julian-Morgenthau......42,346,428		14.50	21.50	37.50
..............	★34 A		20.00	30.00	85.00
..............	1934 B	Julian-Vinson..............337,740		85.00	225.00	550.00
..............	★34 B		400.00	550.00	1300.00
..............	1934 C	Julian-Snyder..........20,032,632		13.00	20.00	30.00
..............	★34 C		17.50	25.00	45.00
..............	1934 D	Clark-Snyder..........11,801,112		12.50	17.00	25.00
..............	★34 D		19.00	30.00	60.00

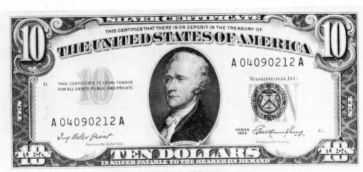

Face Design 1953 through 1953 B

..............	1953	Priest-Humphrey........10,440,000		12.50	17.50	27.50
..............	★53576,000		18.00	28.50	60.00
..............	1953 A	Priest-Anderson..........1,080,000		13.50	18.00	32.50
..............	★53 A144,000		19.00	30.00	60.00
..............	1953 B	Smith-Dillon..............720,000		14.00	22.50	38.50
..............	★53 B			None printed	

NATIONAL CURRENCY — Brown Seal

National Currency was first authorized by the National Banking Act of 1863, superseded by the National Currency Act of June 3, 1864. This Act provided for the establishment of national banks and the issuance of circulating notes. These notes were to be secured by United States interest-bearing registered bonds deposited with the Treasurer, upon which the banks could receive 90% of current market value in notes.

Modern-size National Currency was first issued on July 15, 1929. Unusual features of this issue include the use of the Register-Treasurer signature combination (instead of Secretary-Treasurer as found on most other modern-size notes) and the series date which is 1929. The printing plates for the face side are also quite different from other modern-size types. The engraved borders are reduced in proportion and size to make room for the imprinting of bank names, locations, charter numbers and names of bank officials. All these details were printed by a logotype process onto the notes; since so many different banks issued such notes a great saving was thus made in the preparation of plates. The seal and serial numbers are in brown. The backs are uniform with other modern types. No star notes as such were made for the National Currency series.

There are two distinct types of modern-size National Currency. Type One, issued from July 1929 to May 1933, has the bank's charter number in two places, in black. National Currency was printed 12 notes to a sheet and delivered in vertical sheets of six. For Type One, each of these six notes had the same serial numbers and suffix letter but a different prefix letter, A through F, which served to denote its position on the vertical sheet.

Type Two notes were issued from May 1933 to May 1935. These bore consecutive serial numbers, the suffix letters were dropped and the charter number of the bank was added twice more, in thinner brown numerals. Thus, the charter number appears four times on Type Two notes — twice in black logotype and twice in brown as described. Both Types are illustrated in sheets on page 94. Type Two notes are much scarcer than those of Type One.

National Currency is most often collected by states or by cities or banks with odd names, places of historical interest, and by low charter numbers or low or unusual serial numbers. Recently there has been a surging interest in these notes, spurred by the recent publication of a specialized book sponsored by the Society of Paper Money Collectors (see Bibliography).

Because of their high face value, $50 and $100 notes were not popularly collected until the last several years. None were issued from Alabama, Alaska, Arizona, Georgia, Maine, New Mexico and South Carolina.

Throughout the years National Bank Notes were in use, various amendments were made affecting their circulation and redemption. Provisions were made for the transfer of redemption liability from the separate banks to the United States, which now cancels and retires any National Bank Notes that are turned in. National Currency became obsolete on May 20, 1935, as bonds matured or were otherwise declared ineligible for security purposes.

The redemption clause on these notes reads as follows: "Redeemable in Lawful Money of the United States at United States Treasury or at the Bank of Issue."

Valuations are at best a guide to general availability. Some states are very difficult to obtain, others may have one issue commonly available but very scarce otherwise, one denomination from a state may be easily available and another very hard to find. The table on page 34 lists the states alphabetically with their respective rarity ratings. Values follow accordingly.

TABLE OF RARITY

Valuations following the Table of Rarity are based on this list:

State	Rarity	State	Rarity
Alabama	4	Montana	7
Alaska	9	Nebraska	3
Arizona	7	Nevada	8
Arkansas	5	New Hampshire	6
California	2	New Jersey	3
Colorado	4	New Mexico	6
Connecticut	4	New York	1
Delaware	6	North Carolina	5
District of Columbia	4	North Dakota	4
Florida	6	Ohio	1
Georgia	6	Oklahoma	4
Hawaii	7	Oregon	5
Idaho	7	Pennsylvania	1
Illinois	1	Rhode Island	6
Indiana	1	South Carolina	4
Iowa	2	South Dakota	5
Kansas	3	Tennessee	4
Kentucky	3	Texas	1
Louisiana	5	Utah	6
Maine	4	Vermont	5
Maryland	3	Virginia	3
Massachusetts	3	Washington	5
Michigan	3	West Virginia	3
Minnesota	3	Wisconsin	2
Mississippi	6	Wyoming	7
Missouri	3		

Five Dollars, Portrait of Lincoln

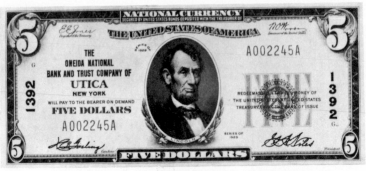

Face Design National Currency (Type 1). Back Design on page 22.

$5.00 & $10.00 NATIONAL CURRENCY

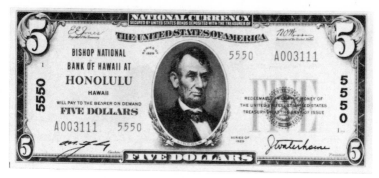

Face Design National Currency (Type 2). Back Design on page 22.

$5.00 TYPE ONE					**$5.00** TYPE TWO				
Rarity	Fine	V. Fine	E. Fine	New	Rarity	Fine	V. Fine	E. Fine	New
1...	$12.00	$20.00	$27.50	$45.00	1...	$15.00	$22.50	$32.50	$50.00
2...	12.00	20.00	30.00	50.00	2...	15.00	25.00	35.00	60.00
3...	12.00	20.00	35.00	60.00	3...	15.00	27.50	40.00	80.00
4...	15.00	25.00	42.50	75.00	4...	20.00	32.50	55.00	95.00
5...	18.00	30.00	50.00	100.00	5...	28.50	42.50	65.00	120.00
6...	25.00	40.00	62.50	125.00	6...	35.00	55.00	80.00	145.00
7...	45.00	65.00	80.00	160.00	7...	50.00	80.00	125.00	200.00
8...	60.00	100.00	150.00	250.00	8...	100.00	200.00	300.00	400.00
9...	350.00	450.00	650.00	1,000	9...	400.00	600.00	850.00	1,250

Ten Dollars, Portrait of Hamilton

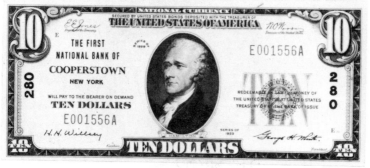

Face Design National Currency (Type 1). Back Design on page 31.

$10.00 & $20.00 NATIONAL CURRENCY

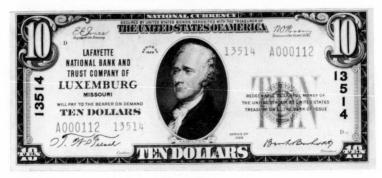

Face Design National Currency (Type 2). Back Design on page 31.

$10.00 TYPE ONE					**$10.00 TYPE TWO**				
Rarity	Fine	V. Fine	E. Fine	New	Rarity	Fine	V. Fine	E. Fine	New
1...	$15.00	$20.00	$27.50	$45.00	1...	$15.00	$22.50	$32.50	$50.00
2...	15.00	20.00	30.00	50.00	2...	15.00	25.00	35.00	60.00
3...	15.00	20.00	35.00	60.00	3...	15.00	27.50	40.00	80.00
4...	17.50	22.50	42.50	75.00	4...	20.00	32.50	55.00	95.00
5...	20.00	30.00	50.00	100.00	5...	28.50	42.50	65.00	120.00
6...	25.00	40.00	62.50	125.00	6...	35.00	55.00	80.00	145.00
7...	45.00	65.00	80.00	160.00	7...	50.00	80.00	125.00	200.00
8...	60.00	100.00	150.00	250.00	8...	100.00	200.00	300.00	400.00
9...	350.00	450.00	650.00	1,000	9...	400.00	600.00	850.00	1,250

Twenty Dollars, Portrait of Jackson

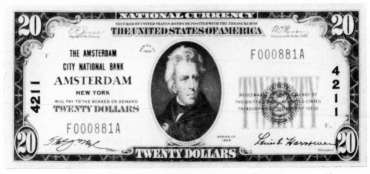

Face Design National Currency (Type 1). Back Design on page 62.

$20.00 & $50.00 NATIONAL CURRENCY

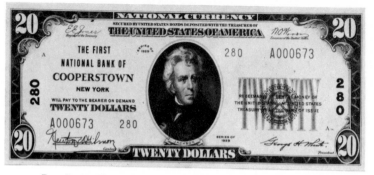

Face Design National Currency (Type 2). Back Design on page 62.

$20.00 TYPE ONE					$20.00 TYPE TWO				
Rarity	Fine	V. Fine	E. Fine	New	Rarity	Fine	V. Fine	E. Fine	New
1 . . .	$27.50	$30.00	$35.00	$50.00	1 . . .	$27.50	$32.50	$40.00	$55.00
2 . . .	27.50	32.50	37.50	55.00	2 . . .	27.50	35.00	42.50	60.00
3 . . .	30.00	37.50	45.00	65.00	3 . . .	30.00	40.00	50.00	80.00
4 . . .	35.00	45.00	57.50	80.00	4 . . .	35.00	50.00	62.50	95.00
5 . . .	40.00	50.00	67.50	105.00	5 . . .	40.00	55.00	75.00	120.00
6 . . .	47.50	65.00	85.00	125.00	6 . . .	60.00	75.00	100.00	145.00
7 . . .	55.00	80.00	100.00	160.00	7 . . .	75.00	100.00	140.00	200.00
8 . . .	67.50	95.00	150.00	250.00	8 . . .	100.00	200.00	300.00	400.00
9 . . .	350.00	450.00	650.00	1,000	9 . . .	400.00	600.00	850.00	1,250

Fifty Dollars, Portrait of Grant

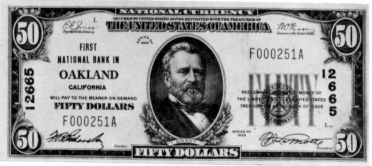

Face Design National Currency (Type 1). Back Design on page 69.

$50 & $100 NATIONAL CURRENCY

$50.00 TYPE ONE, and $50.00 TYPE TWO

Rarity	Fine	Very Fine	Extra Fine	New
1	$62.50	$75.00	$100.00	$140.00
2	65.00	80.00	110.00	150.00
3	67.50	85.00	120.00	165.00
4	70.00	90.00	135.00	190.00
5	75.00	105.00	145.00	200.00
6	80.00	130.00	185.00	235.00
7	100.00	150.00	200.00	275.00
8	200.00	275.00	350.00	500.00
9 Not Issued				

Values shown above are for notes of Type One. Type Two notes are worth 25-50% more.

One Hundred Dollars, Portrait of Franklin

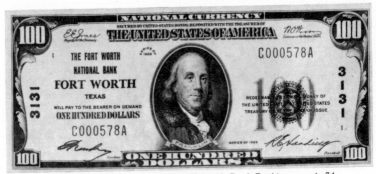

Face Design National Currency (Type 1). Back Design on page 74.

$100 TYPE ONE, and $100 TYPE TWO

Rarity	Fine	Very Fine	Extra Fine	New
1	115.00	130.00	165.00	200.00
2	120.00	140.00	175.00	210.00
3	125.00	150.00	180.00	220.00
4	130.00	160.00	190.00	230.00
5	135.00	175.00	200.00	250.00
6	145.00	185.00	240.00	300.00
7	175.00	225.00	300.00	400.00
8	200.00	275.00	350.00	500.00
9 Not Issued				

Values shown above are for notes of Type One. Type Two notes are worth 25-50% more.

FEDERAL RESERVE BANK NOTES — Brown Seal

Federal Reserve Bank Notes were first authorized by the Act of December 23, 1913, which established the Federal Reserve System. Unlike Federal Reserve Notes, these Bank Notes were not obligations of the United States. Rather, they were obligations of the specific Federal Reserve Banks named on the face. The seal and serial numbers are in brown.

Modern-size Federal Reserve Bank Notes were authorized by the Act of March 9, 1933. This Act permitted Federal Reserve Banks to issue currency equal to 100% of the face value of United States bonds, or 90% of the estimated value of commercial paper used as collateral. These Bank Notes were issued to relieve the emergency brought about by heavy withdrawals of Federal Reserve Notes in January and February of 1933.

Plates originally made for the Series of 1929 National Currency discussed on page 33 were hastily adapted and the Bank Notes were quickly prepared and issued. Naturally, these notes very closely resembled the National Currency issues: alterations were made only in the overprint on the face side. Instead of the local bank's Cashier and President signatures, there appeared the signatures of the Federal Reserve Bank's Cashier and Governor, with but three exceptions. The Cashier's signature was replaced by the Deputy Governor on New York District notes, the Assistant Deputy Governor on Chicago District notes and the Controller on the St. Louis District notes. The designated letter of each Federal Reserve Bank and District was placed on the notes in four places. The brown seal was slightly larger than that used on the National Bank notes, and words OR BY LIKE DEPOSIT OF OTHER SECURITIES were logotyped near the top. The series date remained 1929 and the engraved signatures of Jones and Woods (Register and Treasurer) were also retained.

Serial numbers for each Federal Reserve Bank started with 00000001A, preceded by a District letter A to L used as a prefix. Star notes were made for these issues; they are extremely scarce.

Federal Reserve Bank Notes were delivered in sheets of six notes, as were the National Currency issues. Denominations included $5, $10, $20, $50, and $100. Their issuance was discontinued in July, 1935; however, during World War II (1942) and a temporary shortage of currency, additional supplies of these Bank Notes were released from storage and charged out as Federal Reserve Notes. In new condition FRBN's have become very scarce.

Five Dollars, Portrait of Lincoln

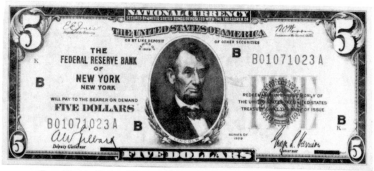

Face Design Federal Reserve Bank Notes. Back Design on page 22.

$5.00 & $10.00 FEDERAL RESERVE BANK NOTES

✓	Federal Reserve Bank	Delivered	V. Fine	Ex. Fine	New
........A	Boston	3,180,000	$15.00	$25.00	$ 45.00
........B	New York	2,100,000	15.00	25.00	45.00
........C	Philadelphia	3,096,000	15.00	25.00	45.00
........D	Cleveland	4,236,000	15.00	25.00	40.00
........E	Richmond	None Issued
........F	Atlanta	1,884,000	20.00	35.00	75.00
........G	Chicago	5,988,000	12.50	17.50	35.00
........H	St. Louis	276,000	70.00	160.00	260.00
........I	Minneapolis	684,000	30.00	60.00	125.00
........J	Kansas City	2,460,000	17.50	30.00	57.50
........K	Dallas	996,000	17.50	25.00	45.00
........L	San Francisco	360,000	160.00	250.00	1000.00

Star notes are valued from 40-75% higher than regular issues.

Ten Dollars, Portrait of Hamilton

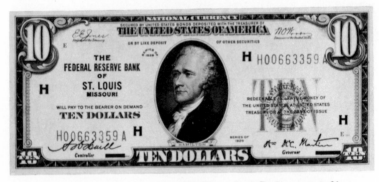

Face Design Federal Reserve Bank Notes. Back Design on page 31.

........A	Boston	1,680,000	17.50	27.50	45.00
........B	New York	5,556,000	15.00	22.50	40.00
........C	Philadelphia	1,416,000	20.00	30.00	47.50
........D	Cleveland	2,412,000	17.50	25.00	42.50
........E	Richmond	1,356,000	20.00	32.50	50.00
........F	Atlanta	1,056,000	22.50	35.00	50.00
........G	Chicago	3,156,000	15.00	22.50	40.00
........H	St. Louis	1,584,000	20.00	32.50	50.00
........I	Minneapolis	588,000	27.50	45.00	75.00
........J	Kansas City	1,284,000	22.50	37.50	55.00
........K	Dallas	504,000	30.00	50.00	80.00
........L	San Francisco	1,080,000	20.00	40.00	70.00

Star notes: see notice under $5 listing.

$20.00 & $50.00 FEDERAL RESERVE BANK NOTES

Twenty Dollars, Portrait of Jackson

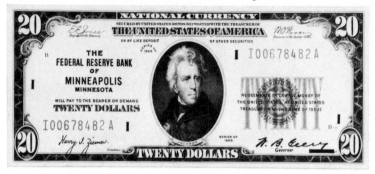

Face Design Federal Reserve Bank Notes. Back Design on page 62.

✓	Federal Reserve Bank	Delivered	V. Fine	Ex. Fine	New
........A	Boston.................	972,000	$32.50	$45.00	$60.00
........B	New York.............	2,568,000	27.50	37.50	50.00
........C	Philadelphia...........	1,008,000	30.00	40.00	55.00
........D	Cleveland.............	1,020,000	30.00	40.00	55.00
........E	Richmond.............	1,632,000	28.50	37.50	57.50
........F	Atlanta................	960,000	32.50	45.00	60.00
........G	Chicago................	2,028,000	27.50	37.50	50.00
........H	St. Louis...............	444,000	40.00	60.00	90.00
........I	Minneapolis............	864,000	30.00	45.00	65.00
........J	Kansas City............	612,000	32.50	45.00	75.00
........K	Dallas.................	468,000	40.00	50.00	75.00
........L	San Francisco...........	888,000	30.00	45.00	70.00

Fifty Dollars, Portrait of Grant

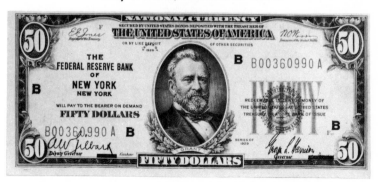

Face Design Federal Reserve Bank Notes. Back Design on page 69.

$50 & $100 FEDERAL RESERVE BANK NOTES

✓	Federal Reserve Bank	Delivered	V. Fine	Ex. Fine	New
.........A	Boston None Issued	
.........B	New York636,000		$65.00	$85.00	$145.00
.........C	Philadelphia None Issued	
.........D	Cleveland684,000		65.00	85.00	145.00
.........E	Richmond None Issued	
.........F	Atlanta None Issued	
.........G	Chicago300,000		70.00	90.00	155.00
.........H	St. Louis None Issued	
.........I	Minneapolis132,000		90.00	150.00	210.00
.........J	Kansas City276,000		75.00	110.00	180.00
.........K	Dallas168,000		80.00	125.00	200.00
.........L	San Francisco576,000		65.00	85.00	145.00

One Hundred Dollars, Portrait of Franklin

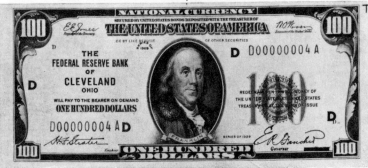

Courtesy G. A. Siegwart
Face Design Federal Reserve Bank Notes. Back Design on page 74.

	Federal Reserve Bank	Delivered	V. Fine	Ex. Fine
.........A	Boston None Issued	
.........B	New York480,000		125.00	180.00
.........C	Philadelphia None Issued	
.........D	Cleveland276,000		140.00	200.00
.........E	Richmond192,000		175.00	235.00
.........F	Atlanta None Issued	
.........G	Chicago384,000		125.00	190.00
.........H	St. Louis None Issued	
.........I	Minneapolis144,000		175.00	235.00
.........J	Kansas City96,000		195.00	270.00
.........K	Dallas36,000		200.00	300.00
.........L	San Francisco None Issued	

FEDERAL RESERVE NOTES — Green Seal

Federal Reserve Notes were first authorized by the Federal Reserve Act of December 23, 1913. Since then, the issues of these notes have increased to the point that today they comprise over 99% of the total volume of paper money in circulation. Federal Reserve Notes are obligations of the United States and until 1968 were secured by Gold Certificates or Gold Certificate credits to the amount of at least 25% of the notes in actual circulation. Government securities accounted for the other 75% of the backing for these notes.

FEDERAL RESERVE NOTES

Modern-size Federal Reserve Notes were first issued in 1929, series dated 1928. Denominations range from $1 to $10,000. Those of $500 and higher were discontinued by action of the Board of Governors of the Federal Reserve System on June 26, 1946; on July 14, 1969, they were retired from circulation, but a few are still held in banks.

The twelve Federal Reserve Banks are organized and operate for public service as authorized by Congress. They are under supervision of the Board of Governors of the Federal Reserve System, an agency of the Federal Government. Members of this Board are appointed by the President and confirmed by the Senate.

Each of the twelve Banks has nine directors. Three of these, including the Chairman, are appointed by the Board of Governors. The other six are elected by member banks.

When Federal Reserve Notes are finished, they are delivered to the Federal Reserve vault, which is under supervision of the Comptroller of the Currency. They are then sent to the issuing Banks as needed, which in turn distribute them to member banks and to the public.

Federal Reserve Banks release these notes according to the needs of their regions. One can easily tell which Bank issued a particular note by examining its face side. A number and corresponding letter were assigned to each of the Federal Reserve Districts, and both have been used on the notes in various combinations. At present a Bank seal to the left of the portrait carries the letter (and the name of the Bank); this same letter serves as the prefix letter for every serial number on all notes issued by the respective Bank. The District number is imprinted in four places, also on the face of the note. The Treasury seal and serial numbers are in green.

Explanatory Notations for Various Series

Series of 1928 — The redemption clause on notes issued before 1934 reads as follows: "Redeemable in Gold on Demand at the United States Treasury, or in Gold or Lawful Money at Any Federal Reserve Bank."

Series of 1934 — In 1933, Acts of Congress removed existing legal tender restrictions from all U.S. money, and in 1934 the Gold Reserve Act halted redemption of Federal Reserve Notes with gold. The redemption clause became a legal tender clause in accordance with these Acts, appearing on notes issued from 1934 to 1963 as follows: "This Note is Legal Tender For All Debts, Public and Private, and is Redeemable in Lawful Money at the United States Treasury, or at Any Federal Reserve Bank."

Series of 1934 A — The size of the numerals in the Face Plate Serial Number was made larger on this and succeeding issues.

Series 1950 — The following changes are incorporated on the face side of the notes for this and succeeding issues until 1963 B:

Series designation appears only once, and the word "OF" is deleted.

The Treasury seal and serial numbers are reduced in size.

Signatures are overprinted instead of engraved.

The Bank seal is smaller and has a toothed edge.

Series 1950 E — Notes of this series date were released after the 1963 issue.

Series 1963 — The change in printing method and increase in number of subjects per sheet took place with this issue. Also, this series marks the first appearance of $1 Federal Reserve Notes. The new legal tender clause is the same as that on United States Notes and reads, "This Note is Legal Tender For All Debts, Public and Private." The motto appears on the backs of

FEDERAL RESERVE NOTES

denominations higher than $1, and the "Will Pay . . ." clause near the bottom no longer appears on any of the notes. No $50 or $100 notes were printed series dated 1963.

Series 1963 A — This is the first issue of $50 and $100 notes bearing the motto. Vignettes are also slightly enlarged on the backs and show better detail.

Series 1963 B — Only $1 notes were made with this series date; these were the "Barr Notes" about which there was so much publicity a few years ago. The surprise appointment of Joseph W. Barr as Treasury Secretary on December 21, 1968, caused immediate speculation that any notes bearing his name would obviously constitute a very limited issue since he was to serve only for the final month of the Johnson administration. Shortly thereafter, production began of $1 Federal Reserve Notes with series date 1963 B, bearing the new Secretary's signature. These were made for only five of the 12 Federal Reserve Districts, where additional supplies of $1 notes were needed. No other Barr notes were printed.

In spite of the intense public interest and numismatic speculation caused by this brief term of office, actual production of Barr notes continued until early June of 1969, and they remain easily available.

This issue is also the first of the current $1 notes to have signatures and series date engraved in the plates (see page 8).

Series 1969 — A new rendition of the Treasury seal is introduced on all denominations.

Series 1969 A — This is the first time in a number of years that all notes of the same type and series do *not* bear the same signature combination. The $1 notes have the Kabis-Kennedy signatures, and all higher denominations the Kabis-Connally signatures.

Printing of Kabis-Kennedy $1 notes started October 26, 1970, and it was expected that higher denominations would follow soon afterwards. The announcement that Kennedy would resign effective February 1, 1971, caused a halt to preparations for all denominations higher than the $1. After Connally's name replaced Kennedy's, notes from $5 through $100 were made with the 1969 A designation but with the new Kabis-Connally combination.

Series 1969 B, C, and D — Because of the signature changes which occurred on the previous issue, the succeeding three series also show a variance in the $1 from all the rest. Signatures appear as follows:

1969 B — $1, Kabis-Connally; $5-$50 Bañuelos-Connally.
1969 C — $1, Bañuelos-Connally; $5-$100 Bañuelos-Shultz.
1969 D — $1, Bañuelos-Shultz.

Series 1974 — This is the first issue under the new policy that each time a different Treasury Secretary is appointed there will be a new series date on the notes. All denominations thus carry the same date and signatures (Neff-Simon). Only the $1 notes have serial numbers starting over again from (A)00 000 001A. Higher values continue the serial numbering from the previous issue.

FEDERAL RESERVE NOTES
Federal Reserve Banks and their Letter Designations

There are 12 Federal Reserve Banks, and each has a specific letter designation on every note currently issued under its name. In the section on Federal Reserve Bank Notes (pages 39-42) these are listed together each time the denominations are cataloged. In this section on Federal Reserve Notes there may be occasions where the bank name is not shown with the letter designation; it is felt that in such cases the listing will remain easy to follow, especially since the list of bank names will reappear from time to time throughout the section. For handy reference there follows the listing of banks and letter designations:

A — Boston	E — Richmond	I — Minneapolis
B — New York	F — Atlanta	J — Kansas City, Mo.
C — Philadelphia	G — Chicago	K — Dallas
D — Cleveland	H — St. Louis	L — San Francisco

One Dollar, Portrait of Washington

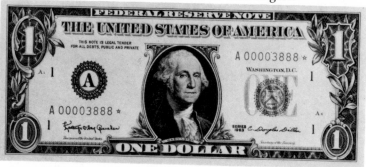

Face Design 1963 through 1974. Back Design on page 29.

Series 1963 — Signatures: Granahan-Dillon

✓	Fed. Res. Bk.	Delivered	New	✓		Delivered	New
A	Boston	87,680,000	$2.25	A★		6,400,000	$2.50
B	N.Y.	219,200,000	2.25	B★		15,360,000	2.50
C	Phil.	123,680,000	2.25	C★		10,880,000	2.50
D	Cleve.	108,320,000	2.25	D★		8,320,000	2.50
E	Rich.	159,520,000	2.25	E★		12,160,000	2.50
F	Atlanta	221,120,000	2.25	F★		19,200,000	2.50
G	Chicago	279,360,000	2.25	G★		19,840,000	2.50
H	St. Louis	99,840,000	2.25	H★		9,600,000	2.50
I	M'apolis	44,800,000	2.25	I★		5,120,000	2.50
J	K. City	88,960,000	2.25	J★		8,960,000	2.50
K	Dallas	85,760,000	2.25	K★		8,960,000	2.50
L	San F.	199,999,999	2.25	L★		14,720,000	2.50

Regular issues: Set of twelve, $24.00. | Star notes: Set of twelve, $27.50.

Series 1963 A — Signatures: Granahan-Fowler

A	Boston	319,840,000	2.00	A★		19,840,000	2.50
B	N.Y.	657,600,000	2.00	B★		48,640,000	2.50
C	Phil.	375,520,000	2.00	C★		26,240,000	2.50

$1.00 FEDERAL RESERVE NOTES

✓	Fed. Res. Bk.	Delivered	New	✓	Delivered	New
D	Cleve.	337,120,000	$2.00	D★	21,120,000	$2.50
E	Rich.	532,000,000	2.00	E★	41,600,000	2.50
F	Atlanta	636,480,000	2.00	F★	40,960,000	2.50
G	Chicago	784,480,000	2.00	G★	52,640,000	2.50
H	St. Louis	264,000,000	2.00	H★	17,920,000	2.50
I	M'apolis	112,160,000	2.00	I★	7,040,000	2.50
J	K. City	219,200,000	2.00	J★	14,720,000	2.50
K	Dallas	288,960,000	2.00	K★	19,184,000	2.50
L	San F.	576,800,000	2.00	L★	43,040,000	2.50

Regular issues: Set of twelve, $22.00. | Star notes: Set of twelve, $23.50.

Series 1963 B *Signatures:* Granahan-Barr

✓	Fed. Res. Bk.	Delivered	New	✓	Delivered	New
B	N.Y.	123,040,000	2.00	B★	3,680,000	2.25
E	Rich.	93,600,000	2.00	E★	3,200,000	2.25
G	Chicago	91,040,000	2.00	G★	2,400,000	2.25
J	K. City	44,800,000	2.00	J★	None Printed
L	San F.	106,400,000	2.00	L★	3,040,000	2.25

Regular issues: Set of five, $8.00. | Star notes: Set of four, $8.00.

Series 1969 *Signatures:* Elston-Kennedy

✓	Fed. Res. Bk.	Delivered	New	✓	Delivered	New
A	Boston	99,200,000	1.75	A★	5,120,000	2.25
B	N.Y.	269,120,000	1.75	B★	14,080,000	2.25
C	Phil.	68,480,000	1.75	C★	3,616,000	2.25
D	Cleve.	120,480,000	1.75	D★	5,760,000	2.25
E	Rich.	250,560,000	1.75	E★	10,880,000	2.25
F	Atlanta	185,120,000	1.75	F★	7,680,000	2.25
G	Chicago	359,520,000	1.75	G★	12,160,000	2.25
H	St. Louis	74,880,000	1.75	H★	3,840,000	2.25
I	M'apolis	48,000,000	1.75	I★	1,920,000	2.25
J	K. City	95,360,000	1.75	J★	5,760,000	2.25
K	Dallas	113,440,000	1.75	K★	5,120,000	2.25
L	San F.	226,240,000	1.75	L★	9,600,000	2.25

Regular issues: Set of twelve, $18.50. | Star notes: Set of twelve, $21.00.

Series 1969 A *Signatures:* Kabis-Kennedy

✓	Fed. Res. Bk.	Delivered	New	✓	Delivered	New
A	Boston	40,480,000	1.75	A★	1,120,000	2.25
B	N.Y.	122,400,000	1.75	B★	6,240,000	2.25
C	Phil.	44,960,000	1.75	C★	1,760,000	2.25
D	Cleve.	30,080,000	1.75	D★	1,280,000	2.25
E	Rich.	66,080,000	1.75	E★	3,200,000	2.25
F	Atlanta	70,560,000	1.75	F★	2,400,000	2.25
G	Chicago	75,680,000	1.75	G★	4,480,000	2.25
H	St. Louis	41,120,000	1.75	H★	1,280,000	2.25
I	M'apolis	21,760,000	1.75	I★	640,000	2.25
J	K. City	40,480,000	1.75	J★	1,120,000	2.25
K	Dallas	27,520,000	1.75	K★	None Printed
L	San F.	51,840,000	1.75	L★	3,840,000	2.25

Regular issues: Set of twelve, $18.50. | Star notes: Set of eleven, $18.50.

$1.00 FEDERAL RESERVE NOTES

Series 1969 B Signatures: Kabis-Connally

√	Fed. Res. Bk.	Delivered	New	√	Delivered	New
........A	Boston.....94,720,000		$1.75A★1,920,000	$2.25
........B	N.Y.329,440,000		1.75B★7,040,000	2.25
........C	Phil.133,280,000		1.75C★3,200,000	2.25
........D	Cleve.91,520,000		1.75D★4,480,000	2.25
........E	Rich.180,000,000		1.75E★3,840,000	2.25
........F	Atlanta...170,400,000		1.75F★3,840,000	2.25
........G	Chicago...204,480,000		1.75G★4,480,000	2.25
........H	St. Louis...59,520,000		1.75H★1,920,000	2.25
........I	M'apolis...33,920,000		1.75I★1,040,000	2.25
........J	K. City....67,200,000		1.75J★2,560,000	2.25
........K	Dallas....116,640,000		1.75K★5,120,000	2.25
........L	San F.208,960,000		1.75L★5,760,000	2.25

Regular issues: Set of twelve, $18.00. | Star notes: Set of twelve, $24.00.

Series 1969 C Signatures: Bañuelos-Connally

√	Fed. Res. Bk.	Delivered	New	√	Delivered	New
........A	Boston..None Printed	A★ None Printed
........B	N.Y.49,920,000		1.75B★ None Printed
........C	Phil. ...None Printed	C★ None Printed
........D	Cleve.15,520,000		1.75D★ 480,000	3.00
........E	Rich.61,600,000		1.75E★ 480,000	3.00
........F	Atlanta....60,960,000		1.75F★ 3,680,000	2.00
........G	Chicago...137,120,000		1.75G★1,748,000	2.00
........H	St. Louis...23,680,000		1.75H★640,000	3.00
........I	M'apolis...25,600,000		1.75I★ 640,000	3.00
........J	K. City....38,560,000		1.75J★1,120,000	2.00
........K	Dallas.....29,440,000		1.75K★ 640,000	3.00
........L	San F. ...101,280,000		1.75L★1,120,000	2.00

Regular issues: Set of ten, $15.00. | Star notes: Set of nine, $19.00.

Series 1969 D Signatures: Bañuelos-Shultz

√	Fed. Res. Bk.	Delivered	New	√	Delivered	New
........A	Boston....187,040,000		1.50A★1,120,000	2.00
........B	N. Y.468,480,000		1.50B★4,480,000	2.00
........C	Phil.218,560,000		1.50C★4,320,000	2.00
........D	Cleve.161,440,000		1.50D★2,400,000	2.00
........E	Rich.374,240,000		1.50E★8,480,000	2.00
........F	Atlanta...377,440,000		1.50F★5,480,000	2.00
........G	Chicago...378,080,000		1.50G★5,480,000	2.00
........H	St. Louis..168,480,000		1.50H★1,760,000	2.00
........I	M'apolis...83,200,000		1.50I★None Printed
........J	K. City...185,760,000		1.50J★3,040,000	2.00
........K	Dallas...158,240,000		1.50K★6,240,000	2.00
........L	San F.400,640,000		1.50L★6,400,000	2.00

Regular issues: Set of twelve, $16.00. | Star notes: Set of eleven, $21.00.

Series 1974 Signatures: Neff-Simon

At this time notes are being issued from all twelve Districts.

$5.00 FEDERAL RESERVE NOTES

Five Dollars, Portrait of Lincoln

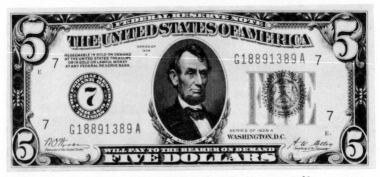

Face Design 1928 and 1928 A. Back Design on page 22.

Series of 1928 — Signatures: Tate-Mellon

Large District numeral of Bank at left.

✔	Federal Reserve Bank	Printed	V. Fine	Ex. Fine	New
1	Boston	8,025,300	$8.50	$20.00	$42.50
2	New York	14,701,884	8.50	16.50	35.00
3	Philadelphia	11,819,712	7.00	17.50	40.00
4	Cleveland	9,049,500	7.00	17.50	40.00
5	Richmond	6,027,600	8.50	20.00	45.00
6	Atlanta	10,964,400	8.50	20.00	40.00
7	Chicago	12,320,052	6.50	15.00	35.00
8	St. Louis	4,675,200	8.50	20.00	45.00
9	Minneapolis	4,284,300	12.00	25.00	55.00
10	Kansas City	4,480,800	11.00	25.00	50.00
11	Dallas	8,137,824	11.00	25.00	50.00
12	San Francisco	9,792,000	8.50	20.00	42.50

Series of 1928 A — Signatures: Woods-Mellon

Large District numeral at left, similar to Series of 1928 issues.

✔	Federal Reserve Bank	Printed	V. Fine	Ex. Fine	New
1	Boston	9,404,352	8.00	18.50	37.50
2	New York	42,878,196	8.00	16.00	32.50
3	Philadelphia	10,806,012	6.50	15.00	35.00
4	Cleveland	6,822,000	6.50	16.00	37.50
5	Richmond	2,409,900	8.50	20.00	40.00
6	Atlanta	3,537,600	8.50	20.00	40.00
7	Chicago	37,882,176	6.50	15.00	32.50
8	St. Louis	2,731,824	8.50	20.00	40.00
9	Minneapolis	652,800	11.00	25.00	47.50
10	Kansas City	3,572,400	8.50	22.00	45.00
11	Dallas	2,564,400	9.00	25.00	47.50
12	San Francisco	6,565,500	8.00	18.50	37.50

$5.00 FEDERAL RESERVE NOTES

Series of 1928 B *Signatures:* Woods-Mellon

Large District letter replaces numeral in seal on this and succeeding issues.

✓	Federal Reserve Bank	Printed	V. Fine	Ex. Fine	New
............A	Boston.............28,430,724	$7.00	$17.50	$32.50	
............B	New York..........51,157,536	6.00	15.00	27.50	
............C	Philadelphia........25,698,396	6.50	15.00	30.00	
............D	Cleveland..........24,874,272	6.50	15.00	32.50	
............E	Richmond..........15,151,932	10.00	22.50	37.50	
............F	Atlanta............13,386,420	8.50	20.00	35.00	
............G	Chicago............17,157,036	6.00	15.00	27.50	
............H	St. Louis...........20,251,716	8.50	20.00	37.50	
............I	Minneapolis.........6,954,060	11.00	25.00	42.50	
............J	Kansas City........10,677,636	10.00	22.50	37.50	
............K	Dallas..............4,334,400	12.50	27.50	45.00	
............L	San Francisco.......28,840,000	7.00	17.50	32.50	

Series of 1928 C *Signatures:* Woods-Mills

............D	Cleveland...........3,293,640	75.00	135.00	250.00	
............F	Atlanta.............2,056,200	100.00	160.00	325.00	
............L	San Francisco..........266,304	125.00	200.00	425.00	

Series of 1928 D *Signatures:* Woods-Woodin

............F	Atlanta.............1,281,600	200.00	400.00	750.00	

Bureau records do not give any indication of the serial numbers for the Series of 1928 D $5. However, a fair number of them have been confirmed with serial numbers scattered from F26 282 729A to F28 617 186A. These were well interspersed with 1928 C notes.*

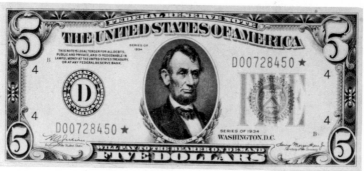

General Face Design 1928 B - 1928 D. Face Design 1934 - 1934 D.
Back Design on page 22.

*Robert H. Lloyd has also published the fact that 9 plates are on record as having been used for the $5.00 Series of 1928 D notes.

$5.00 FEDERAL RESERVE NOTES

Series of 1934 *Signatures:* Julian-Morgenthau

Light green seal.

Star notes exist for all Districts.

✓	Federal Reserve Bank	Printed	V. Fine	Ex. Fine	New
............A	Boston.............30,510,036		$6.50	$15.00	$37.50
............B	New York..........47,888,760		6.00	15.00	30.00
............C	Philadelphia........47,327,760		6.00	15.00	32.50
............D	Cleveland..........62,273,508		6.50	15.00	32.50
............E	Richmond..........62,128,452		8.00	17.50	37.50
............F	Atlanta............50,548,608		8.00	17.50	37.50
............G	Chicago............31,299,156		6.50	15.00	30.00
............H	St. Louis...........48,737,280		10.00	20.00	40.00
............I	Minneapolis........16,795,392		11.00	25.00	50.00
............J	Kansas City........31,854,432		8.50	20.00	45.00
............K	Dallas..............33,332,208		10.00	20.00	45.00
............L	San Francisco.......39,324,168		6.50	15.00	35.00

Amounts printed include light and dark seal notes.

Series of 1934 *Signatures:* Julian-Morgenthau

Dark green seal.

✓	Federal Reserve Bank	Printed	V. Fine	Ex. Fine	New
............A	Boston....................		6.50	15.00	32.50
............B	New York.................		6.00	12.50	27.50
............C	Philadelphia..............		6.00	12.50	27.50
............D	Cleveland.................		6.50	15.00	30.00
............E	Richmond.................		7.00	17.50	37.50
............F	Atlanta...................		7.00	16.00	32.50
............G	Chicago...................		6.00	12.50	27.50
............H	St. Louis.................		6.50	15.00	30.00
............I	Minneapolis...............		7.00	17.50	37.50
............J	Kansas City...............		6.50	15.00	32.50
............K	Dallas....................		6.50	15.00	32.50
............L	San Francisco.............		6.50	15.00	30.00

Series of 1934 A *Signatures:* Julian-Morgenthau

Star notes exist for all issuing Districts; they are scarce.*

✓	Federal Reserve Bank	Printed	V. Fine	Ex. Fine	New
............A	Boston.............23,231,568		6.00	12.50	25.00
............B	New York.........143,199,336		6.00	12.00	20.00
............C	Philadelphia........30,691,632		6.00	12.50	22.50
............D	Cleveland..........1,610,676		6.50	15.00	27.50
............E	Richmond..........6,555,168		6.50	15.00	27.50
............F	Atlanta............22,811,916		6.50	14.00	25.00
............G	Chicago............88,376,376		6.00	12.00	20.00
............H	St. Louis...........7,843,852		6.50	15.00	27.50
............L	San Francisco.......72,118,452		6.00	12.50	25.00

*Bureau records do not show any printings, regular or star, for $5.00 notes Series of 1934 A for Minneapolis, Kansas City or Dallas.

$5.00 FEDERAL RESERVE NOTES

Series of 1934 B *Signatures:* Julian-Vinson

✓	Federal Reserve Bank	Printed	V. Fine	Ex. Fine	New
A	Boston............3,457,800		$6.50	$15.00	$30.00
B	New York.........14,099,580		6.00	12.50	25.00
C	Philadelphia........8,306,820		6.00	12.50	27.50
D	Cleveland.........11,348,184		6.00	12.50	27.50
E	Richmond..........5,902,848		6.50	15.00	32.50
F	Atlanta...........4,314,048		6.50	15.00	32.50
G	Chicago...........9,070,932		6.00	12.50	25.00
H	St. Louis...........4,307,712		7.50	17.50	37.50
I	Minneapolis........2,482,500		8.50	18.50	40.00
J	Kansas City..........73,800		20.00	32.50	60.00
K	Dallas............No Record	
L	San Francisco.......9,910,296		6.00	12.50	27.50

Series of 1934 C *Signatures:* Julian-Snyder

✓	Federal Reserve Bank	Printed	Ex. Fine	New
A	Boston.....................14,463,600		10.00	20.00
B	New York...................74,383,248		9.00	17.50
C	Philadelphia.................22,879,212		9.00	17.50
D	Cleveland...................19,898,256		9.00	17.50
E	Richmond...................23,800,524		9.00	17.50
F	Atlanta.....................23,572,968		9.00	17.50
G	Chicago....................60,598,812		9.00	17.50
H	St. Louis...................20,393,340		9.00	22.50
I	Minneapolis..................5,089,200		12.50	25.00
J	Kansas City..................8,313,504		10.00	22.50
K	Dallas......................5,107,800		12.50	25.00
L	San Francisco................9,451,944		10.00	22.50

Series of 1934 D *Signatures:* Clark-Snyder

	Federal Reserve Bank	Printed	Ex. Fine	New
A	Boston.....................12,660,552		8.00	16.00
B	New York...................50,976,576		7.50	12.50
C	Philadelphia.................12,106,740		8.00	15.00
D	Cleveland....................8,969,052		8.00	16.00
E	Richmond...................13,333,032		8.50	17.50
F	Atlanta......................9,599,352		8.50	16.00
G	Chicago....................36,601,680		8.00	15.00
H	St. Louis....................8,093,412		9.00	18.00
I	Minneapolis..................3,594,900		10.00	20.00
J	Kansas City..................6,538,740		9.00	17.50
K	Dallas......................4,139,016		12.00	22.50
L	San Francisco................11,704,200		8.00	15.00

$5.00 FEDERAL RESERVE NOTES

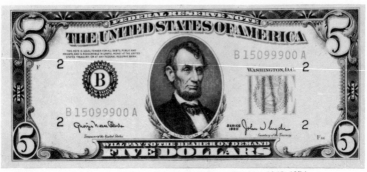

Face Design 1950-1950 E. General Face Design 1963-1974.
Back Design on page 22.

Series 1950 — Signatures: Clark-Snyder

✓	Delivered	Ex. Fine	New	✓	Delivered	Ex. Fine	New
A	30,672,000	$8.00	$15.00	G	85,104,000	$7.50	$13.00
B	106,768,000	7.00	12.50	H	36,864,000	8.00	16.00
C	44,784,000	8.00	15.00	I	11,796,000	10.00	18.00
D	54,000,000	8.00	15.00	J	25,428,000	9.00	16.00
E	47,088,000	7.50	13.50	K	22,848,000	9.00	16.00
F	52,416,000	7.50	15.00	L	55,008,000	7.50	15.00

Series 1950 A — Signatures: Priest-Humphrey

	Delivered	Ex. Fine	New		Delivered	Ex. Fine	New
A	53,568,000	7.00	12.50	G	129,296,000	6.50	12.50
B	186,472,000	7.00	12.50	H	54,936,000	7.50	12.50
C	69,616,000	7.00	12.50	I	11,232,000	9.00	15.00
D	45,360,000	7.00	12.50	J	29,952,000	7.50	14.50
E	76,672,000	7.00	12.50	K	24,984,000	7.50	15.00
F	86,464,000	7.00	12.50	L	90,712,000	7.50	12.50

Series 1950 B — Signatures: Priest-Anderson

	Delivered	Ex. Fine	New		Delivered	Ex. Fine	New
A	30,880,000	7.50	13.50	G	104,320,000	7.00	12.00
B	85,960,000	7.00	12.00	H	25,840,000	7.50	15.00
C	43,560,000	7.00	12.50	I	20,880,000	7.50	15.00
D	38,800,000	7.00	12.50	J	32,400,000	7.50	14.00
E	52,920,000	7.00	12.50	K	52,119,999	7.00	12.00
F	80,560,000	7.00	12.50	L	56,080,000	7.00	12.00

$5.00 FEDERAL RESERVE NOTES

Series 1950 C *Signatures:* Smith-Dillon

✔	Delivered	Ex. Fine	New	✔	Delivered	Ex. Fine	New
A	...20,880,000	$7.00	$11.50	G	...56,880,000	$6.50	$11.50
B	...47,440,000	6.50	11.50	H	...22,680,000	7.00	12.50
C	...29,520,000	6.50	12.50	I	...12,960,000	7.50	15.00
D	...33,840,000	6.50	12.50	J	...24,760,000	6.50	12.50
E	...33,480,000	6.50	12.50	K3,960,000	9.00	18.50
F	...54,360,000	6.50	11.50	L	...25,920,000	6.50	11.50

Series 1950 D *Signatures:* Granahan-Dillon

✔	Delivered		New	✔	Delivered		New
A	...25,200,000	10.00	G	...67,240,000	10.00
B	..102,160,000	10.00	H	...20,160,000	11.00
C	...21,520,000	10.00	I7,920,000	11.50
D	...23,400,000	10.00	J	...11,160,000	11.00
E	...42,480,000	11.00	K7,200,000	11.50
F	...35,200,000	11.00	L	...53,280,000	10.00

Series 1950 E *Signatures:* Granahan-Fowler

✔	Federal Reserve Bank	Delivered	New
B	New York..............................82,000,000		$11.50
G	Chicago...............................14,760,000		13.00
L	San Francisco.........................24,400,000		12.00

Notes of the 1950 E series do *not* have the motto on the back. These were released *after* the 1963 series.

Series 1963 *Signatures:* Granahan-Dillon

Motto "In God We Trust" added on the back.
Back design on page 23.

✔	Fed. Res. Bk.	Delivered	New	✔	Fed. Res. Bk.	Delivered	New
A	Boston	4,480,000	$13.00	G	Chicago	22,400,000	$10.00
B	N.Y.	12,160,000	10.00	H	St. Louis	14,080,000	10.00
C	Phil.	8,320,000	10.00	I	M'apolis	None Printed
D	Cleve.	10,240,000	10.00	J	K. City	1,920,000	12.00
E	Rich.	None Printed	K	Dallas	5,760,000	11.00
F	Atlanta	17,920,000	10.00	L	San F.	18,560,000	10.00

Series 1963 A *Signatures:* Granahan-Fowler

✔		Delivered	New	✔		Delivered	New
A	Boston	77,440,000	9.00	G	Chicago	213,440,000	9.00
B	N.Y.	98,080,000	9.00	H	St. Louis	56,960,000	9.00
C	Phil.	106,400,000	9.00	I	M'apolis	32,640,000	9.00
D	Cleve.	83,840,000	9.00	J	K. City	55,040,000	9.00
E	Rich.	118,560,000	9.00	K	Dallas	64,000,000	9.00
F	Atlanta	117,920,000	9.00	L	San F.	128,800,000	9.00

$5.00 FEDERAL RESERVE NOTES

Series 1969 — *Signatures:* Elston-Kennedy

√		Delivered	New	√		Delivered	New
........A	51,200,000	$8.00G	125,600,000	$8.00
........B	198,560,000	8.00H	27,520,000	8.00
........C	69,120,000	8.00I	16,640,000	8.00
........D	56,320,000	8.00J	48,640,000	8.00
........E	84,480,000	8.00K	39,680,000	8.00
........F	84,480,000	8.00L	103,840,000	8.00

Series 1969 A — *Signatures:* Kabis-Connally

√		Delivered	New	√		Delivered	New
........A	23,040,000	7.00G	60,800,000	7.00
........B	62,240,000	7.00H	15,360,000	7.00
........C	41,160,000	7.00I	8,960,000	7.00
........D	21,120,000	7.00J	17,920,000	7.00
........E	37,920,000	7.00K	21,120,000	7.00
........F	25,120,000	7.00L	44,800,000	7.00

Series 1969 B — *Signatures:* Bañuelos-Connally

√		Delivered	New	√		Delivered	New
........A	5,760,000	6.50G	27,040,000	6.50
........B	34,560,000	6.50H	5,120,000	6.50
........C	5,120,000	6.50I	8,320,000	6.50
........D	12,160,000	6.50J	8,320,000	6.50
........E	15,360,000	6.50K	12,160,000	6.50
........F	18,560,000	6.50L	23,680,000	6.50

Series 1969 C — *Signatures:* Bañuelos-Shultz

√		Delivered	New	√		Delivered	New
........A	50,720,000	6.00G	54,400,000	6.00
........B	120,000,000	6.00H	37,760,000	6.00
........C	53,760,000	6.00I	14,080,000	6.00
........D	43,680,000	6.00J	41,120,000	6.00
........E	73,760,000	6.00K	41,120,000	6.00
........F	81,440,000	6.00L	80,800,000	6.00

Series 1974 — *Signatures:* Neff-Simon

At this time notes are being issued from all 12 Districts.

$10.00 FEDERAL RESERVE NOTES
Ten Dollars, Portrait of Hamilton

Face Design 1928 and 1928 A. Back Design on page 31.

Series of 1928 Signatures: Tate-Mellon

Large District numeral of Bank at left.

✓	Federal Reserve Bank	Printed	V. Fine	Ex. Fine	New
..............1	Boston.............9,804,552	$16.00	$27.50	$50.00	
..............2	New York.........11,295,796	15.00	25.00	45.00	
..............3	Philadelphia........8,114,412	16.00	27.50	47.50	
..............4	Cleveland...........7,570,680	16.00	27.50	47.50	
..............5	Richmond...........4,534,800	17.50	30.00	52.50	
..............6	Atlanta.............6,807,720	17.50	30.00	52.50	
..............7	Chicago.............8,130,000	15.00	25.00	45.00	
..............8	St. Louis............4,124,100	17.50	30.00	50.00	
..............9	Minneapolis........3,874,440	17.50	30.00	55.00	
..............10	Kansas City.........3,620,400	17.50	30.00	55.00	
..............11	Dallas..............4,855,500	20.00	35.00	60.00	
..............12	San Francisco........7,086,900	15.00	25.00	45.00	

Series of 1928 A Signatures: Woods-Mellon

Large District numeral at left, similar to Series of 1928 issues.

✓	Federal Reserve Bank	Printed	V. Fine	Ex. Fine	New
..............1	Boston.............2,893,440	15.00	25.00	40.00	
..............2	New York.........18,631,056	13.00	22.50	37.50	
..............3	Philadelphia........2,710,680	15.00	25.00	40.00	
..............4	Cleveland...........5,610,000	15.00	25.00	40.00	
..............5	Richmond.............552,300	16.00	27.50	45.00	
..............6	Atlanta.............3,033,480	16.00	27.50	45.00	
..............7	Chicago.............8,715,000	13.00	22.50	37.50	
..............8	St. Louis.............531,600	16.00	27.50	45.00	
..............9	Minneapolis..........102,600	17.50	30.00	50.00	
..............10	Kansas City..........410,400	17.50	30.00	50.00	
..............11	Dallas...............961,800	20.00	35.00	57.50	
..............12	San Francisco........2,547,900	13.00	22.50	37.50	

$10.00 FEDERAL RESERVE NOTES

Series of 1928 B *Signatures:* Woods-Mellon

Large District letter replaces numeral in seal on this and succeeding issues.

✓	Federal Reserve Bank	Printed	V. Fine	Ex. Fine	New
............A	Boston............33,218,088		$13.00	$20.00	$30.00
............B	New York..........44,458,308		12.00	18.00	27.50
............C	Philadelphia........22,689,216		13.00	20.00	30.00
............D	Cleveland..........17,418,024		13.00	20.00	30.00
............E	Richmond..........12,714,504		15.00	22.50	35.00
............F	Atlanta.............5,246,700		15.00	22.50	35.00
............G	Chicago............38,035,000		13.00	20.00	30.00
............H	St. Louis...........10,814,664		15.00	22.50	35.00
............I	Minneapolis.........5,294,460		16.00	25.00	40.00
............J	Kansas City.........7,748,040		16.00	25.00	40.00
............K	Dallas.............3,396,096		18.00	30.00	45.00
............L	San Francisco.......22,695,300		13.00	20.00	30.00

Series of 1928 C *Signatures:* Woods-Mills

✓	Federal Reserve Bank	Printed	V. Fine	Ex. Fine	New
............B	New York...........2,902,678		15.00	25.00	50.00
............D	Cleveland..........4,230,428		15.00	25.00	55.00
............E	Richmond............304,800		17.50	30.00	65.00
............F	Atlanta.............688,380		17.50	30.00	65.00
............G	Chicago............2,423,400		15.00	25.00	55.00

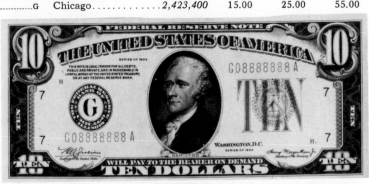

General Face Design 1928 B and 1928 C. Face Design 1934-1934 D.
Back Design on page 31.

Series of 1934 *Signatures:* Julian-Morgenthau

Light green seal.

✓	Federal Reserve Bank	Printed	V. Fine	Ex. Fine	New
............A	Boston............46,276,152		20.00	30.00
............B	New York.........117,298,008		17.50	27.50
............C	Philadelphia........34,770,768		20.00	32.50
............D	Cleveland..........28,764,108		22.50	37.50
............E	Richmond..........16,437,252		22.50	37.50
............F	Atlanta............20,656,872		25.00	40.00

$10.00 FEDERAL RESERVE NOTES

✓	Federal Reserve Bank	Printed	Ex. Fine	New
G	Chicago.....................69,962,064	$17.50	$27.50	
H	St. Louis...................22,593,204	25.00	40.00	
I	Minneapolis................16,840,980	30.00	45.00	
J	Kansas City................22,627,824	27.50	42.50	
K	Dallas......................21,403,488	27.50	42.50	
L	San Francisco..............37,402,308	20.00	32.50	

Figures above include both the light and dark seals.

Series of 1934 Signatures: Julian-Morgenthau

Dark green seal.

✓			
A	17.50	27.50
B	17.50	27.50
C	17.50	30.00
D	20.00	35.00
E	22.50	37.50
F	22.50	40.00
G	17.50	27.50
H	20.00	35.00
I	22.50	40.00
J	22.50	37.50
K	22.50	37.50
L	17.50	30.00

Series of 1934 A Signatures: Julian-Morgenthau

✓	Printed	Ex. Fine	New	✓	Printed	Ex.Fine	New
A	..104,540,088	$16.00	$25.00	G	..177,285,960	$16.00	$25.00
B	..281,940,996	16.00	25.00	H	...50,694,312	20.00	35.00
C	...95,338,032	16.00	25.00	I	...16,340,016	22.50	37.50
D	...93,332,004	17.50	30.00	J	...31,069,978	20.00	35.00
E	..101,037,912	18.50	32.50	K	...28,263,156	20.00	35.00
F	...85,478,160	18.50	32.50	L	..125,537,592	16.00	25.00

Series of 1934 B Signatures: Julian-Vinson

✓	Printed	Ex. Fine	New	✓	Printed	Ex. Fine	New
A3,999,600	15.00	30.00	D1,394,700	15.00	30.00
B	...34,815,948	14.00	22.50	E4,018,272	15.00	30.00
C	...10,339,020	15.00	30.00	F6,746,076	15.00	30.00

$10.00 FEDERAL RESERVE NOTES

✔		Printed	Ex. Fine	New	✔		Printed	Ex. Fine	New
.........G	...18,130,836		$14.00	$25.00J3,835,764		$17.50	$35.00
.........H6,849,348		15.00	35.00K3,085,200		17.50	35.00
.........I2,254,800		20.00	40.00L9,076,800		15.00	30.00

Series of 1934 C Signatures: Julian-Snyder

✔	Printed	Ex. Fine	New	✔	Printed	Ex. Fine	New
.........A	...42,431,404	15.00	25.00G	..105,875,412	13.50	22.50
.........B	..115,675,644	13.50	20.00H	..36,541,404	15.00	27.50
.........C	...46,874,760	15.00	25.00I	..11,944,848	17.50	35.00
.........D332,400	40.00	85.00J	..20,874,072	15.00	25.00
.........E	...37,422,600	15.00	27.50K	..25,642,620	15.00	25.00
.........F	...44,838,264	15.00	25.00L	..49,164,480	15.00	25.00

Series of 1934 D Signatures: Clark-Snyder

✔	Printed	Ex. Fine	New	✔	Printed	Ex. Fine	New
.........A	...19,917,900	15.00	25.00G	..55,943,844	15.00	20.00
.........B	...64,067,904	15.00	20.00H	..15,828,048	15.00	25.00
.........C	...18,432,000	15.00	25.00I	...5,237,220	17.50	30.00
.........D	...20,291,316	15.00	25.00J	...7,992,000	17.50	30.00
.........E	...18,090,312	15.00	25.00K	...7,178,196	17.50	30.00
.........F	...17,064,816	15.00	25.00L	..23,956,584	15.00	25.00

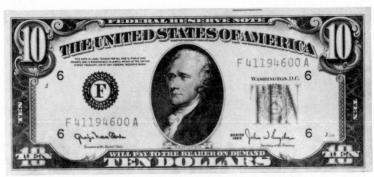

Face Design 1950 - 1950 E. Back Design on page 31.

Series 1950 Signatures: Clark-Snyder

✔	Printed	Ex. Fine	New	✔	Printed	Ex. Fine	New
.........A	...70,992,000	15.00	22.50G	..161,056,000	13.50	20.00
.........B	..218,576,000	13.50	20.00H	..47,808,000	15.00	25.00
.........C	...76,320,000	13.50	22.50I	..18,864,000	15.00	25.00
.........D	...76,032,000	13.50	22.50J	..36,332,000	15.00	25.00
.........E	...61,776,000	15.00	24.00K	..33,264,000	15.00	25.00
.........F	...63,792,000	13.50	22.50L	..76,896,000	13.50	22.50

$10.00 FEDERAL RESERVE NOTES

Series 1950 A Signatures: Priest-Humphrey

✓		Delivered	Ex. Fine	New	✓		Delivered	Ex. Fine	New
........A	..104,248,000		$11.00	$17.50G	..235,064,000		$11.00	$17.50
........B	..356,664,000		11.00	17.50H	...46,512,000		12.00	22.50
........C	...73,920,000		11.00	20.00I8,136,000		15.00	25.00
........D	...75,088,000		11.00	20.00J	...25,488,000		12.00	22.50
........E	...82,144,000		11.00	20.00K	...21,816,000		12.50	22.50
........F	...73,288,000		11.00	20.00L	..101,584,000		11.00	17.50

Series 1950 B Signatures: Priest-Anderson

✓			New	✓			New
........A	...49,240,000	16.50G	..165,080,000	15.00
........B	..170,840,000	15.00H	...33,040,000	16.50
........C	...66,880,000	16.00I	...13,320,000	12.00	20.00
........D	...55,360,000	16.00J	...34,480,000	16.50
........E	...51,120,000	16.00K	...26,280,000	11.00	17.50
........F	...66,520,000	16.00L	...55,000,000	16.50

Series 1950 C Signatures: Smith-Dillon

✓		Delivered	New	✓		Delivered	New
........A51,120,000		$16.00G69,400,000		$16.00
........B126,520,000		16.00H23,040,000		17.50
........C25,200,000		17.50I9,000,000		20.00
........D33,120,000		17.50J23,320,000		17.50
........E45,640,000		16.00K17,640,000		17.50
........F38,880,000		16.00L35,640,000		16.50

Series 1950 D Signatures: Granahan-Dillon

✓		Delivered	New	✓		Delivered	New
........A38,800,000		16.00G115,480,000		15.00
........B150,320,000		15.00H10,440,000		17.00
........C19,080,000		16.00INo Record	
........D24,120,000		16.00J15,480,000		16.00
........E33,840,000		16.00K18,280,000		16.00
........F36,000,000		16.00L62,560,000		15.00

Series 1950 E Signatures: Granahan-Fowler

✓	Federal Reserve Bank	Delivered	New
............B	New York............................37,800,000		15.00
............G	Chicago................................65,080,000		14.00
............L	San Francisco.........................17,280,000		16.00

Notes of the 1950 E series were released *after* Series 1963 but do *not* have the motto on the back.

$10.00 FEDERAL RESERVE NOTES

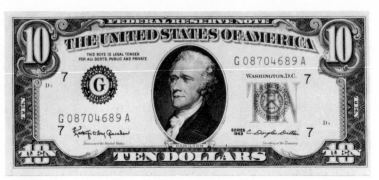

Face Design 1963 through 1974

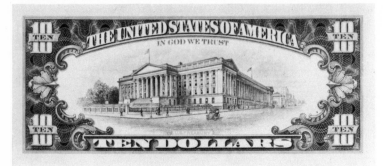

Back Design 1963 through 1974

Series 1963 *Signatures:* Granahan-Dillon

Motto "In God We Trust" added on the back.

✓		Delivered	New	✓		Delivered	New
........A	5,760,000	$16.00G	35,200,000	$15.00
........B	24,960,000	15.00H	13,440,000	15.00
........C	6,400,000	16.00I	None Printed
........D	7,040,000	16.00J	3,840,000	18.00
........E	4,480,000	17.50K	5,120,000	17.50
........F	10,880,000	16.00L	14,080,000	15.00

Series 1963 A *Signatures:* Granahan-Fowler

........A	131,360,000	14.00D	72,960,000	14.00
........B	199,360,000	14.00E	114,720,000	14.00
........C	100,000,000	14.00F	80,000,000	14.00

$10.00 FEDERAL RESERVE NOTES

✓	Delivered	New	✓	Delivered	New
........G195,520,000	$14.00J31,360,000	$14.00
........H43,520,000	14.00K51,200,000	14.00
........I16,640,000	14.00L87,200,000	14.00

Series 1969 *Signatures:* Elston-Kennedy

........A74,880,000	12.00G142,240,000	12.00
........B247,360,000	12.00H22,400,000	12.00
........C56,960,000	12.00I12,800,000	12.00
........D57,600,000	12.00J31,360,000	12.00
........E56,960,000	12.00K30,080,000	12.00
........F53,760,000	12.00L56,320,000	12.00

Series 1969 A *Signatures:* Kabis-Connally

........A41,120,000	12.00G80,160,000	12.00
........B111,840,000	12.00H15,360,000	12.00
........C24,320,000	12.00I8,320,000	12.00
........D23,680,000	12.00J10,880,000	12.00
........E25,600,000	12.00K20,480,000	12.00
........F20,480,000	12.00L27,520,000	12.00

Series 1969 B *Signatures:* Bañuelos-Connally

........A16,640,000	11.00G32,640,000	11.00
........B60,320,000	11.00H8,960,000	11.00
........C16,000,000	11.00I3,200,000	11.00
........D12,800,000	11.00J5,120,000	11.00
........E12,160,000	11.00K5,760,000	11.00
........F13,440,000	11.00L23,840,000	11.00

Series 1969 C *Signatures:* Bañuelos-Shultz

........A44,800,000	11.00G55,200,000	11.00
........B203,200,000	11.00H29,800,000	11.00
........C69,920,000	11.00I11,520,000	11.00
........D46,880,000	11.00J23,040,000	11.00
........E45,600,000	11.00K24,960,000	11.00
........F46,240,000	11.00L56,960,000	11.00

Series 1974 *Signatures:* Neff-Simon

At this time notes are being issued from all 12 Districts.

$20.00 FEDERAL RESERVE NOTES

Twenty Dollars, Portrait of Jackson

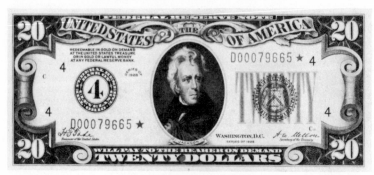

Face Design 1928 and 1928 A

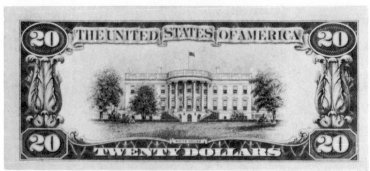

Back Design Federal Reserve Notes 1928 through 1934 C; National Currency;
Federal Reserve Bank Notes; Gold Certificates

Series of 1928 *Signatures:* **Tate-Mellon**

Large District numeral of Bank at left.

✓	Printed	Ex. Fine	New	✓	Printed	Ex. Fine	New
1	3,790,880	$32.50	$52.50	7	10,891,740	$30.00	$50.00
2	12,797,200	30.00	47.50	8	2,523,300	35.00	65.00
3	3,797,200	32.50	52.50	9	2,633,100	35.00	65.00
4	10,626,900	30.00	47.50	10	2,584,500	35.00	65.00
5	4,119,600	35.00	60.00	11	1,568,500	37.50	67.50
6	3,842,388	35.00	60.00	12	8,404,800	32.50	55.00

$20.00 FEDERAL RESERVE NOTES

Series of 1928 A *Signatures:* Woods-Mellon

Large District numeral at left, similar to Series of 1928 issues.

√		Printed	Ex. Fine	New	√		Printed	Ex. Fine	New
11,293,900	$30.00	$47.50		7822,000	$35.00	$60.00	
21,055,800	30.00	47.50		8573,300	35.00	65.00	
31,717,200	30.00	47.50		9	...No Record	
4625,200	35.00	60.00		10113,900	40.00	80.00	
51,534,500	32.50	52.50		111,032,000	35.00	60.00	
61,442,400	32.50	52.50		12	..No Redord	

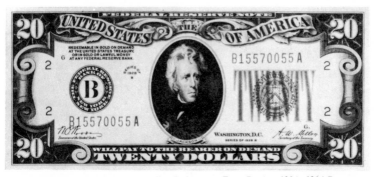

Face Design 1928 B and 1928 C. General Face Design 1934 - 1934 D.

Series of 1928 B *Signatures:* Woods-Mellon

Large District letter replaces numeral in seal on this and succeeding issues.

√	Federal Reserve Bank	Printed	V. Fine	Ex. Fine	New
A	Boston.............7,749,636	$30.00	$47.50	
B	New York.........19,448,436	27.50	45.00	
C	Philadelphia........8,095,548	30.00	45.00	
D	Cleveland..........11,684,196	30.00	45.00	
E	Richmond..........4,413,900	30.00	47.50	
F	Atlanta.............2,390,240	32.50	50.00	
G	Chicago...........17,220,276	27.50	45.00	
H	St. Louis...........3,834,600	32.50	47.50	
I	Minneapolis........3,298,920	30.00	45.00	
J	Kansas City........4,941,252	30.00	47.50	
K	Dallas.............2,406,060	35.00	50.00	
L	San Francisco.......9,689,124	30.00	45.00	

Series of 1928 C *Signatures:* Woods-Mills

√		Printed			
G	Chicago.............3,363,300	$45.00	60.00	125.00	
L	San Francisco........1,420,200	45.00	60.00	135.00	

$20.00 FEDERAL RESERVE NOTES

Series of 1934 *Signatures:* Julian-Morgenthau

Light or dark green seal.

√	Printed	Ex. Fine	New	√	Printed	Ex. Fine	New
A	37,673,068	$30.00	$42.50	G	20,777,832	$27.50	$40.00
B	27,573,264	27.50	40.00	H	27,174,552	30.00	47.50
C	53,209,968	27.50	40.00	I	16,795,116	32.50	50.00
D	48,301,416	28.50	40.00	J	28,865,304	30.00	47.50
E	36,259,224	28.50	45.00	K	20,852,160	30.00	47.50
F	41,547,660	30.00	45.00	L	32,203,956	27.50	42.50

Series of 1934 A *Signatures:* Julian-Morgenthau

√	Printed	Ex. Fine	New	√	Printed	Ex. Fine	New
A	3,202,416	28.50	42.50	G	91,141,452	27.50	40.00
B	102,555,538	27.50	40.00	H	3,701,568	28.50	47.50
C	3,371,316	27.50	40.00	I	1,162,500	30.00	50.00
D	23,475,108	27.50	40.00	J	3,221,184	28.50	47.50
E	46,816,224	27.50	40.00	K	2,531,700	28.50	47.50
F	6,756,816	28.50	45.00	L	94,454,112	27.50	40.00

Series of 1934 B *Signatures:* Julian-Vinson

√	Printed	Ex. Fine	New	√	Printed	Ex. Fine	New
A	3,904,800	30.00	47.50	G	9,084,600	25.00	40.00
B	14,876,436	25.00	40.00	H	5,817,300	30.00	45.00
C	3,271,452	30.00	45.00	I	2,304,800	35.00	52.50
D	2,814,600	30.00	47.50	J	3,524,244	30.00	45.00
E	9,451,632	25.00	40.00	K	2,807,388	35.00	52.50
F	6,887,640	25.00	40.00	L	5,289,540	28.50	42.50

New White House Vignette — Series of 1934 C

On November 10, 1948, Treasury Secretary Snyder announced that the $20.00
note was to bear a new engraving of the White House on the back side. The
"new look" was made from a photograph of the South front and grounds

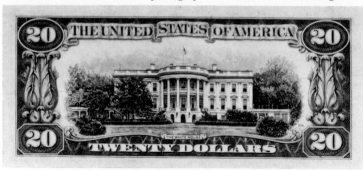

Back Design 1934 C through 1950 E (see old back on page 62)

after the building was renovated. The design used until this time showed the South front as it appeared in 1929. The modified design was actually put to press for the first time on July 20, 1948.

Various structural modifications can be seen when the two designs are compared. These include a balcony at the second floor level and four chimneys instead of two. Other differences are also visible. Lettering beneath the building is changed from "White House" to "The White House."

The new White House vignette was first used during the issue of notes Series of 1934 C. Both the old and new back designs can be found with this same series date. Subsequent issues through 1950 E use the new design.

Series of 1934 C — Signatures: Julian-Snyder

√	Printed	Ex. Fine	New	√	Printed	Ex. Fine	New
A	7,397,352	$30.00	$42.50	G	26,031,660	$27.50	$40.00
B	18,668,148	27.50	40.00	H	13,276,984	28.50	42.50
C	11,590,752	28.50	42.50	I	3,490,200	32.50	52.50
D	17,912,424	27.50	40.00	J	9,675,468	28.50	42.50
E	22,526,568	27.50	40.00	K	10,205,364	28.50	42.50
F	18,858,876	27.50	42.50	L	20,580,828	27.50	40.00

Above listing includes both the old or new back designs. At present there is no difference in value between them.

Series of 1934 D — Signatures: Clark-Snyder

√	Printed	Ex. Fine	New	√	Printed	Ex. Fine	New
A	4,520,000	28.50	38.50	G	15,187,596	27.50	36.50
B	27,894,260	27.50	37.50	H	5,923,248	30.00	40.00
C	6,022,428	30.00	42.50	I	2,422,416	32.50	45.00
D	8,981,688	28.50	40.00	J	4,211,904	28.50	42.50
E	14,055,984	27.50	37.50	K	3,707,364	28.50	42.50
F	7,495,440	28.50	40.00	L	12,015,228	27.50	37.50

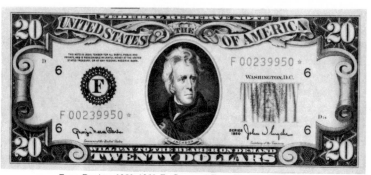

Face Design 1950-1950 E. General Face Design 1963-1974.

$20.00 FEDERAL RESERVE NOTES

Series 1950 — Signatures: Clark-Snyder

✓	Delivered	Ex. Fine	New	✓	Delivered	Ex. Fine	New
A	...23,184,000	$27.50	$36.50	G	...70,464,000	$23.50	$30.00
B	...80,064,000	23.50	30.00	H	...27,352,000	28.50	37.50
C	...29,520,000	27.50	36.50	I9,216,000	30.00	42.50
D	...51,120,000	25.00	32.50	J	...22,752,000	28.50	37.50
E	...67,536,000	25.00	30.00	K	...22,656,000	28.50	37.50
F	...39,312,000	27.50	35.00	L	...70,272,000	25.00	32.50

Series 1950 A — Signatures: Priest-Humphrey

✓	Delivered	Ex. Fine	New	✓	Delivered	Ex. Fine	New
A	...19,656,000	25.00	32.50	G	...73,720,000	22.50	27.50
B	...82,568,000	22.50	27.50	H	...22,680,000	25.00	32.50
C	...16,560,000	27.50	35.00	I5,544,000	28.50	37.50
D	...50,320,000	23.50	28.50	J	...22,968,000	25.00	32.50
E	...69,544,000	23.00	28.00	K	...10,728,000	27.50	37.50
F	...27,648,000	23.50	30.00	L	...85,528,000	22.50	27.50

Series 1950 B — Signatures: Priest-Anderson

✓	Delivered	Ex. Fine	New	✓	Delivered	Ex. Fine	New
A5,040,000	28.50	37.50	G	...80,560,000	22.50	27.50
B	...49,960,000	23.50	30.00	H	...19,440,000	27.50	32.50
C7,920,000	27.50	37.50	I	...12,240,000	27.50	35.00
D	...38,160,000	23.50	30.00	J	...28,440,000	27.50	32.50
E	...42,120,000	23.50	30.00	K	...11,880,000	27.50	35.00
F	...40,240,000	23.50	30.00	L	...51,040,000	23.50	30.00

Series 1950 C — Signatures: Smith-Dillon

✓	Delivered	Ex. Fine	New	✓	Delivered	Ex. Fine	New
A7,200,000	25.00	35.00	G	...29,160,000	22.50	30.00
B	...43,200,000	22.50	27.50	H	...12,960,000	25.00	32.50
C7,560,000	25.00	35.00	I6,480,000	27.50	37.50
D	...28,440,000	22.50	30.00	J	...18,360,000	25.00	35.00
E	...37,000,000	22.50	30.00	K9,000,000	27.50	37.50
F	...19,080,000	25.00	35.00	L	...45,360,000	23.50	27.50

Series 1950 D — Signatures: Granahan-Dillon

✓	Delivered	New	✓	Delivered	New
A9,360,000	$32.50	G67,960,000	$30.00
B54,280,000	30.00	H6,120,000	32.50
C5,400,000	35.00	I3,240,000	35.00
D23,760,000	30.00	J8,200,000	32.50
E30,240,000	30.00	K6,480,000	32.50
F22,680,000	30.00	L69,400,000	30.00

Series 1950 E — Signatures: Granahan-Fowler

✓	Federal Reserve Bank	Delivered	New
B	New York..................................	8,640,000	32.50
G	Chicago...................................	9,360,000	32.50
L	San Francisco.............................	8,640,000	32.50

$20.00 FEDERAL RESERVE NOTES

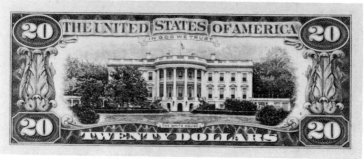

Back Design 1963 through 1974

Series 1963 — *Signatures:* Granahan-Dillon

Motto "In God We Trust" added.

√	Delivered	New	√	Delivered	New
A	2,560,000	$32.50	G	2,560,000	$32.50
B	16,640,000	30.00	H	3,200,000	30.00
C	None Printed	I	None Printed
D	7,680,000	30.00	J	3,840,000	30.00
E	4,480,000	30.00	K	2,560,000	32.50
F	10,240,000	28.50	L	7,040,000	30.00

Series 1963 A — *Signatures:* Granahan-Fowler

√	Delivered	New	√	Delivered	New
A	23,680,000	24.00	G	156,320,000	24.00
B	93,600,000	24.00	H	34,560,000	24.00
C	17,920,000	25.00	I	10,240,000	25.00
D	68,480,000	24.00	J	37,120,000	24.00
E	128,800,000	24.00	K	38,400,000	24.00
F	42,880,000	24.00	L	169,120,000	24.00

Series 1969 — *Signatures:* Elston-Kennedy

√	Delivered	√	Delivered	√	Delivered
A	19,200,000	E	66,560,000	I	12,160,000
B	106,400,000	F	36,480,000	J	39,040,000
C	10,880,000	G	107,680,000	K	25,600,000
D	60,160,000	H	19,200,000	L	103,840,000

Series 1969 A — *Signatures:* Kabis-Connally

√	Delivered	√	Delivered	√	Delivered
A	13,440,000	E	42,400,000	I	7,040,000
B	69,760,000	F	13,440,000	J	16,640,000
C	13,440,000	G	80,640,000	K	14,720,000
D	29,440,000	H	14,080,000	L	50,560,000

$20.00 FEDERAL RESERVE NOTES

Series 1969 B ***Signatures:* Bañuelos-Connally**

✓	Delivered	✓	Delivered	✓	Delivered
A	...None Printed	E27,520,000	I2,560,000
B39,200,000	F14,080,000	J3,840,000
C	...None Printed	G14,240,000	K12,160,000
D6,400,000	H5,120,000	L26,240,000

Series 1969 C ***Signatures:* Bañuelos-Shultz**

✓		✓		✓	
A17,280,000	E80,160,000	I14,080,000
B	...135,200,000	F35,840,000	J32,000,000
C40,960,000	G78,720,000	K31,360,000
D57,760,000	H33,920,000	L82,080,000

Series 1974 ***Signatures:* Neff-Simon**

At this time notes are being issued from all 12 Districts.

$50.00 FEDERAL RESERVE NOTES
Fifty Dollars, Portrait of Grant

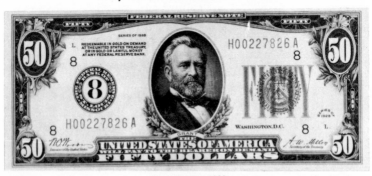

Face Design 1928

Series of 1928 ***Signatures:* Woods-Mellon**

Large District numeral of Bank at left.

✓		Printed	Ex. Fine	New	✓		Printed	Ex. Fine	New
1265,200		$80.00	$130.00	7	...1,348,620		$75.00	$115.00
2	...1,351,800		75.00	115.00	8627,300		90.00	150.00
3997,056		75.00	115.00	9106,200		100.00	160.00
4	...1,161,900		80.00	125.00	10252,600		90.00	150.00
5539,400		85.00	130.00	11109,920		100.00	150.00
6538,800		90.00	135.00	12447,600		85.00	135.00

$50.00 FEDERAL RESERVE NOTES

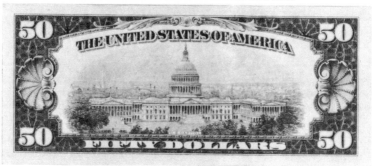

Back Design Federal Reserve Notes 1928-1950 E; National Currency; Federal Reserve Bank Notes; Gold Certificates

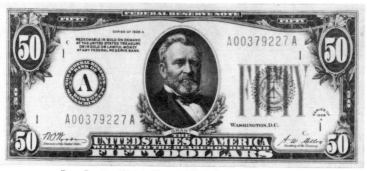

Face Design 1928 A. General Face Design 1934 - 1934 D.

Series of 1928 A *Signatures:* **Woods-Mellon**

Large District letter replaces numeral in Bank seal
on this and succeeding issues.

✓	Federal Reserve Bank	Printed	Ex. Fine	New
..............A	Boston...........................1,834,989		$75.00	$110.00
..............B	New York.........................3,392,328		75.00	110.00
..............C	Philadelphia......................3,078,944		75.00	110.00
..............D	Cleveland........................2,453,364		75.00	110.00
..............E	Richmond.........................1,516,500		75.00	110.00
..............F	Atlanta............................338,400		85.00	140.00
..............G	Chicago..........................5,263,956		75.00	100.00
..............H	St. Louis..........................880,500		85.00	120.00
..............I	Minneapolis........................780,240		85.00	120.00
..............J	Kansas City........................791,604		85.00	120.00
..............K	Dallas.............................701,496		85.00	120.00
..............L	San Francisco.....................1,522,620		75.00	110.00

$50.00 FEDERAL RESERVE NOTES

Series of 1934 *Signatures:* Julian-Morgenthau

Light or dark green seal.

✓	Printed	Ex. Fine	New	✓	Printed	Ex. Fine	New
A	2,729,400	$70.00	$92.50	G	8,675,940	$65.00	$80.00
B	17,894,676	65.00	80.00	H	1,497,144	72.50	100.00
C	5,833,200	65.00	80.00	I	539,700	75.00	110.00
D	8,817,720	65.00	80.00	J	1,133,520	72.50	100.00
E	4,826,628	65.00	85.00	K	1,194,876	72.50	100.00
F	3,069,348	70.00	90.00	L	8,101,200	65.00	80.00

Series of 1934 A *Signatures:* Julian-Morgenthau

✓	Printed	Ex. Fine	New	✓	Printed	Ex. Fine	New
A	406,200	67.50	82.50	G	1,014,600	60.00	77.50
B	4,710,648	57.50	77.50	H	361,944	70.00	85.00
C	No Record	I	93,300	72.50	90.00
D	864,168	60.00	77.50	J	189,300	70.00	85.00
E	2,235,372	60.00	77.50	K	266,700	70.00	85.00
F	416,100	67.50	82.50	L	162,000	60.00	77.50

Series of 1934 B *Signatures:* Julian-Vinson

✓	Printed	Ex. Fine	New	✓	Printed	Ex. Fine	New
A	No Record	G	306,000	70.00	105.00
B	No Record	H	306,000	65.00	95.00
C	509,100	67.50	95.00	I	120,000	70.00	110.00
D	359,100	80.00	110.00	J	221,340	65.00	100.00
E	596,700	70.00	105.00	K	120,108	70.00	105.00
F	416,720	75.00	110.00	L	441,000	67.50	100.00

Series of 1934 C *Signatures:* Julian-Snyder

✓	Printed	Ex. Fine	New	✓	Printed	Ex. Fine	New
A	117,600	75.00	110.00	G	294,432	72.50	92.50
B	1,556,400	65.00	82.50	H	535,200	67.50	90.00
C	107,283	65.00	82.50	I	118,800	75.00	100.00
D	374,400	62.50	77.50	J	303,600	72.50	92.50
E	1,821,960	62.50	77.50	K	429,900	72.50	95.00
F	107,640	72.50	92.50	L	No Record

Series of 1934 D *Signatures:* Clark-Snyder

✓	Printed	Ex. Fine	New	✓	Printed	Ex. Fine	New
A	279,600	65.00	82.50	G	494,016	62.50	80.00
B	898,776	60.00	75.00	H	No Record
C	699,000	62.50	77.50	I	No Record
D	No Record	J	No Record
E	156,000	72.50	100.00	K	103,200	72.50	95.00
F	216,000	67.50	90.00	L	No Record

$50.00 FEDERAL RESERVE NOTES

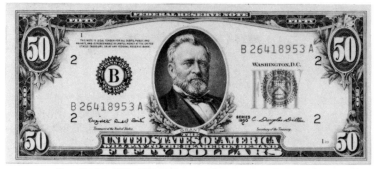

Face Design 1950 - 1950 E. General Face Design 1963 A - 1974.

Series 1950 Signatures: Clark-Snyder

√	Delivered	New	√	Delivered	New
A	1,248,000	$80.00	G	4,212,000	$72.50
B	10,236,000	72.50	H	892,000	85.00
C	2,352,000	75.00	I	384,000	90.00
D	6,180,000	72.50	J	696,000	85.00
E	5,064,000	72.50	K	1,100,000	80.00
F	1,812,000	80.00	L	3,996,000	75.00

Series 1950 A Signatures: Priest-Humphrey

√	Delivered	New	√	Delivered	New
A	720,000	75.00	G	2,016,000	70.00
B	6,480,000	70.00	H	576,000	72.50
C	1,728,000	72.50	I	No Record	
D	1,872,000	72.50	J	144,000	85.00
E	2,016,000	72.50	K	864,000	70.00
F	288,000	80.00	L	576,000	72.50

Series 1950 B Signatures: Priest-Anderson

√	Delivered	New	√	Delivered	New
A	864,000	77.50	G	4,320,000	65.00
B	8,352,000	65.00	H	576,000	80.00
C	2,592,000	70.00	I	No Record	
D	1,728,000	70.00	J	1,008,000	75.00
E	1,584,000	70.00	K	1,008,000	75.00
F	No Record		L	1,872,000	72.50

Series 1950 C Signatures: Smith-Dillon

√	Delivered	New	√	Delivered	New
A	720,000	70.00	G	1,728,000	70.00
B	5,328,000	65.00	H	576,000	70.00
C	1,296,000	70.00	I	144,000	80.00
D	1,296,000	70.00	J	432,000	75.00
E	1,296,000	70.00	K	720,000	75.00
F	No Record		L	1,152,000	70.00

$50.00 FEDERAL RESERVE NOTES

Series 1950 D *Signatures:* Granahan-Dillon

√	Delivered	New	√	Delivered	New
........A	1,728,000	$60.00G	4,176,000	$60.00
........B	7,200,000	60.00H	1,440,000	60.00
........C	2,736,000	60.00I	288,000	65.00
........D	2,880,000	60.00J	720,000	65.00
........E	2,016,000	60.00K	1,296,000	60.00
........F	576,000	65.00L	2,160,000	60.00

Series 1950 E *Signatures:* Granahan-Fowler

√	Federal Reserve Bank	Delivered	New
........B	New York	3,024,000	70.00
........G	Chicago	1,008,000	70.00
........L	San Francisco	1,296,000	70.00

Back Design 1963 A - 1974

Series 1963 A *Signatures:* Granahan-Fowler

Motto on back.

√	Delivered	√	Delivered	√	Delivered
........A	1,536,000E	3,072,000I	512,000
........B	11,008,000F	768,000J	512,000
........C	3,328,000G	6,912,000K	1,536,000
........D	3,584,000H	512,000L	4,352,000

Series 1969 *Signatures:* Elston-Kennedy

........A	2,048,000E	2,560,000I	512,000
........B	12,032,000F	256,000J	1,280,000
........C	3,584,000G	9,728,000K	1,536,000
........D	3,584,000H	256,000L	6,912,000

Series 1969 A *Signatures:* Kabis-Connally

........A	1,536,000E	2,304,000I	512,000
........B	9,728,000F	256,000J	256,000
........C	2,560,000G	3,584,000K	1,024,000
........D	2,816,000H	256,000L	5,120,000

$50.00 FEDERAL RESERVE NOTES

Series 1969 B **Signatures:** Bañuelos-Connally

✓	Delivered	✓	Delivered	✓	Delivered
A	1,024,000	E	1,536,000	I	None Printed
B	2,560,000	F	512,000	J	None Printed
C	2,048,000	G	1,024,000	K	1,024,000
D	None Printed	H	None Printed	L	None Printed

Series 1969 C **Signatures:** Bañuelos-Shultz

✓	Delivered	✓	Delivered	✓	Delivered
A	1,792,000	E	2,304,000	I	256,000
B	7,040,000	F	256,000	J	1,280,000
C	9,584,000	G	6,784,000	K	3,456,000
D	5,120,000	H	2,688,000	L	4,608,000

Series 1974 **Signatures:** Neff-Simon

At this time notes are being issued from all 12 Districts.

One Hundred Dollars, Portrait of Franklin

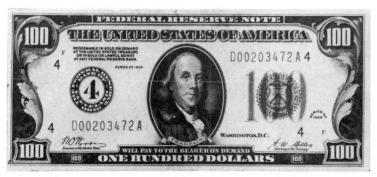

Face Design 1928

Series of 1928 **Signatures:** Woods-Mellon

Large District numeral of Bank at left.

✓	Printed	Ex. Fine	New	✓	Printed	Ex. Fine	New
1	376,000	$150.00	$200.00	7	783,300	$140.00	$180.00
2	755,400	145.00	190.00	8	187,200	165.00	200.00
3	389,100	150.00	190.00	9	102,000	175.00	225.00
4	542,400	150.00	190.00	10	234,612	165.00	200.00
5	364,416	165.00	210.00	11	80,140	175.00	225.00
6	357,000	165.00	210.00	12	486,000	150.00	190.00

$100 FEDERAL RESERVE NOTES

Back Design Federal Reserve Notes 1928 - 1950 E; National Currency; Federal Reserve Bank Notes; Gold Certificates

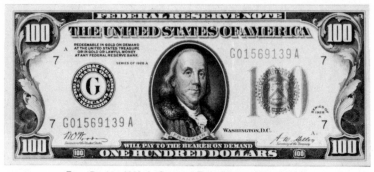

Face Design 1928 A. General Face Design 1934 - 1934 D.

Series of 1928 A *Signatures:* **Woods-Mellon**

Large District letter replaces numeral in Bank seal
on this and succeeding issues.

✔	Federal Reserve Bank	Printed	Ex. Fine	New
..........A	Boston...........................	980,400	$150.00	$185.00
..........B	New York........................	2,938,176	145.00	175.00
..........C	Philadelphia.....................	1,496,844	150.00	180.00
..........D	Cleveland........................	992,436	150.00	180.00
..........E	Richmond........................	621,364	160.00	190.00
..........F	Atlanta..........................	371,400	160.00	190.00
..........G	Chicago.........................	4,010,424	145.00	180.00
..........H	St. Louis........................	749,544	160.00	190.00
..........I	Minneapolis.....................	503,040	165.00	210.00
..........J	Kansas City.....................	681,804	160.00	190.00
..........K	Dallas...........................	594,456	165.00	210.00
..........L	San Francisco...................	1,228,032	150.00	180.00

$100 FEDERAL RESERVE NOTES

Series of 1934　　　　　*Signatures:* Julian-Morgenthau

Light or dark green Treasury Seal.

√	Federal Reserve Bank	Printed	Ex. Fine	New
............A	Boston.............................3,710,000		$145.00	$180.00
............B	New York.........................3,086,000		135.00	165.00
............C	Philadelphia.....................2,776,800		145.00	175.00
............D	Cleveland.........................3,447,108		145.00	175.00
............E	Richmond.........................4,317,600		145.00	175.00
............F	Atlanta.............................3,264,420		145.00	175.00
............G	Chicago.............................7,075,000		140.00	170.00
............H	St. Louis...........................2,106,192		145.00	175.00
............I	Minneapolis.........................852,600		160.00	185.00
............J	Kansas City.....................1,932,900		145.00	175.00
............K	Dallas.............................1,506,516		150.00	180.00
............L	San Francisco...................6,521,940		140.00	170.00

Series of 1934 A　　　　　*Signatures:* Julian-Morgenthau

............A	Boston..............................102,000		145.00	180.00
............B	New York.......................15,278,892		135.00	165.00
............C	Philadelphia........................588,000		145.00	175.00
............D	Cleveland...........................645,300		145.00	175.00
............E	Richmond...........................770,100		145.00	175.00
............F	Atlanta.............................589,896		145.00	175.00
............G	Chicago...........................3,328,800		140.00	175.00
............H	St. Louis............................434,208		145.00	175.00
............I	Minneapolis.........................153,000		160.00	190.00
............J	Kansas City.........................455,100		145.00	175.00
............K	Dallas.............................226,164		145.00	180.00
............L	San Francisco...................1,130,400		140.00	170.00

Series of 1934 B　　　　　*Signatures:* Julian-Vinson

√		Printed	Ex. Fine	New	√		Printed	Ex. Fine	New
........A41,400		$165.00	$210.00G396,000		$165.00	$210.00
........B	...No Record	H676,200		145.00	180.00
........C39,600		165.00	210.00I377,000		145.00	180.00
........D61,200		165.00	210.00J364,500		165.00	210.00
........E977,400		135.00	175.00K392,700		150.00	190.00
........F645,000		145.00	175.00L	...No Record	

Series of 1934 C　　　　　*Signatures:* Julian-Snyder

........A13,800		175.00	225.00D1,473,200		145.00	175.00
........B	...1,556,400		125.00	155.00E	...No Record	
........C13,200		175.00	225.00F493,900		135.00	165.00

$100 FEDERAL RESERVE NOTES

√	Printed	Ex. Fine	New	√	Printed	Ex. Fine	New
........G612,000	$130.00	$160.00J401,100	$135.00	$165.00
........H957,000	130.00	160.00K280,700	135.00	165.00
........I392,904	135.00	165.00L432,600	135.00	165.00

Series of 1934 D
Signatures: Clark-Snyder

√	Printed	Ex. Fine	New	√	Printed	Ex. Fine	New
........A	...No RecordG78,000	140.00	175.00
........B156		RareH166,800	140.00	175.00
........C308,400	140.00	175.00I	...No Record
........D	...No RecordJ	...No Record
........E	...No RecordK66,000	135.00	180.00
........F260,400	140.00	175.00L	...No Record

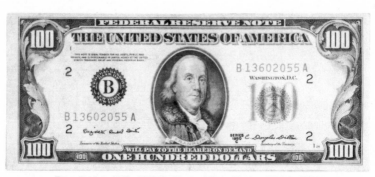

Face Design 1950 - 1950 E. General Face Design 1963 A - 1974.

Series 1950
Signatures: Clark-Snyder

√	Delivered	New	√	Delivered	New
........A768,000	165.00G4,428,000	130.00
........B3,908,000	140.00H1,284,000	145.00
........C1,332,000	145.00I564,000	160.00
........D1,632,000	145.00J864,000	155.00
........E4,076,000	140.00K1,216,000	145.00
........F1,824,000	145.00L2,524,000	140.00

Series 1950 A
Signatures: Priest-Humphrey

√	Delivered	New	√	Delivered	New
........A1,008,000	140.00G864,000	140.00
........B2,880,000	125.00H432,000	145.00
........C576,000	145.00I144,000	160.00
........D288,000	150.00J288,000	150.00
........E2,160,000	125.00K432,000	145.00
........F288,000	150.00L720,000	140.00

$100 FEDERAL RESERVE NOTES

Series 1950 B Signatures: Priest-Anderson

✓	Delivered	New	✓	Delivered	New
A	720,000	$140.00	G	2,592,000	$125.00
B	6,336,000	125.00	H	1,152,000	130.00
C	720,000	140.00	I	288,000	150.00
D	432,000	140.00	J	720,000	140.00
E	1,008,000	130.00	K	1,728,000	130.00
F	576,000	140.00	L	2,880,000	125.00

Series 1950 C Signatures: Smith-Dillon

✓	Delivered	New	✓	Delivered	New
A	864,000	130.00	G	1,584,000	125.00
B	2,448,000	125.00	H	720,000	135.00
C	576,000	135.00	I	288,000	150.00
D	576,000	135.00	J	432,000	140.00
E	1,440,000	130.00	K	720,000	135.00
F	1,296,000	130.00	L	2,160,000	130.00

Series 1950 D Signatures: Granahan-Dillon

✓	Delivered	New	✓	Delivered	New
A	1,872,000	125.00	G	4,608,000	125.00
B	7,632,000	125.00	H	1,440,000	125.00
C	1,872,000	125.00	I	432,000	130.00
D	1,584,000	125.00	J	864,000	130.00
E	2,880,000	125.00	K	1,728,000	125.00
F	1,872,000	125.00	L	3,312,000	125.00

Series 1950 E Signatures: Granahan-Fowler

✓	Federal Reserve Bank	Delivered	New
B	New York	3,024,000	125.00
G	Chicago	576,000	130.00
L	San Francisco	2,736,000	125.00

Series 1963 A Signatures: Granahan-Fowler

Motto on back.

✓	Delivered	✓	Delivered	✓	Delivered
A	1,536,000	E	2,816,000	I	512,000
B	12,544,000	F	1,280,000	J	1,024,000
C	1,792,000	G	4,352,000	K	1,536,000
D	2,304,000	H	1,536,000	L	6,400,000

Series 1969 Signatures: Elston-Kennedy

✓	Delivered	✓	Delivered	✓	Delivered
A	2,048,000	E	2,560,000	I	512,000
B	11,520,000	F	2,304,000	J	1,792,000
C	2,560,000	G	5,888,000	K	2,048,000
D	768,000	H	1,280,000	L	7,168,000

$100 FEDERAL RESERVE NOTES

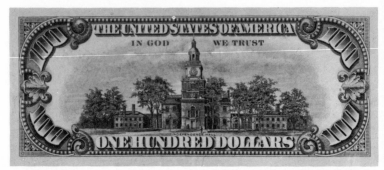

Back Design Federal Reserve Notes 1963 A-1974; also United States Notes

Series 1969 A *Signatures:* **Kabis-Connally**

✓	Delivered	✓	Delivered	✓	Delivered
A	1,280,000	E	2,304,000	I	1,024,000
B	11,264,000	F	2,304,000	J	512,000
C	2,048,000	G	5,376,000	K	3,328,000
D	1,280,000	H	1,024,000	L	4,352,000

Series 1969 B *Signatures:* **Bañuelos-Connally**

None printed.

Series 1969 C *Signatures:* **Bañuelos-Shultz**

✓	Delivered	✓	Delivered	✓	Delivered
A	2,048,000	E	7,296,000	I	512,000
B	15,616,000	F	2,432,000	J	4,736,000
C	2,816,000	G	6,016,000	K	2,944,000
D	3,456,000	H	5,376,000	L	10,240,000

Series 1974 *Signatures:* **Neff-Simon**

At present notes are being issued from all 12 Districts.

$500 FEDERAL RESERVE NOTES

Illustrations for the following high denomination Federal Reserve Notes were obtained through courtesy of the U.S. Bureau of Engraving. Notes shown are Specimen printings.

No notes higher than $100 are now in general circulation but they may occasionally be located in some banks.

$500 FEDERAL RESERVE NOTES

Five Hundred Dollars, Portrait of McKinley

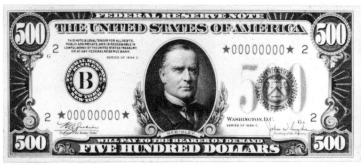

General Face Design Federal Reserve Notes. Resembling Face Design Gold Certificates.

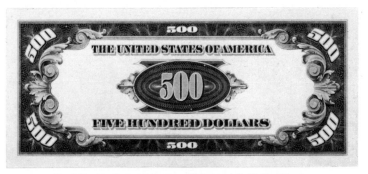

Back Design Federal Reserve Notes and Gold Certificates

Issues of $500 Federal Reserve Notes have been recorded for the following series: *Series of 1928* (Woods-Mellon); *1934* (Julian-Morgenthau); *1934 A* (Julian-Morgenthau); *1934 B* (Julian-Vinson); *1934 C* (Julian-Snyder).

See page 155 for amounts printed of these issues.

$1,000 FEDERAL RESERVE NOTES

Issues of $1,000 Federal Reserve Notes have been recorded for the following series: *Series of 1928* (Woods-Mellon); *1934* (Julian-Morgenthau); *1934 A* (Julian-Morgenthau); *1934 C* (Julian-Snyder).

See pages 155 for amounts printed of these issues.

$1,000 FEDERAL RESERVE NOTES

One Thousand Dollars, Portrait of Cleveland

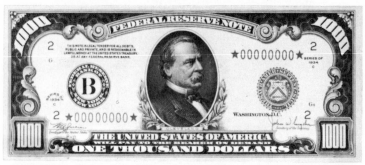

General Face Design Federal Reserve Notes. Resembling Face Design Gold Certificates.

Back Design Federal Reserve Notes and Gold Certificates

$5,000 FEDERAL RESERVE NOTES

Five Thousand Dollars, Portrait of Madison

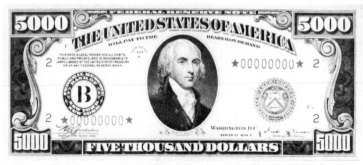

General Face Design Federal Reserve Notes. Resembling Face Design Gold Certificates.

[80]

$5,000 AND $10,000 FEDERAL RESERVE NOTES

Back Design Federal Reserve Notes and Gold Certificates
Ten Thousand Dollars, Portrait of Chase

General Face Design FRN's. Resembling Face Design Gold Certificates.

Back Design Federal Reserve Notes and Gold Certificates

Issues of both the $5,000 and $10,000 Federal Reserve Notes have been recorded for the following series: *1928* (Woods-Mellon); *1934* (Julian-Morgenthau); *1934 A* (Julian-Morgenthau); *1934 B* (Julian-Vinson.)

See page 156 for amounts printed of these issues.

GOLD CERTIFICATES — Gold Seal

Gold Certificates were not made for general circulation until 1882, though they first appeared in 1865. The first three issues were used for larger commercial transactions and were held mainly by banks and clearing houses. Denominations of large-size notes ranged from $10 to $10,000. These notes were often referred to as "gold backs" because of their orange or gold color backs.

Modern-size Gold Certificates were issued for general circulation from 1929 to 1933. Most were dated 1928 only, but it is possible that some 1928 A $10 notes were also released. There could not have been many, as the Emergency Bank Act of 1933 prevented further use of any Gold Certificates and required that they be turned in and exchanged for other currency. On December 28 of that year, Treasury Secretary Morgenthau issued an order prohibiting the holding of these notes by any private individual for any reason. Relatively few modern-size Gold notes were thus saved, especially in new condition; if any could have been hidden, they would more likely have been the large-size pieces which were naturally included in Morgenthau's order.

The Gold Reserve Act of January 31, 1934 immediately followed; this Act raised the value of gold from $20.67 to $35 per troy ounce, prohibited the circulation of gold coins, and allowed Gold Certificates to be issued only to Federal Reserve Banks. A new series of Gold Certificates, Series of 1934, was made and released to the Federal Reserve Banks in exchange for gold coin or bullion. No specimen of any notes of this series was released outside the Federal Reserve System. The $100,000 note, the highest denomination printed, is included in the Series of 1934 issue.

On April 24, 1964, Treasury Secretary Dillon signed an order removing all restrictions from the holding or acquiring of Gold Certificates issued before passage of the Gold Reserve Act of 1934. This action made possible the entry of these notes into the numismatic market, and they are now openly collected and exhibited.

Modern-size Gold Certificates Series of 1928 and 1928 A are "Gold Coin" notes, so stated on the face. No heading is found in the usual place at the top; instead, it is to the left of the portrait near the Treasury seal. The color of the seal and serial numbers is gold.

Explanatory Notations for Various Series

Series of 1928 — Notes of this series and the Series of 1928 A carry the following legal tender clause: "This Certificate Is A Legal Tender in the Amount Thereof in Payment of All Debts and Dues Public and Private."

The backs of these notes are all uniform with other modern types of similar denominations, and are printed in green.

Series of 1928 A — Apparently a small quantity of $10 Gold Certificates of this series was in fact released. The following excerpts from a sworn and notarized statement dated Feb. 5, 1971 by Robert H. Lloyd are revealing:

Robert H. Lloyd, of Silver Lake, Wyoming County, State of New York, being duly sworn, deposes, and says —

1. That during the year 1933, he was employed as a cashier in . . . Buffalo, New York, and
2. That on at least two occasions between April, 1933 and July, 1933 he received and paid out Gold Certificates, $10 denomination, Series of 1928 A (Woods-Mills) in circulated condition, and
3. That because the Certificates were soiled and wrinkled, he did not retain them for collection purposes, and
4. That he believes that the information supplied that none of these Certificates were issued is an oversight, and
5. That he believes that the early printings of the Series of 1928 A were shipped in packages bearing the label "Series of 1928" and
6. That it is known that other types of notes were shipped in packages bearing 1928 designations, while the contents were Series of 1928 A or 1928 B, and
7. That it is unlikely that the Bureau had printed a supply of labels designating the Gold Certificates, Series of 1928 A.

$10.00 & $20.00 GOLD CERTIFICATES

Series of 1934 — No notes of this series were released to circulation; therefore, they are not included in the catalog listings. The $100,000 note is illustrated, however, on page 85.

The backs of notes in this series are printed in gold, a radical departure from the green backs of all other types and series of modern notes. The "Gold Coin" clause is not used for this series, but the legal tender clause is the same as on earlier issues except for the deletion of the word "A."

Ten Dollars, Portrait of Hamilton

Face Design 1928 and 1928 A. Back Design on page 31.

√	Series	Treasurer-Secretary	Delivered	Fine	V. Fine	Ex. Fine	New
............	1928	Woods-Mellon....... 130,812,000		$15.00	$25.00	$40.00	$85.00
............	★28		45.00	85.00	130.00	200.00
............	1928 A	Woods-Mills........... 2,544,000		Unconfirmed in any collection			

Twenty Dollars, Portrait of Jackson

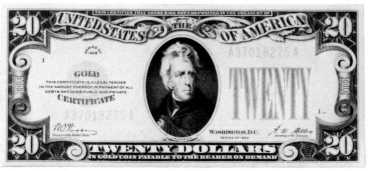

Face Design 1928 and 1928 A. Back Design on page 62.

............	1928	Woods-Mellon........ 66,204,000		25.00	32.50	55.00	100.00
............	★28		75.00	135.00	210.00	300.00
............	1928 A	Woods-Mills........... 1,500,000		Not Issued			

$50, $100, $500 & $1,000 GOLD CERTIFICATES
Fifty Dollars, Portrait of Grant

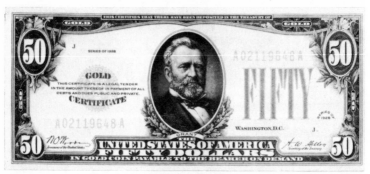

Face Design 1928. Back Design on page 69.

√	Series	Treasurer-Secretary	Delivered	Fine	V. Fine	Ex. Fine	New
............	1928	Woods-Mellon.........5,520,000		$60.00	$85.00	$120.00	$200.00
............	★28		125.00	175.00	250.00	400.00

One Hundred Dollars, Portrait of Franklin

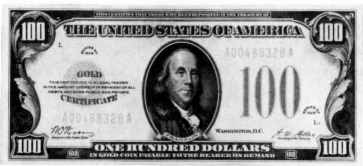

Face Design 1928. Back Design on page 74.

............	1928	Woods-Mellon.........3,240,000		115.00	140.00	175.00	275.00
............	★28		200.00	320.00	450.00	700.00
............	1928 A	Woods-Mills.............120,000			Not Issued		

Five Hundred Dollars, Portrait of McKinley
See page 79 for Resembling Face and Back Designs.

	√	Series	Treasurer-Secretary	Delivered
	1928	Woods-Mellon...........420,000	

One Thousand Dollars, Portrait of Cleveland
See page 80 for Resembling Face and Back Designs.

............	1928	Woods-Mellon...........288,000

$5,000, $10,000 & $100,000 GOLD CERTIFICATES

Five Thousand Dollars, Portrait of Madison
See pages 80-81 for Resembling Face and Back Designs.

✓	Series	Treasurer-Secretary	Delivered
............	1928	Woods-Mellon	24,000

Ten Thousand Dollars, Portrait of Chase
See page 81 for Resembling Face and Back Designs.

............	1928	Woods-Mellon	48,000

Gold Certificates were made in the Series of 1934 for use within the Federal Reserve System, and were not allowed into outside circulation. Denominations were $100, $1000, $10,000 and $100,000. This last is the highest denomination of modern-size currency ever printed by the United States, and is shown below. The portrait is of Woodrow Wilson.

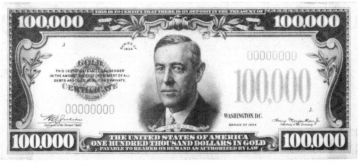

The $100,000 Gold Certificate, Series of 1934.

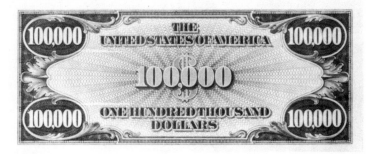

The order of April 24, 1964 legalizing the holding of Gold Certificates covered all such Certificates released to general circulation through January 30, 1934. Thus, no Gold Certificates Series of 1934 may be legally held, since they were all made and delivered after the January 30 cutoff date. For this reason, no Series of 1934 Gold Certificates are included in the listings, but their delivery totals are shown in Appendix B.

WORLD WAR II ISSUES

The Yellow Seal Silver Certificates

These were issued in North Africa during operations there in 1942. Later they were issued briefly at the beginning of the Sicilian campaign.

All bear the Julian-Morgenthau signature combination. Though the Treasury seals were printed in yellow, the serial numbers retained their usual blue color.

✔	Denomination	Series	Delivered	V. Fine	Ex. Fine	New
...............	$1.00	1935 A	26,916,000	$5.00	$8.00	$21.00
...............		★35 A		50.00	85.00	175.00
...............	5.00	1934 A	16,660,000	12.00	18.00	32.50
...............		★34 A		60.00	80.00	120.00
...............	10.00	1934	included below	1000.00	2250.00
...............		★34			Very Rare	
...............	10.00	1934 A	21,860,000	16.50	25.00	42.50
...............		★34 A		50.00	70.00	110.00

The $5.00 1934 series was reported some years ago but has never been confirmed. Verification is welcomed.

The HAWAII Overprints — Brown Seal

In July of 1942, specially marked U.S. currency was introduced in Hawaii as an economic defense measure against a possible Japanese invasion. If these notes had fallen into enemy hands, they could have been isolated easily and declared valueless. After August 15, 1942, no currency other than the "Hawaiian Series" was allowable without a license from the Territorial Governor. It was not until October 21, 1944, that all restrictions were revoked and normal monetary conditions returned to the area.

The notes are overprinted HAWAII face and back as illustrated. They also contain brown seals and serial numbers. All bear the Julian-Morgenthau signature combination. $1 notes are Silver Certificates; all the rest are San Francisco Federal Reserve notes.

It is significant that the HAWAII dollars were also used to redeem Japanese Military Yen on the liberated Central Pacific islands.

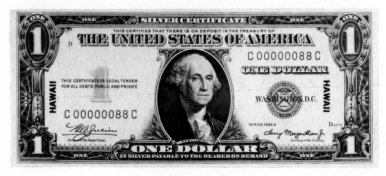

Face Design $1 HAWAII

WORLD WAR II ISSUES

Back Design $10 HAWAII

Face Design $20 HAWAII

✓	Denomination	Series	Delivered	V. Fine	Ex. Fine	New
...............	$1.00	1935 A.........35,052,000		$5.00	$7.00	$16.50
...............		★35 A.................		65.00	85.00	160.00
...............	5.00	1934.........3,000,000		30.00	55.00	95.00
...............		★34....................		80.00	160.00	275.00
...............	5.00	1934 A.........6,416,000		13.50	25.00	45.00
...............		★34 A.................		50.00	75.00	125.00
...............	10.00	1934 A.........10,424,000		20.00	30.00	50.00
...............		★34 A.................		50.00	75.00	125.00
...............	20.00	1934.......included below		110.00	235.00	500.00
...............		★34....................		300.00	500.00	1000.00
...............	20.00	1934 A.........11,246,000		32.50	50.00	80.00
...............		★34 A.................		65.00	95.00	180.00

Experimental "R" and "S" $1.00 Silver Certificates

These notes were made during World War II to test the wearing qualities of regular and special paper. Equal quantities were overprinted on the face with a red R or S, in the position shown. All bear signatures of Julian-Morgenthau and are dated Series 1935 A.

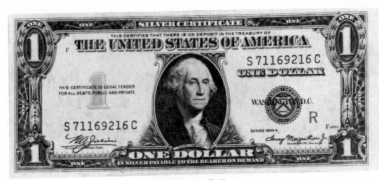

Face Design R Note

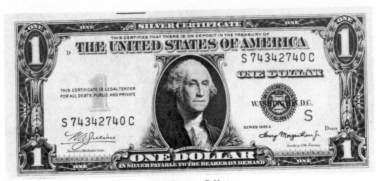

Face Design S Note

✓		Delivered	Fine	V. Fine	Ex. Fine	New
........	$1 with Red R..........1,184,000		$17.50	$30.00	$50.00	$90.00
........	R Star note....*12,000 printed*		200.00	300.00	400.00	525.00
........	$1 with Red S..........1,184,000		15.00	22.50	40.00	75.00
........	S Star note....*12,000 printed*		200.00	300.00	400.00	525.00

The R and S overprints were made to determine whether a special kind of paper might wear better in circulation than the regular paper normally used. The "R" represented those notes made of regular paper and the "S" was for those notes made of the special paper. Results of the experiment were inconclusive and no change was made in the kind of paper used for U. S. currency.

It is advisable to check the serial numbers given on page 158 in the Appendix when purchasing these notes, as dangerous imitations exist.

UNCUT SHEETS OF CURRENCY

Subjects Per Sheet and Check Letters

Modern U. S. currency has been printed in sheets of 12, 18 and 32 notes. All issues up to April of 1953 were made in 12-subject sheets, with Check Letters from A to L (12 letters for 12 notes). Each note carries two identical Check Letters, which serve to indicate its particular position on the sheet when it was printed. These small capital letters are found in the upper left and lower right areas on the face side. The little number accompanying the lower right Check Letter is the Face Plate Number; it has nothing to do with the sheet position of the note.

On April 2, 1953, the Treasury issued the first notes printed in 18-subject sheets. These carry Check Letters from A through R but are otherwise similar to earlier issues.

On July 25, 1957, the Bureau of Engraving began production of notes printed in sheets of 32 subjects. Each sheet consists of four quadrants of eight notes, as shown in the diagram on page 97. The upper left quadrant contains Check Letters and numbers A_1 through H_1, the lower left A_2 through H_2, the upper right A_3 through H_3 and the lower right A_4 through H_4. The letter indicates position and the number indicates the quadrant. As with earlier issues, each note bears two identical Check Letters, but there is an important difference. The quadrant number (1 to 4) appears only with the *upper left* Check Letter. The number found with the lower right Check Letter is the Face Plate Serial Number; while it may correspond at times with the quadrant number, it has no relationship to the position or quadrant of the note. (Backs also carry a Back Plate Serial Number; its position varies with the design or denomination.)

Serial Numbering for Different Sizes of Sheets

As the number of subjects per sheet was changed, so also was the system used for placing serial numbers on the notes. The following table shows which system was used for each size of sheet, and applies to all issues except National Currency Series of 1929 and Federal Reserve Bank Notes:

Size of Sheet	Check Letters	System of Numbering
12 Subjects	A through L	Consecutive numbering by half sheet, six down on the left and six down on the right.*
18 Subjects	A through R	Numbering advances by 8,000, six down on the left, six following in the middle and six down on the right.
32 Subjects	A_1-H_1 A_2-H_2 A_3-H_3 A_4-H_4	Numbering advances by 20,000, proceeding by quadrant from the upper left to the lower right.

*See next page for numbering of sheets released in uncut form.

UNCUT SHEETS OF CURRENCY
Sheet Sizes for Currency Issues 1929 to Date

| Type | Denomination | SHEET SIZE AND SERIES | | |
		12 Subjects	18 Subjects	32 Subjects
United States Notes	$1	1928		
	$2	1928-1928G	1953-1953C	1963-1963A
	$5	1928-1928F	1953-1953C	1963
	$100			1966-1966A
Silver Certificates	$1	1928-1935D	1935D-1935H	1957-1957B
	$5	1934-1934D	1953-1953C	
	$10	1933-1934D	1953-1953B	
Federal Reserve Notes	$1			1963-1974
	$5, $10, $20	1928-1950	1950A-1950E	1963-1974
	$50, $100	1928-1950	1950A-1950E	1963A-1974
	All above $100	12 subjects		

In addition, all modern-size National Currency, Federal Reserve Bank Notes, and Gold Certificates were printed in 12-subject sheets.

Clarification of 12-Subject Numbering

12-subject sheets exist both with consecutive serial numbers by half sheet as described above and with *all twelve* notes in full consecutive order. An example of each is illustrated on pages 91-92. As explained by the Bureau, the general rule was that sheets intended for processing as regular issues for circulation were numbered by the half sheet according to the following example: Suppose that the total of a particular run was to be 1,200 notes, or 100 sheets. The first sheet would contain serial numbers from 1 to 6 on the left side and 601 to 606 on the right side, the second sheet would have numbers 7 to 12 and 607 to 612, and so on until the end of the run.

Sheets delivered to the Treasurer in uncut form, presumably for release upon request to collectors and others, often but not always bore consecutive numbers for all the notes on the sheet. In 1950, it was officially ordered that all uncut 12-subject sheets scheduled for delivery to the Treasurer should thenceforth bear serial numbers in fully consecutive order for the entire sheet.

Reconstructed Sheets and Consecutive Numbers

If a collector is able to locate all of the single notes originally printed as one unit or sheet, he will then be able to show them in the positions they formerly occupied before being cut apart. This group of notes comprises what is termed a "reconstructed sheet" of currency.

Reconstructed half-sheets of 12-subject printings could easily be assembled by obtaining six consecutively numbered notes from a new pack, making sure that Check Letters ran from A to F, or G to L. It would be extremely difficult to assemble all notes for a full 12-subject sheet as evidenced by the explanation of the numbering system (see above). Reconstruction of larger sheets is practically impossible, since the changes in the numbering system make a difference of 136,000 numbers on each 18-subject sheet and 640,000 numbers on each 32-subject sheet.

Consecutively numbered notes from the 18 or 32-subject sheets are readily available, but are of little consequence since *each note* comes from a *different sheet*. Easy proof of this fact can be seen on the notes themselves; they will all have the same Check Letters indicating identical positions on their respective sheets.

UNCUT SHEETS OF CURRENCY

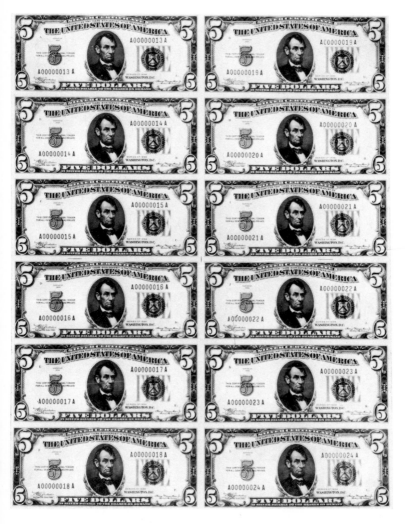

12-subject sheet of currency with all notes consecutively numbered. Sheets with this kind of numbering were the ones generally made available to collectors during the years when uncut sheets could be obtained.

UNCUT SHEETS OF CURRENCY

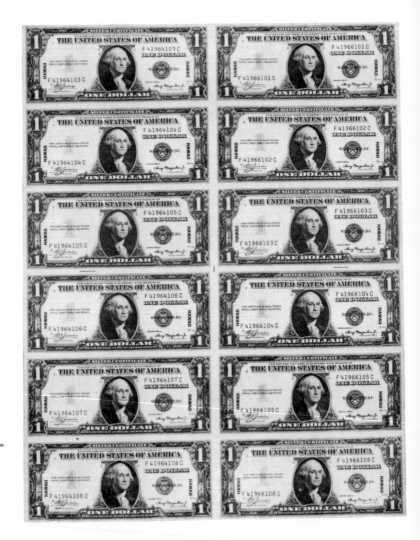

12-subject sheet of currency with notes consecutively numbered by half-sheet, and a number gap between notes in the lower left and upper right positions. Sheets with this kind of numbering are scarcer than those with fully consecutive numbering for all 12 notes.

UNCUT SHEETS OF CURRENCY

National Currency and Federal Reserve Bank Notes

National Currency and Federal Reserve Bank Notes were printed in sheets of 12 subjects, then cut and delivered to the banks in vertical sheets of six subjects.

Type One National Currency used the same serial number and suffix letter for all six notes; however, each note had a different prefix letter (A through F) which also served to denote its position on that particular six-subject sheet.

Type Two National Currency notes were consecutively numbered and bore the same prefix letter, but the suffix letter was dropped. The only way to tell the sheet position of a Type Two note or a Federal Reserve Bank Note is by its Check Letters. (See illustrations of National Currency sheets on following page.)

Since National Currency and Federal Reserve Bank Notes were all printed in 12-subject sheets (even though delivered in six-subject sheets), Check Letters proceeded from A to L as on all other 12-subject printings. Thus, it is always possible to pinpoint the exact position of any note on the original 12-subject sheet. Check Letters A through F indicate the left strip of six notes, and G through L indicate the right strip of six notes.

Each note also carries a Face Plate Serial Number in its normal position alongside the lower right Check Letter.

Numbering for Federal Reserve Bank Notes was also consecutive. Every serial number was preceded by the District letter as a prefix, and "A" as a suffix. No single issue was large enough to require the change of suffix letter to "B."

VALUATIONS OF UNCUT SHEETS

The most readily available uncut sheets of any U. S. currency are the six-subject sheets of National Currency which were delivered to issuing banks intact. It is easy to see why quantities of these sheets exist; the banks released the notes as they were needed, and many never used all that they had ordered. Also, quantities of sheets with low serial numbers were preserved for various reasons.

The following valuations apply to any sheet of these notes after the particular rarity rating of the issue as single notes has been ascertained from the listing on page 34.

National Currency Series of 1929

Six-subject Sheets

Denom-ination	Rarity 1 & 2	Rarity 3 & 4	Rarity 5	Rarity 6	Rarity 7	Rarity 8
$5.00	$350.00	$350.00	$425.00	$500.00	$625.00	$1125.00
10.00	385.00	425.00	450.00	525.00	650.00	1150.00
20.00	450.00	500.00	525.00	600.00	725.00	1200.00
50.00	1050.00	1125.00	1250.00	1325.00	1400.00	1550.00
100.00	1325.00	1500.00	1600.00	1900.00	2300.00	2600.00

Until about 1954, limited quantities of certain uncut sheets of currency were available from the Bureau of Engraving for numismatic and educational purposes. Most sheets released in this manner were of 12 subjects, since the Bureau had only begun the printing of 18-subject sheets during 1953. Shortly thereafter, no more uncut sheets were made available to anyone.

UNCUT SHEETS OF CURRENCY

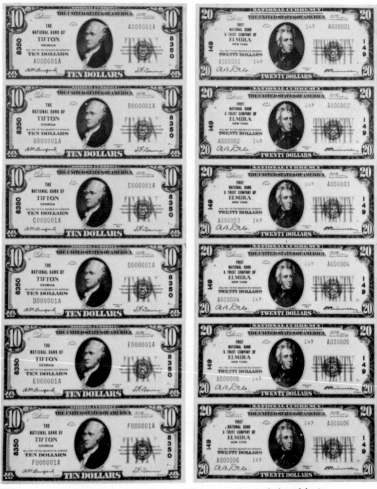

AT LEFT: Type One National Currency sheet of six subjects. Each note has the same serial numbers except for prefix letter.

AT RIGHT: Type Two National Currency sheet of six notes. Serial numbers are consecutive and without suffix letter. Much scarcer than Type One.

(For explanation of the above, see pages 33 and 93.)

UNCUT SHEETS OF CURRENCY

Apparently the two types generally released in sheets were United States Notes and Silver Certificates. Other types are known but are extremely rare.*

All uncut sheets are considered to be in new condition, even though the edges, corners or margins may have minor flaws. The following listing represents all sheets which may occasionally be available. Number of sheets issued is given where known. NR = Not Reported.

* One six-subject sheet of $10 New York Federal Reserve Bank Notes is recorded in the Grinnell Collection. Another, a 12-subject sheet of the same issue, was uncovered in the estate of a Federal Reserve Bank official in 1966. Both are possibly unique.

Sheets of Federal Reserve Notes are almost their equal in rarity. For a listing see Gene Hessler's book (in Bibliography).

UNITED STATES NOTES

One Dollar

✔	Series	Issued	Sheet Size	Valuation
...........	1928.........11 (8 traced)........12 Subjects.......$7500.00			

Two Dollars

...........	1928.........5 (3 traced).........12 Subjects............Rare			
...........	1928 C.......25 (9 traced)........12 Subjects....... 1300.00			
...........	1928 D.......50 (9 traced)........12 Subjects....... 1000.00			
...........	1928 E.......50 (17 traced).......12 Subjects....... 1150.00			
...........	1928 F.......100................12 Subjects....... 800.00			
...........	1928 G.......100................12 Subjects....... 800.00			
...........	1953.........100................18 Subjects....... 1400.00			

Five Dollars

...........	1928.........5...................12 Subjects....... 1400.00			
...........	1928 D.......NR (10 traced)......12 Subjects....... 1450.00			
...........	1928 E.......100................12 Subjects....... 950.00			
...........	1928 F.......NR (None verified).....................			
...........	1953.........100................18 Subjects....... 2000.00			

SILVER CERTIFICATES

One Dollar

...........	1928.........80.................12 Subjects....... 1100.00			
...........	1928 A.......NR (None verified)....................			
...........	1928 B.......6 (None verified).....................			
...........	1928 C.......11 (6 traced)........12 Subjects............Rare			
...........	1928 D.......60 (18 traced)......12 Subjects............Rare			
...........	1928 E.......25† (7 traced).......12 Subjects......Very Rare			
...........	1934.........25 (7 traced)........12 Subjects....... 1300.00			
...........	1935.........100................12 Subjects....... 900.00			
...........	1935 A.......100................12 Subjects....... 900.00			

† Most were cut into single notes.

(Cont. on page 98)

UNCUT SHEETS OF CURRENCY

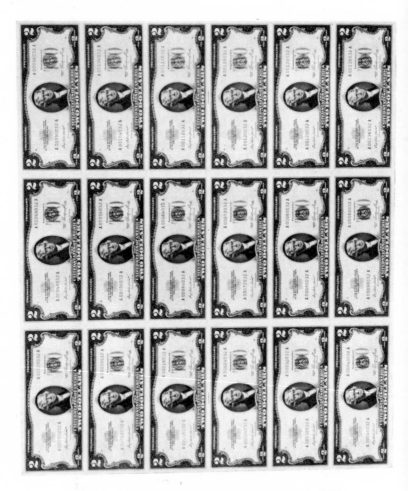

18-subject sheet of currency. Numbering advances by 8,000
(see pages 89-90 for further data).

UNCUT SHEETS OF CURRENCY

E_3 E	A_3 A	E_1 E	A_1 A
F_3 F	B_3 B	F_1 F	B_1 B
G_3 G	C_3 C	G_1 G	C_1 C
H_3 H	D_3 D	H_1 H	D_1 D
E_4 E	A_4 A	E_2 E	A_2 A
F_4 F	B_4 B	F_2 F	B_2 B
G_4 G	C_4 C	G_2 G	C_2 C
H_4 H	D_4 D	H_2 H	D_2 D

Layout of 32-Subject Currency Sheet

Check letters and quadrant number are shown for each note.

(Also see page 89 for further details.)

UNCUT SHEETS OF CURRENCY

✓	Series	Issued	Sheet Size	Valuation
............	1935 B.........100 (23 traced).......12 Subjects........$1000.00			
............	1935 C.........100.................12 Subjects........ 900.00			
............	1935 D.........300.................12 Subjects........ 800.00			
............	1935 D.........102.................18 Subjects........ 900.00			
............	1935 E.........400.................18 Subjects........ 950.00			

Five Dollars

✓				
............	1934.........25 (8 traced).........12 Subjects........ 2000.00			
............	1934 A.......NR (None verified).....................			
............	1934 B.......20 (8 traced).........12 Subjects........ 2000.00			
............	1934 C.......100.................12 Subjects........ 1000.00			
............	1934 D.......100.................12 Subjects........ 850.00			
............	1953.........100.................18 Subjects........ 1750.00			

Ten Dollars

✓				
............	1933.........1....................12 Subjects........			
............	1933 A.......1....................12 Subjects.....Not Located			
............	1934.........10 (5 traced).........12 Subjects...........Rare			
............	1953.........100.................18 Subjects........ 1500.00			

WORLD WAR II ISSUES
One Dollar, HAWAII Overprint

✓				
............	1935 A........25.................12 Subjects........ 1650.00			

One Dollar, Yellow Seal

✓				
............	1935 A........25.................12 Subjects........ 2000.00			

ERROR AND FREAK NOTES

Though every effort is made to prevent error notes from slipping into circulation, some have occasionally been found by alert collectors. Error notes are those which show some irregularity from having gone incorrectly through one or more of the printing and cutting processes. Much collector interest has been focused on such notes, especially in recent years as a parallel to the spiraling demand for freak and error coins.

There are many ways an error can occur on currency. Consider that the sheets must undergo separate processes for printing the faces, backs, and the overprint which for years consisted of seals, serial numbers, series, signatures (and District numbers where applicable). In addition, there are the trimming and cutting operations — and it is not hard to imagine all sorts of errors or error combinations appearing on some notes.

VALUATIONS OF ERROR NOTES

As a general rule, the prominence of the error directly affects its numismatic desirability. Valuations included here are thus to be considered as approximate premiums only, *in addition to the face value of any note.* Rare notes with a high catalog value may have an additional premium.

Caution: collectors should be aware of contrived error notes which have recently been reported on the market.

On rare occasions a piece of paper will adhere to a currency sheet, take some of the imprint, go through the various processes and fall off at a later time. The above note carries a large blank space formerly occupied by just such a piece of paper, perhaps a marker or some sort of tab. On rarer occasions, such a note *with the stray piece of paper still adhering to it* has been found.

V. Fine, $45.00 Ex. Fine, $65.00 New, $120.00

This note carries a double impression because the sheet on which it was printed went twice through the same overprinting process for its seals, signatures, and serial numbers.

V. Fine, $150.00 Ex. Fine, $250.00 New, $425.00

ERROR AND FREAK NOTES

The above note has an extra flap of paper on one corner, the result of an accidental folding of the sheet before it was face printed and cut. The flap is unfolded to show a corner of the face printing.

V. Fine, $25.00 Ex. Fine, $30.00 New, $45.00

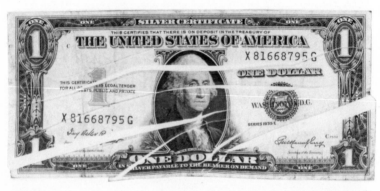

This note has long white streaks of unprinted paper through it, the result of inner folds in the sheet before the face side was printed. This kind of note usually has one single white streak. Multiple streaking is rare. Values below are for the usually found single streak error.

V. Fine, $7.00 Ex. Fine, $10.00 New, $20.00

The following note has the top of the next note showing, and a slice of its own top missing — resulting from the face of this note having been printed off-register.

Since notes are trimmed with faces showing, the faulty alignment went undetected.

V. Fine, $17.50 Ex. Fine, $22.50 New, $40.00

A double denomination note, showing $5 on the face and $10 on the back. This is the result of a sheet printed on one side being inadvertently placed with sheets of another denomination which were also printed only on one side. Such notes are among the rarest and most desirable of all errors.

V. Fine, $1500.00 Ex. Fine, $2000.00 New, $3750.00

ERROR AND FREAK NOTES

A wet ink transfer, front printing on back. This was caused by the impression roller making contact with the plate, the plate transferring ink to

the roller, then the roller placing the image in retrograde on the next sheet fed into the press.

V. Fine, $65.00 **Ex. Fine, $95.00** **New, $150.00**

Note with part of the overprinting on a corner of the face and some of the back is pictured with fold intact. Later the sheet became unfolded for cutting into individual notes.

V. Fine, $70.00 **Ex. Fine, $90.00** **New, $135.00**

ERROR AND FREAK NOTES

This note has its serial numbers mis-matched, on the second digit.

V. Fine, $15.00 Ex. Fine, $25.00 New, $40.00

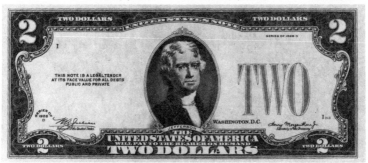

This United States Note never received any of the usual overprinting features. Missing are seal and serial numbers.

V. Fine, $135.00 Ex. Fine, $190.00 New, $300.00

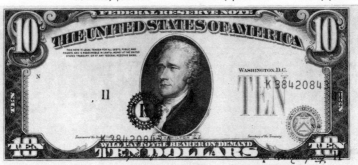

Overprint too low and too far to the right. Caused by faulty alignment of sheets for the overprinting operation.

V. Fine, $35.00 Ex. Fine, $50.00 New, $75.00

ERROR AND FREAK NOTES

This extraordinary item is a fragment that went through the normal printing processes of a finished note. As such it is an obvious rarity.

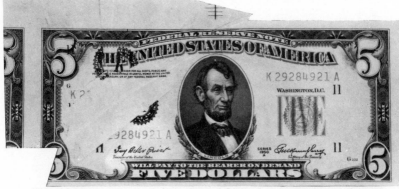

This misprint was caused by a large fold in the sheet prior to the overprint only, the back and face being normal. The fold remained intact through the cutting operation. V. Fine, $45.00 Ex. Fine, $55.00 New, $85.00

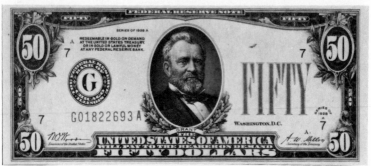

This note had a large portion of the sheet covered during the overprinting operation, thus deleting some features of the overprint.

V. Fine, $30.00 Ex. Fine, $50.00 New, $75.00

ERROR AND FREAK NOTES

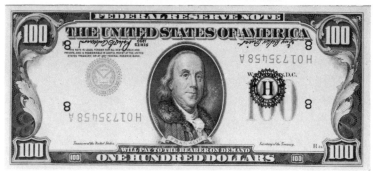

The above note received its overprint; however, the sheet was turned up-side down as it was overprinted with seals, District numbers, series date, signatures and serial numbers.

V. Fine, $350.00 Ex. Fine, $400.00 New, $500.00

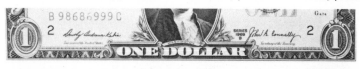

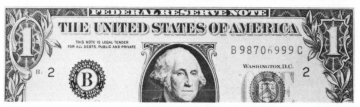

The above note came from a sheet grossly out of alignment during the cutting process.

V. Fine, $300.00 Ex. Fine, $400.00 New, $600.00

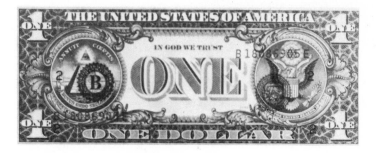

ERROR AND FREAK NOTES

The bottom note on the previous page received the overprinting of seals and serial numbers (third process) on the back instead of the face.

V. Fine, $150.00 Ex. Fine, $200.00 New, $300.00

Aside from those illustrated, some other errors are as follows:

a. Mis-matched type designation vs. overprint, such as a Silver Certificate frame with green seal, serial numbers and a Federal Reserve Bank seal. This is truly an amazing error and obviously of extreme rarity.

V. Fine, $850.00 Ex. Fine, $1200.00 New, $1600.00

b. An extraordinary error which escaped the face design printing entirely and received only the third process overprinting (seals and serial numbers) on the blank face side. In recent months this odd-looking item has been illustrated in a coin newspaper and a private sales list.

Very rare

c. So-called inverted backs; in reality, inverted faces. This is because the backs are printed first and the sheet becomes rotated for the printing of its face side, the second operation.

V. Fine, $50.00 Ex. Fine, $75.00 New, $110.00

d. Uneven printing, where a section of the note may be lightly printed or practically missing.

V. Fine, $10.00 Ex. Fine, $12.50 New, $20.00

e. The "Red Dye Strip" note — this piece has a bright red strip diagonally across both the face and the back. The red strip on the paper meant the end of the roll was near. One example verified.

On rare occasions a substantial quantity of notes may be made with a repeated mistake. A now-famous error occurred during the printing of $1 Silver Certificates Series 1957, serial numbers in the G55------A issue. The second digit in the serial numbers was mis-matched (G55 vs. G54) on 10,000 of these dollars, which were stored until mid-1963 and then released at Ft. Benning, Georgia. The error was quickly noticed, resulting in widespread national publicity; many of them have since been absorbed in the numismatic market.

BUREAU OF ENGRAVING A.N.A. SOUVENIR CARDS

During recent years the Bureau of Engraving has produced and made available to collectors a special souvenir card for the annual convention of the American Numismatic Association. These cards have become popular with collectors as they feature subjects of recognized significance artistically and numismatically. Original selling price for all cards from 1969 to 1974 was $1; those that have gone "out of print" now sell for considerably more.

A.N.A. SOUVENIR CARDS

The A.N.A. 78th Anniversary Card 1969

This was the first A.N.A. numismatic card produced by the Bureau; it was initially released at the A.N.A. Convention in 1969 in Philadelphia. Measuring 229 x 156 mm, the card features a fine black and white engraving of the American Eagle and an interesting explanation of the famous misnomer "Jackass Notes" for some early notes which showed this eagle.

A.N.A. 78th Anniversary Card 1969: 12,362 produced $25-35

The A.N.A. 79th Anniversary Card 1970

The second A.N.A. card was released at the St. Louis A.N.A. Convention in 1970. Of larger size, 270 x 217 mm, this card bears a full-color collage of portions of various notes as examples of the fine engraving work inherent in their production.

A.N.A. 79th Anniversary Card 1970: 12,017 produced $45-55

A.N.A. SOUVENIR CARDS

The A.N.A. 80th Anniversary Card 1971

The third A.N.A. souvenir card was released at the 1971 A.N.A. Convention in Washington, D.C. The design centers on a reproduction of the "History Instructing Youth" scene from the face side of the $1 Silver Certificate Series of 1896. Size is the same as the 1970 card.

A.N.A. 80th Anniversary Card 1971: 54,721 produced...............$4-5

The A.N.A. 81st Anniversary Card 1972

The fourth A.N.A. souvenir card was released at the 1972 Convention in New Orleans, Louisiana. It shows the face side of the $2 Silver Certificate Series of 1896. This is part of the well known and beautiful "Educational Series"; the vignette is entitled "Science Presenting Steam and Electricity to Commerce and Manufacture."

A.N.A. 81st Anniversary Card 1972: 74,172 produced...............$2-3

A.N.A. SOUVENIR CARDS
The A.N.A. 82nd Anniversary Card 1973

The fifth **A.N.A.** souvenir card was released at the 1973 Convention in Boston, Massachusetts. The design centers on the highest issued denomination of the large-size "Educational Series" of notes made in 1896, the $5.

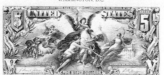

A.N.A. 82nd Anniversary Card 1973: 49,544 produced$5-6

The A.N.A. 83rd Anniversary Card 1974

The sixth souvenir card, released at the 1974 **A.N.A.** Convention in Bal Harbour, Florida, shows the face side of the proposed $10 Silver Certificate Series of 1897. It was designed as part of the "Educational Series"; the vignette is entitled "Agriculture and Forestry."

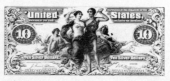

A.N.A. 83rd Anniversary Card 1974: c. 50,000 produced$2

The A.N.A. 84th Anniversary Card 1975

The seventh card is scheduled for release in Los Angeles during the **A.N.A.** Convention there. Cost is $1 at the show and $1.25 by mail from the Bureau.

MILITARY PAYMENT CERTIFICATES

Military Payment Certificates are special U.S. government notes in denominations ranging from 5¢-$20. They were issued only to U.S. military and authorized civilian personnel overseas and only in certain areas where currency control was deemed necessary. No MPC is negotiable in the United States.

An urgent need for this type of special currency arose immediately after the end of World War II. U.S. military personnel had access to all sorts of goods then extremely scarce in war-torn Europe and the Pacific area. Through a combination of short-sightedness, mismanagement and general apathy a vigorous black market emerged, especially in Germany where a veritable flood of Russian-made Allied Military Marks easily came into possession of U.S. troops through various transactions with Russian soldiers; this money was then exchanged into dollar credits which the U.S. soldiers sent home. It was thus possible for military personnel to amass huge profits as they exchanged amounts into dollar credits far in excess of what they had been paid. The resultant deficit in the Army budget was called an overdraft; at its height this amounted to a staggering $530,775,440!

It was acutely apparent that military currency control had broken down completely. Various methods were then introduced in an effort to stabilize the situation, but none proved successful. Finally, after various proposals, recommendations, and a successful trial run in the Pacific using Type A Military Yen, the issuance of Military Payment Certificates was approved by the Secretary of War on August 7, 1946. Target dates were set for the European and Mediterranean theaters at between September 10 and 20, and between the 20th and 30th in the Pacific. Actual dates of issue were September 16 and 29, respectively. Immediate objectives were achieved through these notes, and they have since been used in all places where the military desired to maintain effective currency control.

Use of MPC's in Designated Countries or Areas

At first widespread, the use of MPC's has gradually diminished as areas became financially able to welcome the dollar. MPC's have been used in the following places for the periods indicated:

Country	Period of Use	Country	Period of Use
Austria	9/16/46–1/27/56	Japan	9/29/46–5/19/69
Belgium	9/16/46–3/25/55	Korea	9/29/46–11/18/73
Cyprus	1/14/59–6/5/67	Libya	9/16/46–1970
England	9/16/46–3/29/60	Morocco	9/16/46–1/9/61
France	9/16/46–8/25/58	Philippines	9/29/46–9/10/63
Germany	9/16/46–8/25/58	Ryukyus	9/29/46–8/25/58
Greece	9/16/46–1955	Scotland	9/16/46–3/29/60
Hungary	9/16/46–1955	Trieste, Free Territory	9/16/46–1955
Iceland	9/16/46–9/13/61	Vietnam	8/31/65–3/15/73
N. Ireland	12/20/57–3/29/60	Yugoslavia	9/16/46–1955
Italy	9/16/46–8/25/58		

No issues are currently being used anywhere.

General Characteristics of MPC's

All Military Payment Certificates are lithographed (surface printed) instead of being produced from engraved plates as is regular U.S. currency. The first seven issues (Series 461-591) were produced by two private firms under contract with the Bureau of Engraving, with printing plates prepared by the Bureau. Beginning with Series 611, all issues have been printed entirely by the Bureau.

Thirteen different issues have been made since their inception in 1946. As these issues have progressed, there has been a tendency to be more flexible and creative in their makeup. The first two issues, Series 461 and 471, are identical in design except for color, and the style is hardly more than utili-

MILITARY PAYMENT CERTIFICATES

tarian. The third issue, Series 472, makes a better appearance but is still rather plain. Series 481 introduces a significant dimension to the usage of vignettes in that the one used on the $5 and $10 appeared in the past on regular issue currency ($50 National Currency Series of 1902). This practice is again employed later for one Series 521 and two Series 661 vignettes. Also, for the first time (Series 481) separate designs are used for each size of note.

It is with Series 521 that radical departures are made from previous issues which became standard for succeeding series. Each denomination now has its own color combination, and designs are uniform only for the small size notes as the others each have individual designs. The portrayals of unidentified female faces also begins at this time, and is fairly consistent except for Series 681 which uses military vignettes. The $5 notes are made smaller than the $10 but still larger than the $1. Also, beginning with Series 521 the denomination is shown on the back, where formerly none did.

In a number of instances vignettes have been borrowed from one **MPC** series to another. The vignette on small notes of Series 481 is also seen on the back of the $10 Series 611. The young girl on the back of the $1 Series 521 appears again on small notes of Series 661. Another 521 portrait, that on the $10 face side, is used also on the back of the 661 $10. The $10 Series 591 and $1 Series 661 have similar portraits, and the entire Series 651 is the same as Series 641 except for the Minute Man addition and color changes.

Changeover of MPC from an Old Series to a New Series

As the use of MPC occurs in a designated area, it has been found that a large quantity of the notes eventually comes into possession of local nationals and to some extent into the local economies. When these and other conditions of unauthorized use of **MPC** are found to exist it becomes necessary to invalidate the current **MPC**, swiftly recall all of it from authorized holders, and issue a new series. This conversion from the old to a new series takes place in a 24-hour period called C-Day. C-Day can be expected to occur on an unannounced date, as the element of surprise is essential to its success. Many restrictions on personnel activities are imposed, and various other precautions are taken to ensure that no unauthorized holders of **MPC** may convert their holdings to the new series.

General Specifications for All MPC Issues

a. *Denominations:* All series from 461 through 641 consist of 5¢, 10¢, 25¢, 50¢, $1, $5 and $10. Series 651 contains only the $1, $5 and $10 which were issued; Series 661 introduces the $20 denomination which is included in all succeeding issues.

b. *Sizes of individual notes are as follows:*
All 5¢ through 50¢, small size: 110/55 mm.
All $1, intermediate size: 112/66 mm.
$5 Series 461-481, large size: 156/66 mm.
$5 Series 521 and later, modified size: 136/66 mm.
$10 and $20, large size: 156/66 mm.

c. *Position numbers:* Each note has a position number to designate its exact position on a full sheet of notes. Sheets are divided as follows for the various note sizes (see charts under d.):
5¢ through 50¢, small size: Position numbers 1-84.
$1, intermediate size: Position numbers 1-70.
$5, modified size: Position numbers 1-50.
Sheets of the modified size $5 notes have a very wide blank margin on one side before they are trimmed.
$5, $10, $20, large size: Position numbers 1-50.

MILITARY PAYMENT CERTIFICATES

d. *Sheet layout:* The various denominations are positioned on their respective sheets as follows:

5-50¢ Sheet Layout

1	5	9	13	17	21	25
2	6	10	14	18	22	26
3	7	11	15	19	23	27
4	8	12	16	20	24	28
29	33	37	41	45	49	53
30	34	38	42	46	50	54
31	35	39	43	47	51	55
32	36	40	44	48	52	56
57	61	65	69	73	77	81
58	62	66	70	74	78	82
59	63	67	71	75	79	83
60	64	68	72	76	80	84

$1 Sheet Layout

1	6	11	16	21	26	31
2	7	12	17	22	27	32
3	8	13	18	23	28	33
4	9	14	19	24	29	34
5	10	15	20	25	30	35
36	41	46	51	56	61	66
37	42	47	52	57	62	67
38	43	48	53	58	63	68
39	44	49	54	59	64	69
40	45	50	55	60	65	70

$5-10-20 Sheet Layout

1	6	11	16	21
2	7	12	17	22
3	8	13	18	23
4	9	14	19	24
5	10	15	20	25
26	31	36	41	46
27	32	37	42	47
28	33	38	43	48
29	34	39	44	49
30	35	40	45	50

e. *Sheet size:* When printed by commercial firms the notes are made in double sheets 54 x 32 inches. After the notes are finished these are cut in half and each part is then inventoried as a full 27 x 32 inch sheet. When printed by the Bureau of Engraving the sheets are made only in the 27 x 32 inch size.

f. *Paper:* All issues are produced on unwatermarked paper in which are embedded tiny blue and pink colored discs called planchettes. Planchettes are widely used as an anti-counterfeiting device.

g. *Identifying letters with serial numbers:* The first issue, Series 461, has eight-digit serial numbers with prefix and suffix letter A; the second issue, Series 471, uses letter B, and so on. Series 641 uses J instead of I to avoid confusion between letters and numbers. Series 651 begins again with letter A, Series 661 with B, and the pattern is set once again.

h. *Replacement notes:* These are notes made to substitute for regular notes spoiled during printing. For every series, replacement notes use the correct prefix letter but simply omit the suffix. They have their own numbering sequence; thus their serial numbers are generally rather low. No figures are available regarding numbers of such notes made for any series, but all are scarce and command substantial premiums.

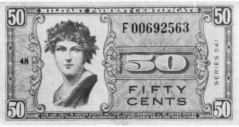

These notes have some mystery surrounding them. Shown above is a normal replacement note, and on the next page another from the same series but with a serial number higher than the total for the regular issue! A number of such notes are known for this particular denomination and series.

MILITARY PAYMENT CERTIFICATES

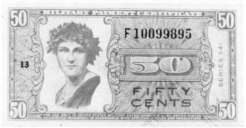

Moreover, there are a number of regular issues for which no replacement notes have been reported. These are Series 471 25¢, 50¢, $1 and $5; 472 25¢; 481 $5; 541 $5; 591 10¢, 25¢ and $5; 611 50¢; 651 $5. Confirmation of any of these is welcomed.

On Collecting MPC's

MPC's have every desirable quality any collector could wish for — well printed, colorful, different sizes and vignettes, and a degree of availability. Though no large stocks exist of most issues, the new collector will find that with a little patience he can fairly easily assemble a collection with at least one note of each series. Naturally, the lower denominations will prove the most accessible, and the $1 may also be readily found. Conditions will usually range from Good to Fine, with an occasional choice piece at times.

The higher denominations present a great challenge, as most are very scarce and some are truly rare. Even though they were issued in substantial quantities, few normally come into collectors' hands because all obsolete notes are supposed to be destroyed by supervised incineration. In several instances, however, various higher denomination notes have been located in quantity and sometimes sell below face value. For most of the rest, the only pieces available are those sent back as souvenirs, or those overlooked on C-Day. Thus the completion of an MPC type set will indeed be an accomplishment! (Less than 20 complete type sets are presently accounted for.)

CATALOG SECTION

Series 461 (A---A) *Issued September 16, 1946*

Printer: Tudor Press Corporation, Inc. of Boston, Massachusetts. One printing. Numbering and separating done by Bureau of Engraving.

Colors —

Face: Black print, gray and light blue-green background. Black serial numbers and other designations. *Back:* Brown print, reddish tan background.

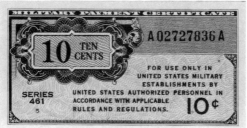

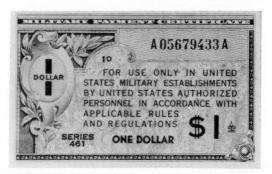

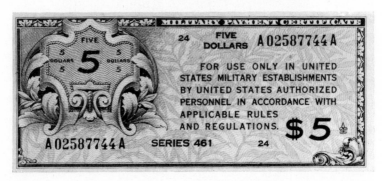

Denom.	SERIES 461	Delivered	Good	Fine	V. Fine	Ex. Fine	New
5¢......................		7,616,000	$.25	$.65	$1.50	$4.75	$10.00
10¢......................		8,064,000	.25	.65	1.50	4.75	10.00
25¢......................		4,704,000	.70	1.50	3.50	9.00	25.00
50¢......................		4,032,000	1.25	2.50	4.00	9.50	27.50
$1......................		14,560,000	1.00	2.00	3.50	7.50	18.50
$5......................		5,400,000	6.00	7.50	10.00	20.00	40.00
$10......................		40,800,000	10.00	12.50	15.00	19.00	37.50

Series 471 (B---B) *Issued March 10, 1947*

Printer: Tudor Press Corporation, Inc. One printing. Numbering and separating done by Bureau of Engraving.

Design: Similar to Series 461.

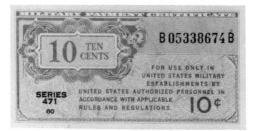

Colors —

Face: Red print, light blue-green and red background. Blue serial numbers and other designations. *Back:* Red print, deeper blue background.

Denom.	SERIES 471	Delivered	Good	Fine	V. Fine	Ex. Fine	New
5¢		8,288,000	$1.10	$3.00	$4.50	$8.00	$12.50
10¢		7,616,000	1.10	3.00	4.50	8.00	12.50
25¢		4,480,000	3.00	5.00	8.00	12.50	25.00
50¢		4,032,000	3.00	5.00	8.00	13.50	28.50
$1		14,560,000	3.00	4.50	7.50	13.50	28.50
$5		5,400,000	175.00	350.00	600.00	900.00	1,500
$10		13,600,000	75.00	100.00	175.00	275.00	550.00

Series 472 (C---C) *Issued March 22, 1948*

Printer: Tudor Press Corporation, Inc. One printing. Numbering and separating done by Bureau of Engraving.

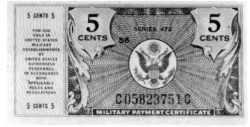

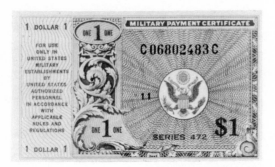

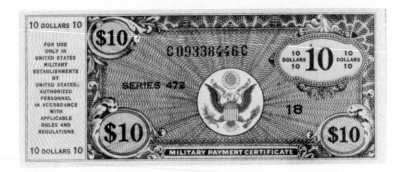

Colors —

Face: Eagle center and text at left in blue. Gray frame, light blue-green background. Black serial and position numbers. *Back:* Light brown print, light purple background.

Denom.	SERIES 472	Delivered	Good	Fine	V. Fine	Ex. Fine	New
5¢		7,960,000	$.20	$.30	$.50	$.85	$1.75
10¢		7,960,000	.20	.30	.50	.85	1.75
25¢		4,824,000	1.00	2.00	3.50	6.50	13.00
50¢		4,232,000	1.50	3.50	5.00	8.00	15.00
$1		11,760,000	1.50	3.50	5.00	8.00	15.00
$5		4,200,000	50.00	90.00	135.00	250.00	600.00
$10		11,600,000	12.00	15.00	25.00	50.00	250.00

Series 481 (D---D) *Issued June 20, 1951*

Printer: Forbes Lithographic Co., Boston, Massachusetts. Issue completed in four printings. Notes finished and delivered by Forbes.

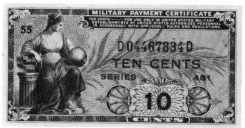

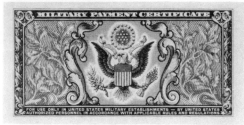

Design: Vignette on small notes is used again on $10 Series 611. Vignette of reclining man on face side of $5 and $10 is from the back of U.S. $50 National Currency Series of 1902.

The illustrated $1 shows position number on left side of note. Earlier printing (low serial numbers) shows position number on right side of note.

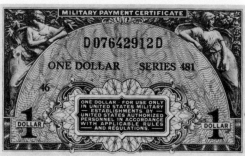

Colors —

Face: Black print, light blue-green and brown background. Serial number and other designations in black. *Back:* Deep blue print with purple background on all except the $5 which is violet with blue background.

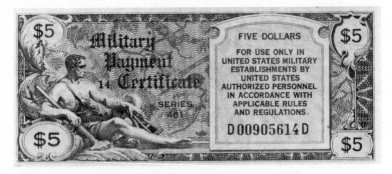

Denom.	SERIES 481	Delivered	Good	Fine	V. Fine	Ex. Fine	New
5¢		23,968,000	$.20	$.40	$.75	$1.10	$3.25
10¢		23,064,000	.20	.40	.75	1.10	3.25
25¢		14,776,000	1.00	2.00	3.00	4.50	8.50
50¢		10,032,000	1.50	3.00	4.00	5.00	11.50
$1		25,480,000	2.00	3.25	4.50	7.50	13.00
$5		8,600,000	25.00	35.00	50.00	150.00	450.00
$10		24,800,000	12.00	20.00	40.00	70.00	250.00

Series 521 (E---E) *Issued May 25, 1954*

Printer: Forbes Lithographic Co. Issue made in three printings. Notes completed and delivered by Forbes.

Design: Vignette on back of $1 reappears on small notes of Series 661. Vignette on $5 face side is from Bank of the Philippine Islands 10 Pesos note issued 1908 to 1933 (see page 149). Vignette on $10 face side is used again on the $10 Series 661, back. Figure on back of small notes is taken from the face of the 50 Deutsche Mark "Banknote" issue of 1948 (Special Army Currency).

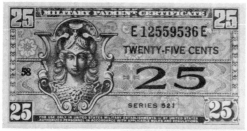

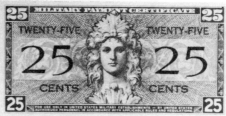

Colors — All have black serial and position numbers.

5¢ *Face:* Blue print, deep yellow and green background. *Back:* As face side but with deep yellow background only.

10¢ *Face:* Violet print, blue and green background. *Back:* As face side but with light blue background only.

25¢ *Face:* Tan print, green background. *Back:* As face side.

50¢ *Face:* Dull green print, violet background. *Back:* As face side.

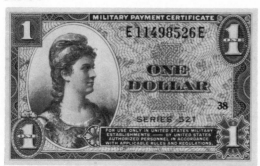

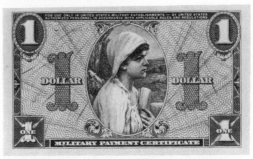

$1 *Face:* Brown print, orange and light blue background. *Back:* As face side but with light blue background only.

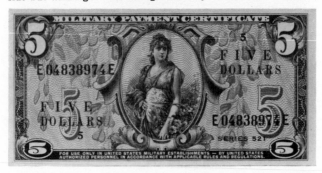

$5 *Face:* Blue print, violet and green background. *Back:* As face side but with violet background only.

$10 *Face:* Dark reddish tan, gold and light blue background. *Back:* Dark reddish tan frame, denomination in center deep blue, tiny words "TEN DOLLARS" in background over most of the back.

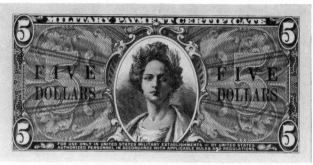

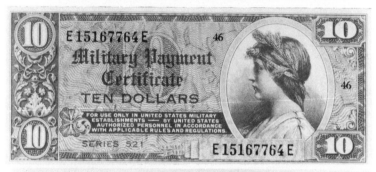

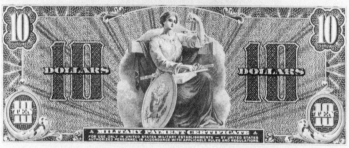

Denom.	SERIES 521	Delivered	Good	Fine	V. Fine	Ex. Fine	New
5¢		27,216,000	$.30	$.50	$.75	$1.75	$3.75
10¢		26,880,000	.30	.50	.75	2.50	6.00
25¢		14,448,000	1.10	2.50	3.50	5.00	9.50
50¢		11,088,000	2.00	3.00	4.00	7.00	13.00
$1		28,000,000	2.00	3.75	5.50	11.00	20.00
$5		6,400,000	55.00	90.00	175.00	265.00	500.00
$10		24,400,000	50.00	85.00	160.00	250.00	450.00

Series 541 (F---F) *Issued May 27, 1958*

Printer: Tudor Press Corporation, Inc. One printing. Notes completed and delivered by Tudor.

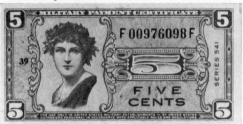

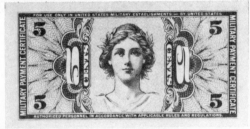

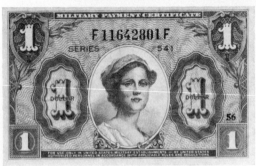

Colors — All have black serial and position numbers.

5¢ *Face:* Violet print, light and dark green background. *Back:* As face side but with light green background only.

10¢ *Face:* Deep green print, orange background. *Back:* As face side.

25¢ *Face:* Blue print, pink and green background. *Back:* As face side but with pink background only.

50¢ *Face:* Slate red print, green and yellow background. *Back:* As face side but with yellow background only.

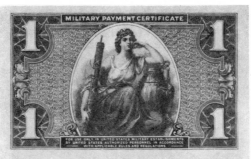

$1 *Face:* Blue print, light green and gold background. *Back:* As face side but with gold background only.

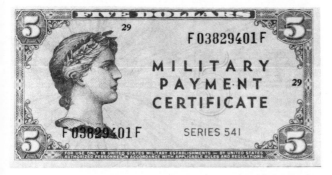

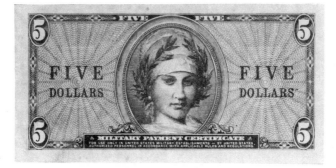

$5 *Face:* Slate red print, yellow and green background. *Back:* As face side but with light green background only.

$10 *Face:* Brown print, blue-green background. *Back:* As face side.

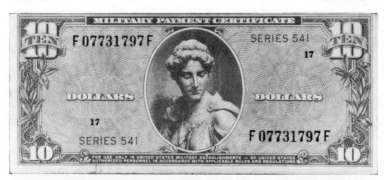

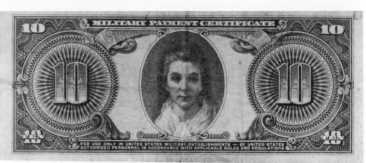

Denom.	SERIES 541	Delivered	Good	Fine	V. Fine	Ex. Fine	New
5¢	18,816,000	$.25	$.60	$1.00	$1.50	$2.25
10¢	18,816,000	.30	.65	1.25	1.75	3.25
25¢	12,096,000	.75	1.50	2.25	3.25	6.00
50¢	8,064,000	1.00	1.75	2.50	4.50	10.00
$1	20,160,000	3.00	3.75	5.00	8.00	16.00
$5	6,000,000	150.00	210.00	325.00	450.00	750.00
$10	21,200,000	65.00	125.00	225.00	325.00	475.00

Series 591 (G---G) *Issued May 26, 1961*

Printer: Forbes Lithographic Co. One printing. Notes completed and delivered by Forbes.

Design: Vignette on $10 is used again on $1 Series 661.

Colors — All have black serial and position numbers.

5¢ *Face:* Dark red print, green and yellow background. *Back:* As face side but with yellow background only.

10¢ *Face:* Blue print, pink and green background. *Back:* As face side but with pink background only.

[124]

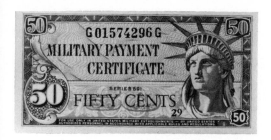

25¢ *Face:* Green print, purple and blue background. *Back:* As face side
 but with purple background only.

NOTE: Because the 25¢ denomination is written out in two lines on the note, the Series
591 designation is moved to the left bottom position.

50¢ *Face:* Brown print, blue and green background. *Back:* As face side
 but with light blue background only.

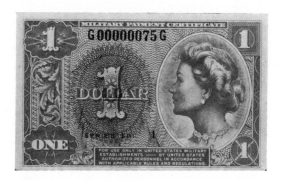

$1 *Face:* Red-orange print, purple and blue background. *Back:* As face
 side but with purple background only.

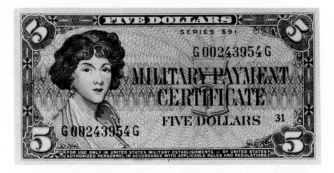

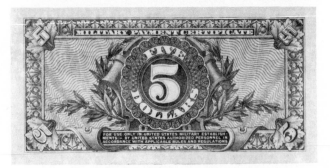

$5 *Face:* Blue print, violet and green background. *Back:* As face side but with violet background only.

$10 *Face:* Green print, green and red background. *Back:* As face side.

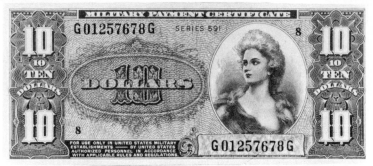

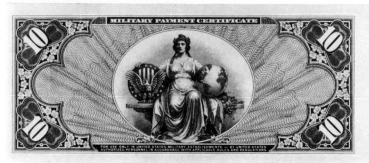

Denom.	SERIES 591	Delivered	Good	Fine	V. Fine	Ex. Fine	New
5¢		7,392,000	$1.25	$2.00	$3.00	$4.50	$6.00
10¢		8,400,000	1.25	2.00	3.00	4.50	6.00
25¢		4,704,000	2.00	3.75	5.00	10.00	18.00
50¢		3,696,000	3.00	4.50	6.00	12.00	20.00
$1		10,080,000	3.00	4.50	6.00	12.50	25.00
$5		2,400,000	130.00	180.00	225.00	350.00	550.00
$10		6,800,000	65.00	85.00	120.00	175.00	300.00

Series 611 (H---H) *Issued January 6, 1964*

It is reported that troops in Libya used only the $1, $5 and $10 notes of this issue. The lower denominations were apparently not used for long as they were reportedly withdrawn from circulation in Japan shortly after issue date.

Printer: Bureau of Engraving.

Design: Vignette on the face side of small notes closely resembles the obverse design of the Peace Dollar. Vignette on $10 back was previously used for small notes of Series 481.

Colors — All have black serial and position numbers.

5¢ *Face:* Deep blue print, violet and green background. *Back:* As face side.

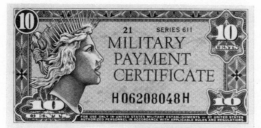

10¢ *Face:* Green print, blue-green background. *Back:* As face side but
 with blue-green and violet background.

25¢ *Face:* Light brown print, blue-green background. *Back:* As face side
 but with light blue background.

50¢ *Face:* Dark red print, green and yellow background. *Back:* As face
 side but with yellow background only.

$1 *Face:* Aqua blue print, deep orange background. *Back:* As face side.

$5 *Face:* Deep orange print, light blue and purple background. *Back:* As face side but with purple background only.

$10 *Face:* Deep blue print, light blue and violet background. *Back:* As face side but with violet background only.

Denom.	SERIES 611	Delivered	V. Good	Fine	V. Fine	Ex. Fine	New
5¢		9,408,000	$.40	$.65	$1.25	$2.25	$3.50
10¢		10,080,000	.40	.75	1.50	2.50	4.50
25¢		5,376,000	1.00	1.50	2.00	3.75	8.00
50¢		4,704,000	1.00	1.50	2.25	4.00	9.00
$1		10,640,000	1.10	2.00	2.75	4.50	11.50
$5		2,800,000	12.00	20.00	40.00	60.00	100.00
$10		8,400,000	12.00	17.50	30.00	45.00	80.00

Series 641 (J---J) *Issued August 31, 1965*

This issue was used only in Vietnam.

Design: The head on the face of the $10 was taken from the left side of the $2 Educational note Series of 1896.

Printer: Bureau of Engraving.

Colors — All have black serial and position numbers.

5¢ *Face:* Purple print, deep blue numerals, light blue background. *Back:* As face side.

10¢ *Face:* Green print, deep red numerals, red and blue-green background. *Back:* As face side.

25¢ *Face:* Light red print, dark green numerals, light blue-green background. *Back:* As face side.

50¢ *Face:* Orange print, brown numerals, aqua background. *Back:* As face side.

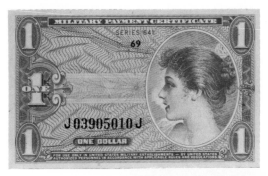

$1 *Face:* Red print, yellow and green background. *Back:* As face side but with yellow background only.

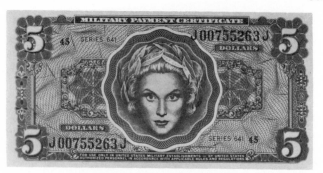

$5 *Face:* Aqua blue print, red and aqua background. *Back:* As face side.

$10 *Face:* Brown print, orange and aqua background. *Back:* As face side but with orange background only.

Denom.	SERIES 641	Delivered	V. Good	Fine	V. Fine	Ex. Fine	New
5¢		22,848,000	$.10	$.20	$.25	$.35	$.60
10¢		23,520,000	.10	.20	.25	.35	.60
25¢		12,096,000	.25	.35	.50	.75	1.00
50¢		11,424,000	.50	.75	1.00	1.40	2.00
$1		33,040,000	.75	1.25	1.75	2.50	4.00
$5		6,800,000	5.00	6.50	8.50	11.50	17.50
$10		20,400,000	8.50	12.50	16.00	20.00	40.00

Series 651 (A---A) *Issued April 28, 1969*

This issue was released *after* Series 661, and was used only in South Korea. Only the $1, $5 and $10 notes were released; no lower denominations were issued though they were printed (see illus. below). Instead, U.S. coins were used.

Note that A---A serial numbers reappear with this issue.

Printer: Bureau of Engraving.

Design: Basically like Series 641 except for the addition of a Minute Man at left on the face sides. Backs are identical with Series 641; however, the colors (on both sides) are different. Lettering style for *Series 651* designation is also changed from 641.

Colors — All have black serial and position numbers.

[133]

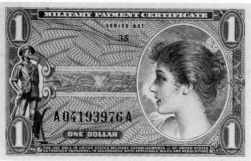

$1 *Face:* Green print, dark red and aqua background. *Back:* As face side but with dark red background only.

$5 *Face:* Brown print, aqua with red background. *Back:* As face side.

$10 *Face:* Purple print, brown with aqua background. *Back:* As face side but with brown background only.

Denom.	SERIES 651	Delivered	Fine	V. Fine	Ex. Fine	New
$1	6,720,000	$1.00	$1.25	$2.25	$4.00
$5	1,600,000	5.00	6.25	9.00	18.50
$10	3,600,000	10.00	12.00	16.00	24.00

Series 661 (B---B) *Issued October 21, 1968*

This issue was used only in Vietnam. The $20 denomination was introduced with this series.

Printer: Bureau of Engraving.

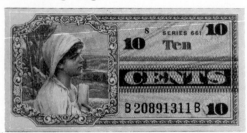

Design: Vignette on small notes is taken from the back of $1 Series 521. Vignette on the $1 face side is that of the $10 Series 591. The back shows a scene of what is reported as Mt. Rainier. Vignette on the $10 face side is from the back of the U.S. $20 National Currency large size, Series of 1902. The back takes its portrait from the $10 Series 521, face side. Vignette on the $20 back is from the face side of Bank of the Philippine Islands 50 Pesos issued 1908 to 1928.

Colors — All have black serial and position numbers.

5¢ *Face:* Red frame right, green frame and vignette left, green numerals, red and aqua background. *Back:* Red print, green background.

10¢ *Face:* Violet frame right, blue frame and vignette left, blue numerals' violet and aqua background. *Back:* Violet print, blue background.

25¢ *Face:* Orange frame right, brown frame and vignette left, brown numerals, orange and aqua background. *Back:* Brown print, orange background.

50¢ *Face:* Aqua frame right, pale red-orange frame and vignette left, red-orange numerals, aqua background. *Back:* Deep aqua print, red-orange background.

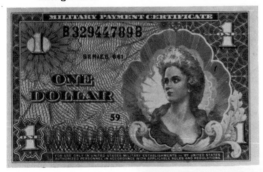

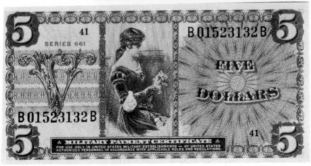

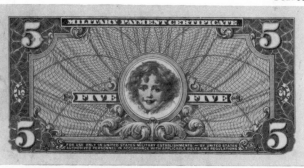

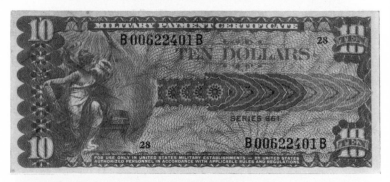

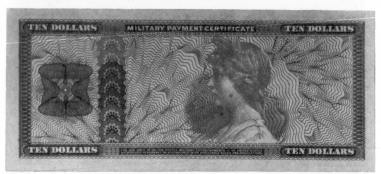

$1 *Face:* Blue print, purple vignette, aqua and purple background. *Back:* Light blue print, scene of Mt. Rainier in blue, trees and some background in purple.

$5 *Face:* Brown print, red and aqua background. *Back:* As face side but with red background only.

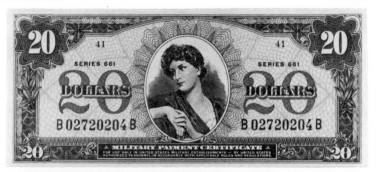

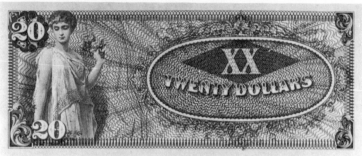

$10 *Face:* Red print, orange and aqua background. *Back:* Red print, orange vignette and part of background.

$20 *Face:* Slate print, center numerals tan, aqua and tan background. *Back:* Tan vignette and oval design, slate frame.

Denom.	SERIES 661	Delivered	Fine	V. Fine	Ex. Fine	New
5¢		23,520,000	$.10	$.15	$.25	$.50
10¢		23,520,000	.15	.20	.30	.75
25¢		13,440,000	.30	.40	.60	1.00
50¢		10,080,000	.60	.75	1.00	1.50
$1		33,040,000	1.25	1.50	2.00	3.00
$5		7,200,000	2.00	3.00	4.00	6.00
$10		4,800,000	15.00	30.00	45.00	95.00
$20		8,000,000	25.00	32.50	45.00	90.00

Series 681 (C---C) *Issued August 11, 1969*

This issue was used only in Vietnam, replacing the short-lived Series 661. For the first time military vignettes and scenes dominate every note.

Printer: Bureau of Engraving.

Design: Eagle vignette on back of $5 is taken from the back of U.S. $100 National Currency Series of 1882.

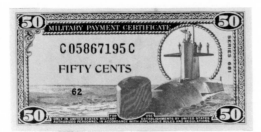

The space walking
astronaut on these notes
has recently been
identified from photos as
Major Edward H. White.

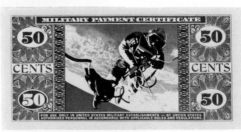

Colors — All have black serial and position numbers.

5¢ *Face:* Green frame, blue vignette of nuclear submarine and water, aqua background. *Back:* Deep blue astronaut walking in space, also inner vertical border in blue, otherwise green print.

10¢ *Face:* Purple frame, vignette and background as above. *Back:* Vignette in blue as above, otherwise purple print.

25¢ *Face:* Red frame, vignette and background as above. *Back:* Vignette as above, otherwise red print.

50¢ *Face:* Brown frame, vignette and background as above. *Back:* Vignette as above, otherwise brown print.

$1 *Face:* Purple print including Air Force pilot, aqua and red background.

Back: Orange frame and scene of four jet fighters in formation, light purple background.

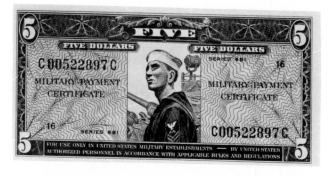

$5 *Face:* Purple frame and vignette of sailor, light green and aqua background. *Back:* Ornate frame and eagle in purple, yellow background.

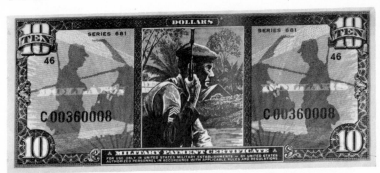

(Replacement note shown.)

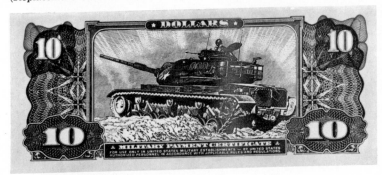

$10 *Face:* Blue frame and vignette of soldier, light red and aqua background. *Back:* Blue frame and tank, brown background.

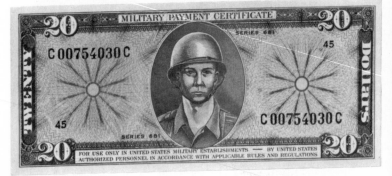

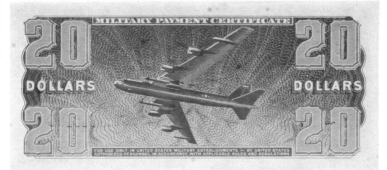

$20 *Face:* Brown frame and vignette of marine in center; pink, blue and
 aqua background. *Back:* Brown jet bomber and background, shades
 of red frame and numerals.

Denom. SERIES 681	Delivered	Fine	V. Fine	Ex. Fine	New
5¢ . 14,112,000		$.10	$.15	$.25	$.50
10¢ . 14,112,000		.10	.15	.25	.50
25¢ . 8,736,000		.30	.40	.65	1.00
50¢ . 6,720,000		.50	.60	1.00	2.00
$1 . 22,400,000		1.00	1.25	1.50	2.25
$5 . 4,800,000		5.00	5.50	6.50	8.00
$10 . 3,200,000		8.50	10.00	12.50	22.50
$20 . 6,400,000		18.00	20.00	23.50	36.50

Series 692 (E---E) *Issued October 7, 1970*

This issue replaced Series 681 in Vietnam and was the last issue of MPC to
be released. Design features once again incorporated the use of unidentified
female faces on some of the notes, while the two highest denominations por-
tray Indians and American scenes. Strictly military scenes or vignettes were
completely removed.

The "cent" notes of this series were withdrawn from circulation June 1, 1971
and the use of U.S. coins authorized.

Printer: Bureau of Engraving.

Design: The bison vignette on the back of the $1 is the same as that on the
$10 United States Note Series of 1901. The $10 face side portraying Indian
in headdress resembles the $5 Silver Certificate 1899 but is not the same.
The portrait on the $20 face side is reported to be that of Sioux Chief Sitting
Bull. The back of the $20 shows Hoover Dam. The sitting figure on the face
of the small notes is taken from a statue by James Earle Fraser at the Na-
tional Archives.

Colors — All have black serial and position numbers.

5¢ *Face:* Vignette in reddish-brown, black corner numerals, deep pink
 border, light tan background. *Back:* Reddish-brown eagle, deep pink
 design and tan background.

10¢ *Face:* Vignette in aqua, black numerals, blue border, orange and green background. *Back:* Aqua eagle, blue design and green background.

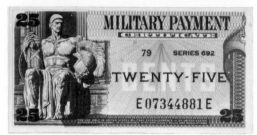

25¢ *Face:* Deep blue vignette and border, yellow center, gray background, black numerals. *Back:* Slate blue eagle, deep blue design and gray background.

50¢ *Face:* Purple vignette and border, gold center, pink background, black numerals. *Back:* Brown eagle, purple design, light brown background.

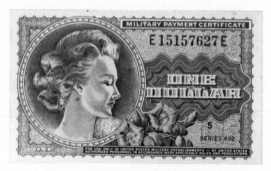

$1 *Face:* Gray-blue vignette and border, violet flowers with green leaves, red-brown background. *Back:* Gray-blue print, black background lines.

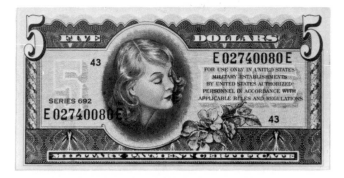

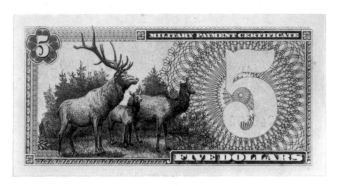

$5 *Face:* Brown portrait and border, orange numeral, word FIVE and
flowers, blue background. *Back:* Brown print, light tan background.

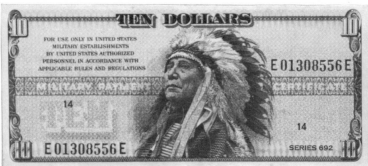

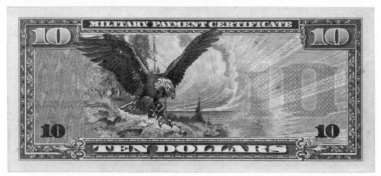

$10 *Face:* Blue vignette and border, purple center line, pink and red background. *Back:* Blue print, purple numeral 10, reddish-purple background.

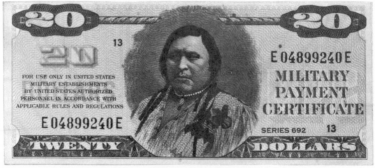

$20 *Face:* Purple vignette with upper and lower borders, pale red 20 at left, mostly dark orange background. *Back:* Shades of purple print, blue background.

[144]

Denom.	SERIES 692	Delivered	Fine	V.Fine	Ex. Fine	New
5¢		14,112,000	$.15	$.20	$.30	$.60
10¢		14,112,000	.15	.20	.30	.60
25¢		8,736,000	.30	.40	.60	1.10
50¢		6,720,000	.65	.75	1.25	2.25
$1		22,400,000	1.50	2.00	2.50	3.50
$5		4,800,000	6.50	7.50	9.50	13.50
$10		3,200,000	12.00	14.00	18.00	22.50
$20		6,400,000	22.00	25.00	30.00	40.00

MPC Training Money

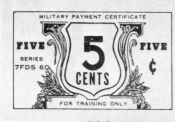

MPC training money was used at the Army Finance Center, Fort Benjamin Harrison, Indianapolis, Indiana at various times. Its purpose was to train finance clerks to handle MPC. It is found in a variety of series. The illustrations are typical.

PHILIPPINE PAPER MONEY UNDER
U.S. SOVEREIGNTY

Many collectors of U.S. currency are not familiar with the extensive and attractive series of notes produced at the Bureau of Engraving for the Philippines under U.S. sovereignty. Notes in this category were issued from 1903 to 1949, and consisted of the following types: Silver Certificates, Treasury Certificates, Philippine National Bank Circulating Notes, and Bank of the Philippine Islands notes. This section will describe each type briefly.

Silver Certificates 1903-1918

The United States brought immediate order out of financial chaos with the introduction of a silver peso backed at the rate of two per U.S. dollar. Both coins and paper money of this new system were released in 1903, the paper being designated as Silver Certificates.

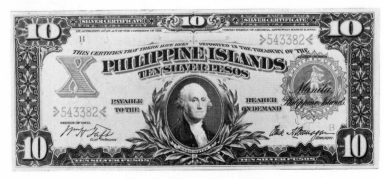

Silver Certificate, Series of 1903.

The size of the Philippine notes was made smaller than U.S. currency in use at that time to avoid any possible confusion between the two currencies. It proved so convenient and satisfactory that U.S. currency was eventually reduced to the same dimensions (see Appendix A for background information).

At first the redemption clause on Silver Certificates allowed payment only in silver pesos. This was changed in 1906, and all subsequent issues of Silver Certificates were redeemable "in silver pesos or in gold coin of the United States of equivalent value."

Philippine Silver Certificates were abolished through a reorganization of reserve funds on August 1, 1918. At that time a new kind of government note, the Treasury Certificate, replaced them.

Silver Certificate Issues

Series Date	Denominations	Series Date	Denominations
1903	2, 5, 10 Pesos	1910	5 Pesos
1905	20, 50, 100, 500 Pesos	1912	10 Pesos
1906	2, 500 Pesos	1916	50, 100 Pesos
1908	20 Pesos		

U.S.-PHILIPPINE CURRENCY

Treasury Certificates 1918-1949

A study of Treasury Certificates shows the great influence of numismatic and historical events as the issues progressed. The first major alterations in Philippine currency took place in 1929 because of the reduction in size of U.S. paper money, and were made to avoid any confusion between Philippine notes and the newly reduced U.S. currency about to be issued. Among the many changes were the relocation of various portraits and the substitution of several colors, resulting in an array of new Philippine designs in 1929.

The second instance of change on Philippine notes occurred as a result of the Commonwealth having been established in 1935 as a giant step towards independence. Alterations on the notes were fairly simple this time, the most obvious being the substitution of the word "Philippines" for "Philippine

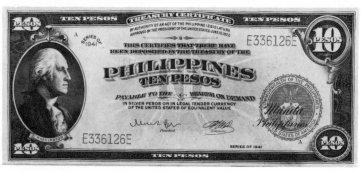

Treasury Certificate, Series of 1941.

Islands" and the introduction of a new seal. On Treasury Certificates these occurred on notes series dated 1936 and later.

The final instance of obvious outside influence is seen in the last issue, the VICTORY Series. World War II had interrupted the normal flow of notes from the United States, and during the war there were in circulation only the clandestine guerrilla or emergency issues and the Japanese occupation notes. When MacArthur returned to the Philippines on October 20, 1944, his forces had with them a new series of notes heralding the coming end of the war; this issue had the backs appropriately overprinted VICTORY in large black letters.

Treasury Certificates continued to be made and issued even after Philippine independence was granted in 1946. It was not until 1949 that the new Central Bank of the Philippines began to issue its own notes with completely different designs. Even so, Treasury Certificates remained in use until 1964.

Treasury Certificate Issues

Series Date	Denominations
1918	1, 2, 5, 10, 20, 50, 100, 500 Pesos
1924	1, 2, 5, 10, 500 Pesos
1929	1, 2, 5, 10, 20, 50, 100, 500 Pesos
1936	1, 2, 5, 10, 20, 50, 100, 500 Pesos
1941	1, 2, 5, 10, 20 Pesos
VICTORY (1944)	1, 2, 5, 10, 20, 50, 100, 500 Pesos

U.S.-PHILIPPINE CURRENCY

Philippine National Bank Circulating Notes 1916-1937

The Philippine National Bank was established on February 4, 1916, and soon thereafter began to issue notes much the same as U.S. national banks. While some of its notes closely resembled the government issues, there were

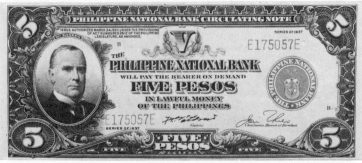

Philippine National Bank issue, Series of 1937.

several unusual variations of significant numismatic interest.

Two issues of an emergency nature were made by the bank. The first of these took place in 1917 and was the result of a severe shortage of coins in circulation. The issue itself consisted of 10, 20, 50 Centavos and 1 Peso, all printed in the Philippines.

The second emergency issue occurred around 1919 or 1920. Apparently the bank ran short of new notes, so it overprinted a quantity of Bank of the Philippine Islands 5, 10 and 20 Pesos notes for circulation in its own name.

Portraiture also differed in two instances from the government notes. The 1 Peso showed Charles A. Conant, father of the Philippine currency system, and the 20 Pesos portrayed Congressman William A. Jones of Virginia who was chiefly responsible for the establishment of the bank and also the sponsor of the Jones Bill (an Organic Act preparatory to independence).

Notes of this bank were withdrawn on June 1, 1948 and were redeemed for one year afterwards.

PNB Circulating Note Issues

Series Date	Denominations	Series Date	Denominations
1916	2, 5, 10 Pesos	(1919) Overprints	5, 10, 20 Pesos
1917 (Emergency Notes)	10, 20, 50 Centavos, 1 Peso	1920	50, 100 Pesos
		1921	1, 2, 5, 10, 20 Pesos
1918	1 Peso	1924	1 Peso
1919	20 Pesos	1937	5, 10, 20 Pesos

Bank of the Philippine Islands Notes 1908-1933

This bank was the direct descendant of the Banco Español-Filipino established in 1852. It issued notes through the last years of Spanish rule, and subsequently did so under the U.S. as well. The first U.S.-printed issue took place in 1908 using the same Spanish name as on previous issues. New de-

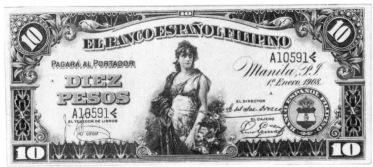

Banco Español Filipino, 1908 issue.

signs distinctive to the bank were introduced; only the size and colors were made to conform with the government notes.

In 1912, the name was anglicized to the Bank of the Philippine Islands, and all issues from then through the last one in 1933 carried that name. Designs initiated for the 1908 Spanish issue were retained throughout. All

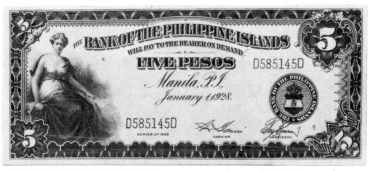

Bank of the Philippine Islands, Series of 1928.

differed considerably from the government and Philippine National Bank issues, as BPI notes did not have a guaranteed final redemption and it was the desire to have them easily recognizable.

The Bank of the Philippine Islands did not make many issues, and all notes were withdrawn from circulation at the outbreak of World War II.

Bank of the Philippine Islands Issues

Series Date	Denominations
1908 (Spanish issue)	5, 10, 20, 50, 100, 200 Pesos
1912	5, 10, 20, 50, 100, 200 Pesos
1920	5, 10, 20 Pesos
1928	5, 10, 20, 50, 100, 200 Pesos
1933	5, 10, 20 Pesos

N.B. For detailed information and a full catalog listing with values for all regular issue Philippine currency from 1903 to 1949, the reader is referred to this author's book entitled, *A Guide Book of Philippine Paper Money* (see Bibliography).

APPENDIX A

HISTORY
OF THE
PROPOSAL TO ADOPT THE PHILIPPINE SIZE
OF PAPER CURRENCY FOR USE IN THE
UNITED STATES, AS REVEALED IN
TREASURY RECORDS

Prepared by the
United States Bureau of Efficiency
October 17, 1925

Early Reports and Statements on Currency Size Made by Secretary MacVeagh in 1910

The MacVeagh committee on design and size of currency, working through 1909-1910, consisting of the Chief of the Division of Loans and Currency, the Treasurer of the United States, the Chief of the Secret Service, and the Director of the Bureau of Engraving and Printing, made a very careful and exhaustive study of the proposal to change the size of the paper currency. It arrived at the following conclusion set down in an undated report: The committee "strongly" recommended adopting the Philippine size which, it said, had proven an unqualified success. It enumerated as savings (1) the additional bills per plate; (2) decrease in piece rate of plate printing; (3) increased production; (4) saving in cost of paper; (5) saving in transportation of paper; (6) reduction in paper handling force; (7) reduction of force in redemption division. It figured the saving on the basis of money output at that time at $612,603 a year.

The committee believed the change in size would be advantageous to banks and commercial houses. The fact that the smaller bills would be carried flat, it held, would make them generally easier to handle. They would occupy less storage space. They would cramp the hand of counters less than the present money. The committee did not believe that the smaller notes would necessitate a change in tills. It did not believe that the temporary inconvenience of changing size would be so serious as to have great weight.

On September 10, 1910, Mr. MacVeagh gave out an interview on the proposed change in design and size of paper money which crystallized his views on the matter. It is important since the file which shows the detail of this investigation has been lost and these general conclusions are its chief record. The following quotation bears on the question of size. Mr. MacVeagh said:

"I am hopeful that the public will consider favorably, as the Treasury Department is inclined to consider favorably, the economies and other advantages which would result ultimately from the use of a somewhat smaller paper currency. It has been suggested that our notes be reduced to $2\frac{1}{2}$ inches wide by 6 inches long, the same size as the Philippine paper currency, which has proved an unqualified success — and a size which, when it is not brought into direct comparison with the present note, and when not scrutinized, would not, to most people, present a noticeable change. From the Treasury point of view, the proposed reduction would result in an estimated saving to the Government of $612,603 every year. This economy would be gained from various sources. For example, we would print five notes where we print four now, and the increased production of 25 per cent more notes with the same labor as at present, carried through all the various processes of wetting, examining, counting, drying, numbering, sealing, separating, etc., would save more than $200,000 a year alone. The saving in the cost of paper would be almost $90,000, and the decrease in the cost of plate printing would amount to almost $270,000. These, with a possible reduction of the force in the re-

demption division of the Treasurer's office, due to the smaller number of notes redeemed because of the longer life of the smaller notes, represent the chief items in this estimate of $612,000.

"On the popular side, I am inclined to think the change would cause little if any inconvenience and would quickly be commended by the people. The smaller notes could be carried flat and, being preserved in that shape, would not wear from folding and would be more readily handled by cashiers, tellers, and clerks. We have carefully experimented with bank clerks and tellers in the city of Washington and learn that the smaller notes do not tend to cramp the hands of persons manipulating them, as do the present notes, and that they are just as easily handled and counted as the old notes. The smaller notes could be more closely packed on the counters of the banks and, in fact, banks as well as subtreasuries probably could store 25 per cent more of the new than of the old notes in their vaults.

"It will not be necessary to change the dimensions of cash drawers, tills, compartments, etc., which now hold the present size of money as they will hold also currency of the size proposed. This would not be true, of course, if the suggestions were to enlarge the size of the notes.

"The only objection to adopting smaller notes which seems to me of special importance is that for some time two sizes of paper money would be in use and bank tellers and the business public would be correspondingly inconvenienced. I think, however, that this objection could be largely if not almost wholly overcome by preparing in advance enough of the new notes so that they could be exchanged for old notes on a fixed date at all subtreasuries, banks, and other large financial institutions. Preparation for the change, including the making of designs and plates and the printing of notes, probably would require about eighteen months, and within that time, no doubt, enough new notes could be printed to make possible an almost complete change. The people themselves would aid this change naturally and rapidly in their desire to secure specimens of the new money . . .

"No special legislation is necessary to enable the Government to reduce the size of United States notes and gold and silver certificates. In order, however, to effect a reduction in the size of national-bank currency without legislation, and at the same time continue the present multiplicity of designs, it would be necessary to eliminate the 13,000 plates now in use and to engrave as many more. This could be done, I presume, only by the Government's assumption of the expense of new plates, and as each plate costs $75, the total cost of the new series would reach about $900,000. It would be quite possible, however, to use the same uniform engraved plates for all bank notes, and to print later by separate process the name of the individual bank upon the notes which that bank was to issue."

MacVeagh's Official Order of 1913 to Reduce the Size of U.S. Currency

On February 26, 1913, Secretary MacVeagh issued instructions to the Bureau of Engraving and Printing embodying the recommendations of the committee and directing complete redesign of the currency and the adoption of the smaller size. With relation to the question of size the instructions read:

"Confirming my oral approval and instructions of January 31, 1913, the design prepared by Mr. Kenyon Cox, of New York City, for use on the backs of all denominations of paper money is hereby approved, and you are instructed to proceed immediately with the engraving of a die of this design, completing the work at the earliest moment possible.

Appendix A

"I have caused this design to be prepared for use in connection with a change in the size of United States notes, gold and silver certificates and national-bank notes from their present dimensions to the dimensions of the Philippine certificates, and as soon as the engraving of the die of the new design is completed you will at once prepare plates for the printing of the classes above named of this reduced size.

"1. The engraving on the faces of the notes will be 2½ by 6⅛ inches and that on the backs will be 2¼ by 5⅞ inches."

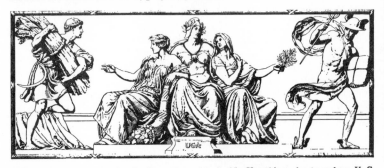

This is the approved design by Cox referred to in MacVeagh's order to reduce U. S. currency size. It was to be used as the uniform back design for all denominations. Work had progressed to the point that George F. C. Smillie was able to engrave a die of the design which is shown in the above illustration.

With only minor revisions, this design was selected as the central feature for the back of the $100 Federal Reserve Note Series of 1914.

Mr. MacVeagh's instructions to the Bureau were given about a week before his retirement. He was succeeded in March, 1913 by Mr. McAdoo. Soon after the introduction of the new Secretary into office the chief of the Bureau of Engraving and Printing visited him and asked if the preparation of the new designs should be continued. Mr. McAdoo replied that he looked favorably on the proposal but instructed his Bureau chief to hold the matter up until he had time to go into it in detail. The setting up of the Federal Reserve system was then imminent and absorbed the attention of the Department for some time. Then the First World War commenced, and the order of Mr. MacVeagh was never executed.

Later Considerations and Recommendations

On June 6, 1922, President Harding wrote Secretary Mellon: "Personally I have long since been inclined to favor the smaller-sized bill. I had an opportunity of seeing some of the Philippine paper currency when it was first issued and thought it to be an ideal size. I wonder, however, if there would not be a curious psychological effect if we were to reduce the size of the currency at a time when there is a general complaint about the reduced purchasing power of our currency."

On September 10, 1923, Secretary Mellon announced a new series of designs. Instructions were given for the issue of these new designs and some of them were actually executed. Difficulties arose, however, which stopped the implementation of this program.

On November 12, 1924, Secretary Mellon appointed a new committee on currency design and instructed it to make an entirely new study of the subject.

On July 15, 1925, representatives of all the Federal Reserve Banks met in Washington to discuss currency matters and occasion was taken to place before them anew the proposal to reduce the size of currency notes. Reasons for and against the change were presented to the conference, concerning the following points:

1. Should the size be reduced.
2. If reduced, should the present width be retained and the length shortened.
3. If reduced, should both the length and width be reduced.

After discussion it was the unanimous opinion of the conference that the size should be reduced, that the reduction should apply to all kinds and denominations, and that the width as well as the length should be reduced.

The Federal Reserve Bank of San Francisco was not represented at the conference, but the Governor of that Bank wrote that "we have no proposals to offer further than my own opinion that it would be highly undesirable to reduce the size of one denomination (any denomination) and highly desirable to reduce the size of all denominations."

Origin of the Philippine Currency Size

On October 3, 1925, General McIntyre, of the Bureau of Insular Affairs, submitted memoranda to the Bureau of Efficiency throwing light on the origin and success of the Philippine size of paper currency. According to this data Dr. Meredith, of the Bureau of Engraving and Printing, had been asked to prepare designs for Philippine money. On April 24, 1903, he sent models of the face and back of the two-peso silver certificate. These models were found satisfactory but the Secretary of War, Elihu Root, was fearful that there might be confusion between the Philippine and American money. The possibility of using the smaller size was taken up with the Bureau, and the result was the initiation of the present size. It came about, it would seem, not because the size was regarded as better, but because it was different, and because it manufactured readily at the Bureau. In 1911, after eight years' use of this paper money, General Edwards, who had been chief of the Bureau of Insular Affairs all the time, wrote Senator Gallinger: "This paper has been satisfactory from every point of view and the size of the bills has been very favorably commented upon by a great many people." J. B. Peat, for many years a teller in the Philippine Treasury, appearing before the American Bankers' Association in 1910, said that he "was impressed with the suitability and serviceability of the banknote of the Philippine size. The smaller size note is a distinct advantage when compared with our own notes or with the still larger bank notes of the Spanish circulation. The smaller notes are not so subject to mutilation, nor are the corners so often turned up as in the case of the larger notes. In actual handling, counting and sorting the smaller size really facilitates the various operations. The initial cost of the smaller notes is considerably less, and they are more easily stored in vaults. For remitting purposes, either by post or express, the smaller notes will, of course, weigh considerably less. The adoption and circulation of notes of the Philippine size would be a material step toward improvement of American Currency."

A canvass of officers in the Bureau of Insular Affairs who had served in the Philippines showed that they were unanimously of the opinion, after handling the smaller-sized money, that it was more convenient than that used in the States. They said that, after years of service in the Philippines and use of this money, the currency at home seemed "like blankets" when

they returned. They all believed that the Philippines had demonstrated, had definitely proved, the superiority of the smaller currency.

The Final Proposals of 1925

On August 20, 1925, the Treasury Department appointed a new General Currency Committee to restudy the whole question. This committee was broken up into eight subcommittees. Subcommittee No. 1 was instructed to study design. It was asked to report on:

1. New designs.
2. Uniform backs
3. Denominational faces.
4. Use of color.
5. National bank notes.
6. Federal reserve notes.
7. Reduced size.

On October 17, 1925, this committee voted unanimously in favor of a proposal to recommend to the General Committee that the size of the paper currency of the United States be reduced to the size of that of the Philippines.

A P P E N D I X B

Official Bureau of Engraving Records
Showing Deliveries of Modern-Size Notes Beginning in 1929

This section contains a portion of the records kept by the Bureau of Engraving for printings of modern U.S. currency. Issue totals and dates of delivery are its most useful components.

Some earlier editions of this book carried these Bureau records in their entirety; starting with the Fourth edition a portion of them was deleted to allow room for the preceding sections on Military Payment Certificates and U.S.-Philippine issues. The remaining section has been revised according to Chuck O'Donnell's findings.

SILVER CERTIFICATES

$1.00 1928 A and B Experimental Notes

In the early 1930's an experimental run of $1 Series of 1928 A and 1928 B was made as a test for durability of different paper. Block letters for each series are X-B, Y-B, and Z-B. All are very scarce.

$1.00 Series 1935 Experimental Notes

In 1937 there were several short runs of experimental Series 1935 notes with B suffix in the serial number. Mr. Robert H. Lloyd published details concerning these notes in the *Numismatic Scrapbook* (October 1964, p. 2664, and February 1968, p. 196). The following letter from the Bureau of Engraving explaining the reasons for their manufacture is contained in his 1964 article:

"Dear Sir: "December 23, 1938

"Receipt is acknowledged of your letter of December 16, 1938, enclosing silver certificate No. C01,263,845B, and inquiring as to the reason for the suffix letter 'B.'

"Your certificate is one of the 3,300,000 $1 silver certificates, series 1935, delivered in the latter part of the calendar year 1937, numbered from C00,000,001B to C03,300,000B, which was regular work. At the same time there was delivered an equal number of $1 silver certificates, series 1935, numbered from B00,000,001B to B03,300,000B. This was platered by a new method. These two deliveries were made for the purpose of determining any objectionable conditions due to the new method of platering. The silver certificate is returned herewith.

Very truly yours,
A. W. Hall, Director."

Though this letter makes no mention of similar notes with A---B serial numbers, such notes are known.

$500 FEDERAL RESERVE NOTES

The following listings of notes printed are shown according to Chuck O'Donnell's Standard Handbook. Bureau records had indicated that only the 1928 and 1934 series were made, but the Standard Handbook has much different information. Also included is O'Donnell's complete listing of the 1934 A series which was being confirmed piecemeal around the country.

BANK	SERIES OF 1928	SERIES OF 1934	SERIES OF 1934 A	SERIES OF 1934 B	SERIES OF 1934 C
A	69,120	56,628	———	———	1,440
B	299,400	288,000	276,000	———	204
C	135,120	31,200	45,300	———	———
D	166,440	39,000	28,800	———	———
E	84,720	40,800	36,000	———	———
F	69,360	46,200	Confirmed*	2,472	———
G	573,600	212,400	214,800	———	———
H	66,180	24,000	57,600	———	———
I	34,680	24,000	14,400	———	———
J	510,720	40,800	55,200	———	———
K	70,560	31,200	34,800	———	———
L	64,080	83,400	93,000	———	———

* Illustration in COIN WORLD July 16, 1975, page 65.

$1,000 FEDERAL RESERVE NOTES

As with the $500 issues, O'Donnell has located records showing that more issues of $1,000 notes were made than previously indicated by Bureau files.

BANK	SERIES OF 1928	SERIES OF 1934	SERIES OF 1934 A	SERIES OF 1934 C
A	30,000	46,200	30,000	1,200
B	174,348	332,784	174,348	168
C	78,000	33,000	78,000	———
D	28,800	35,400	28,800	———
E	16,800	19,560	16,800	———
F	80,964	67,800	80,964	———
G	134,400	167,040	134,400	———
H	39,600	22,440	39,600	———
I	4,800	12,000	4,800	———
J	21,600	51,840	21,600	———
K	———	46,800	———	———
L	36,600	90,600	36,600	———

$5,000 FEDERAL RESERVE NOTES

Instead of the two issues previously shown from Bureau files, four are contained in the following compilation from O'Donnell's book:

BANK	SERIES OF 1928	SERIES OF 1934	SERIES OF 1934 A	SERIES OF 1934 B
A	1,320	9,480	——	1,200
B	2,640	11,520	——	12
C	——	3,000		
D	3,000	1,680		
E	3,984	2,400		
F	1,440	3,600		
G	3,480	6,600		
H	——	2,400	1,440	
I	——	——		
J	720	2,400		
K	360	2,400		
L	51,300	6,000		

$10,000 FEDERAL RESERVE NOTES

Only two issues were shown in Bureau records; however, O'Donnell has located data on four issues as contained in the following listing:

BANK	SERIES OF 1928	SERIES OF 1934	SERIES OF 1934 A	SERIES OF 1934 B
A	1,320	9,720	——	——
B	4,680	11,520	——	24
C	——	6,000		
D	960	1,480		
E	3,024	1,200		
F	1,440	2,400		
G	1,800	3,840	1,560	
H	480	2,040		
I	480	——		
J	480	1,200		
K	360	1,200		
L	1,824	3,600		

GOLD CERTIFICATES

Denom.	Series Date	Serial Numbers	Inclusive Dates of Delivery	Total Delivered
$10	1928	A00 000 001A B30 812 000A	May 29, 1929 Feb. 6, 1933	130,812,000
$10	1928 A	B30 812 001A B33 356 000A	March 28, 1933 Apr. 14, 1933	2,544,000
$20	1928	A00 000 001A A66 204 000A	May 29, 1929 Feb. 8, 1933	66,204,000
$20	1928 A	A66 204 001A A67 704 000A	Apr. 18, 1933 Apr. 28, 1933	1,500,000
$50	1928	A00 000 001A A05 520 000A	Aug. 21, 1929 Oct. 26, 1931	5,520,000
$100	1928	A00 000 001A A03 240 000A	Oct. 1, 1929 Oct. 24, 1931	3,240,000
$100	1934	A00 000 001A A00 120 000A	June 25, 1934	120,000
$500	1928	A00 000 001A A00 420 000A	Dec. 2, 1929 Oct. 20, 1930	420,000
$1000	1928	A00 000 001A A00 288 000A	Dec. 2, 1929 Oct. 20, 1930	288,000
$1000	1934	A00 000 001A A00 084 000A	June 25, 1934	84,000
$5000	1928	A00 000 001A A00 024 000A	Nov. 29, 1929 Dec. 10, 1929	24,000
$10,000	1928	A00 000 001A A00 048 000A	Nov. 23, 1929	48,000
$10,000	1934	A00 000 001A A00 036 000A	June 25, 1934	36,000
$100,000	1934	A00 000 001A A00 042 000A	Jan. 9, 1935	42,000

Series or Denomination	Serial Numbers	Inclusive Dates of Delivery	Total Delivered
$1.00 Yellow Seal		Sept. 4, 1942 - April 24, 1944	26,916,000

B30 000 001C		B51 624 001C	B99 000 001C
B31 000 000C		B52 624 000C	B99 999 999C
C60 000 001C	C78 000 001C	F41 952 001C ⎱ This F lot was delivered to the	
C62 000 000C	C79 904 000C	F41 955 996C ⎰ Treasurer in uncut sheets.	
F41 955 997C		I30 000 001C	R90 000 001C
F41 964 000C		I40 000 000C	R99 999 999C

$5.00 Yellow Seal		Sept. 4, 1942 - May 8, 1944	16,660,000
K34 188 001A		K36 420 001A	K37 464 001A
K34 508 000A		K36 740 000A	K37 784 000A
K40 068 001A		K43 152 001A	K53 984 001A
K42 068 000A		K44 852 000A	K65 984 000A

$10.00 Yellow Seal		Sept. 4, 1942 - May 8, 1944	21,860,000
A91 044 001A	A92 764 001A	B00 000 001A	B01 564 001A
A92 764 000A	A99 999 999A	B00 904 000A	B13 564 000A

Experimental "R" and "S" $1.00 Silver Certificates

R Note	S70 884 001C		
	S72 068 000C	June 20, 1944	1,184,000
S Note	S73 884 001C		
	S75 068 000C	June 20, 1944	1,184,000

$1.00 HAWAII Silver Certificates

$1		June 8, 1942 - June 8, 1944	35,052,000

Y68 628 001B	Z99 000 001B	A99 000 001C	C00 000 001C
Y71 628 000B	Z99 999 999B	A99 999 999C	C07 000 000C
	F41 964 001C ⎱ This lot was delivered to the		
	F41 967 996C ⎰ Treasurer in uncut sheets.		
F41 967 997C	L75 996 001C	P31 992 001C	S39 996 001C
F41 976 000C	L78 996 000C	P37 032 000C	S54 996 000C

$5.00 HAWAII S.F. Federal Reserve Notes

1934	L12 396 001A	First lot	3,000,000
	L14 996 000A	delivered	
		June 8, 1942.	
	L19 776 001A		
	L20 176 000A		
1934 A	L46 404 001A		6,416,000
	L47 804 000A		
	L54 072 001A		
	L56 088 000A		
		Last lot	
	L66 132 001A	delivered	
	L69 132 000A	May 30, 1944.	

$10.00 HAWAII S.F. Federal Reserve Notes

Series	Serial Numbers	Inclusive Dates of Delivery	Total Delivered
1934 A	L65 856 001A L66 456 000A	First lot delivered June 8, 1942.	10,424,000
	L67 476 001A L69 736 001A L69 076 000A L71 336 000A		
	L77 052 001A L77 172 000A	Last lot delivered July 12, 1944.	
	L11 160 001B L12 664 000B		
L28 212 001B L29 712 000B	L43 032 001B L45 532 000B	L50 292 001B L51 292 000B	

$20.00 HAWAII S.F. Federal Reserve Notes

Series	Serial Numbers	Inclusive Dates of Delivery	Total Delivered
1934 and 1934 A	L30 540 001A L31 090 000A	First lot delivered June 8, 1942.	11,246,000
	L31 632 001A L32 032 000A		
	L33 420 001A L34 220 000A	Last lot delivered July 18, 1944.	
	L56 412 001A L56 912 000A		
L60 588 001A L61 592 000A	L67 984 001A L69 976 000A	L76 980 001A L78 480 000A	L85 536 001A L90 036 000A

Bicentennial Food Coupon Series

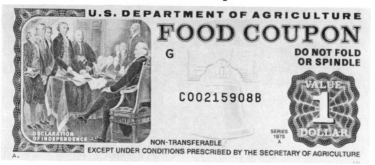

A Bicentennial theme is strong on the newest issue of U.S.D.A. Food Coupons introduced in March of 1975. The $1 shown above has as its main design a portion of Robert Trumbull's famous painting. The $5 portrays Jefferson with Independence Hall, and the $10 shows Hamilton and an eagle. All three have the Liberty Bell as a center device.

Present regulations make no provision for the numismatic holding of such coupons. It is hoped that this situation will be changed to allow collectors to possess these and all earlier issues as well.

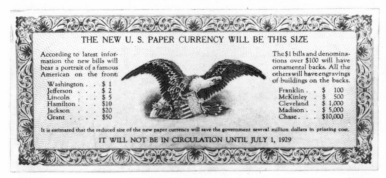

THE NEW U. S. PAPER CURRENCY WILL BE THIS SIZE

According to latest information the new bills will bear a portrait of a famous American on the front:

Washington . . $ 1
Jefferson . . . $ 2
Lincoln . . . $ 5
Hamilton . . . $10
Jackson . . . $20
Grant $50

The $1 bills and denominations over $100 will have ornamental backs. All the others will have engravings of buildings on the backs.

Franklin . . $ 100
McKinley . . $ 500
Cleveland . $ 1,000
Madison . . $ 5,000
Chase . . . $10,000

It is estimated that the reduced size of the new paper currency will save the government several million dollars in printing cost.

IT WILL NOT BE IN CIRCULATION UNTIL JULY 1, 1929

This is an example of a privately made circular describing the coming "reduced size" currency. Such circulars were distributed by various businessmen shortly before the new currency was placed into circulation in 1929. The back of the one shown contains an advertisement.

BIBLIOGRAPHY

Along with various smaller articles from a wide variety of sources, the following books and periodicals were consulted:

Donlon, William P., *Donlon Price Catalog of United States Small Size Paper Money*, Hewitt Bros., Chicago, Illinois, various editions 1964-

Friedberg, Robert, *Paper Money of the United States*, Coin and Currency Institute, Inc., New York, 8th Edition, 1975.

Hessler, Gene, *The Comprehensive Catalog of U.S. Paper Money*, Henry Regnery Company, Chicago, Illinois, 1974.

History of the Bureau of Engraving and Printing 1862-1962, Treasury Department, Washington, D.C., 1964.

Huntoon, P., and Van Belkum, L., *The National Bank Note Issues of 1929-1935*, ed. by M. O. Warns. Published by the Society of Paper Money Collectors, Hewitt Bros., Chicago, Illinois, 1970.

Kemm, Theodore, *Official Guide of United States Paper Money*, New York, various editions 1968-

Lloyd, Robert H., *National Bank Notes, Federal Reserve Bank Notes, Federal Reserve Notes 1928-1950*, Coin Collector's Journal, January-February 1953, Wayte Raymond, Inc., 1953. Also other articles from this magazine.

O'Donnell et al., *Standard Handbook of Modern U.S. Paper Money*. Fourth Edition 1974.

Petrov, Vladimir, *Money and Conquest - Allied Occupation Currencies in World War II*, The Johns Hopkins Press, Baltimore, Maryland, 1967.

Rundell, Walter, Jr., *Black Market Money*, Louisiana State University Press, 1964.

Shafer, Neil, *A Guide Book of Philippine Paper Money*, Whitman Publishing Co., Racine, Wisconsin, 1964.

Toy, R. S., and Schwan, Carlton F., *World War II Allied Military Currency*, Portage, Ohio, Fourth Edition 1974.

The Numismatist

Banknote Reporter

Numismatic News Weekly

Coin World weekly newspaper

Numismatic Scrapbook

Paper Money, published by the Society of Paper Money Collectors